CONTENTS

Acknowledgements	5
Introduction	7
1. Les Petite Côtes Under Spanish Rule	9
2. A Bargain for the United States: The Louisiana Purchase	25
3. The Lewis and Clark Expedition	39
4. St. Charles During the Territorial Period	49
5. The Struggle for Statehood and the Two Missouri Compromises	69
6. St. Charles, the First Capital of Missouri	75
7. German Immigration	85
8. The Slavery Question Returns	91
9. The Civil War in St. Charles	99
10. Industrialization to Suburbanization	123
11. The Great Flood of 1993	149
12. St. Charles Today	157
Bibliography	163
Index	171
About the Author	175

ST. CHARLES
MISSOURI

· A BRIEF HISTORY ·

James W. Erwin

THE
History
PRESS

Published by The History Press
Charleston, SC
www.historypress.net

Copyright © 2017 by James W. Erwin
All rights reserved

Front cover, top: Missouri's First State Capitol, late nineteenth century. *St. Charles County Historical Society*; *bottom*: *Library of Congress*.
Back cover: *photograph courtesy of Jim Steinhart of TravelPhotoBase.com*.

First published 2017

Manufactured in the United States

ISBN 9781467136198

Library of Congress Control Number: 2017931804

Notice: The information in this book is true and complete to the best of our knowledge. It is offered without guarantee on the part of the author or The History Press. The author and The History Press disclaim all liability in connection with the use of this book.

All rights reserved. No part of this book may be reproduced or transmitted in any form whatsoever without prior written permission from the publisher except in the case of brief quotations embodied in critical articles and reviews.

ACKNOWLEDGEMENTS

The rich history of St. Charles has generated an equally rich collection of books, articles, photographs and festivals, many of which are mentioned here. It is impossible to cite or write about them all. I wish to thank the staff and volunteers at the St. Charles County Historical Society for their assistance in providing information and images. I also wish to thank Jim Karll at the O'Fallon Historical Society, Paul Huffman at Lindenwood University, Nick Fry at the St. Louis Mercantile Library at the University of Missouri–St. Louis, Jaime Bourassa at the Missouri History Museum, the staff of the State Historical Society of Missouri, Maria Leljedal at the U.S. Army Heritage and Education Center and Jim Steinhart at TravelPhotoBase.com. The historical reference section in the Kathryn Linnemann Library was also an invaluable resource. The Kirkwood Public Library and the Municipal Library Consortium of St. Louis County made requesting needed books a simple pleasure.

Steven Clay gladly shared information about Charles Bentzoni with some guy who fired an e-mail to him from the void. A special thanks to Ann Hazelwood, one of the Main Street rehabilitation pioneers, who graciously provided me with documents and information about the development of the Main Street Historic District. I cannot forget my editor for the last five years, Ben Gibson, who gave me the opportunity to write yet another book for The History Press.

Finally, how do I thank my wife, Vicki? She provided encouragement, information (she's an author who has written about St. Charles, too), editing and all-around support. I guess all I can say is something I should say every day: Thank you.

INTRODUCTION

In the late afternoon of a beautiful fall day in October 1765, Louis Blanchette and three companions paddled their canoe up the Missouri River. As they approached a line of low hills, they could see over the trees a thread of smoke from a campfire.

Blanchette ordered the canoe to land near some thick bushes on the north shore. Leaving the others behind, he took his musket and climbed to the top of the hill. There he saw a party of Indians decked out in war paint, beads and feathers, carrying fresh scalps on their belts. It was a war party.

Blanchette quickly took a handkerchief from his pocket and tied it on the muzzle of his weapon. He spoke to them in several of the Indian tongues he had learned, trusting that one of them would be understood. He told them he was exploring the Missouri and that he loved the Indian.

One of the party, an old man and evidently the chief, paused, smiled and, in excellent French, told Blanchette he was welcome and to call for his companions to join them. Two of Blanchette's men came willingly, but the third tried to flee, fearing that his scalp would be added to the collection of their hosts. He was captured and brought to the Indian camp. The old chief laughed, and Blanchette calmed his frightened man by telling him that his scalp was as safe as the crown on the French king's head.

Blanchette fetched a jug of whiskey from the canoe. That evening, the men smoked a communal pipe and downed the whiskey. The old chief spun a lengthy tale of murder, escape and assimilation into the tribe of the Dakotas. His French name was Bernard Guillet. Guillet said he was from

Introduction

Marseilles. His parents died when he was very young and he was left as an apprentice to a master who mistreated him for years. When Guillet was seventeen, his master snatched the only memento the boy had of his late mother: her rosary. Furious, Guillet strangled the man to death. He fled to the harbor and signed on as a sailor on a ship headed to Canada. From there, Guillet spent more than twenty years living among the Indians, hunting, trapping and fishing. He came to white settlements only to sell his furs, buy powder and ball and partake of the whiskey there. Eventually, Guillet made his way to the place where Blanchette met him. Guillet found deer, beaver and muskrat. He built a cabin and commenced trapping. One day, he caught an Indian stealing from his traps and killed him.

Not long after, Guillet's cabin was besieged by ten of the dead man's friends. They set his cabin on fire and captured him as he fled the flames. Guillet learned that the man he killed was a Dakota, a fierce nomadic Plains tribe. The Dakotas tortured him and were about to burn him at the stake when, according to Guillet, he was saved by the chief's daughter. He took her as his wife and became a chief when her father died.

When Blanchette and Guillet parted the next day, Blanchette asked, "Bernard, when you lived here did you give any name to your home?" Guillet replied, "I called the place Les Petites Côtes from the sides of the little hills that you see."

Louis Blanchette would return to Les Petites Côtes ("the Little Hills") four years later, this time with his family. The little village, dubbed San Carlos del Misury by the Spanish and St. Charles by the Americans, would play a major role in the early history of Missouri. It was the jumping-off point for Meriwether Lewis and William Clark's exploration of the Louisiana Purchase, as well for settlers moving west along and beyond the Missouri River. St. Charles was the home of important politicians, judges, soldiers, businesspersons, educators and even a saint. It was the first capital of the new state. From a sleepy French village, St. Charles grew into a dynamic city in one of the fastest-growing areas of the nation. But it never forgot its history. The heart of the city is its historic district, where one can still experience its heritage.

This is the story of St. Charles, from Les Petite Côtes to today.

1
LES PETITE CÔTES UNDER SPANISH RULE

Europeans Discover the Missouri River

Father Jacques Marquette, one of the first European explorers of the Mississippi River basin, learned from the Illini Indians of another river that flowed into the Mississippi. On this river, called the Pekitanoui, the Illini said there lived "some great nations who use wooden canoes." In 1673, Marquette and Louis Joliet descended the Mississippi and came to the mouth of this river. Marquette later wrote:

> As we were gently sailing down the still, clear water, we heard a noise of a rapid into which we were about to fall. I have seen nothing more frightful, a mass of large trees entire with branches, real floating islands came from Pekitanoui, so impetuous that we could not without great danger expose ourselves to pass across. The agitation was so great that the water was all muddy, and could not get clear. The Pekitanoui is a considerable river coming from the northwest and empties into the Mississippi. Many towns are located on this river and I hope to make the discovery of the Vermilion or California Sea.

Marquette's guides told him that the people who lived on this river were the *mihsoori* or *wemihsoori*—"people of the wood canoe." Marquette wrote the name as *8emess8rit*. According to Michael Dickey, in seventeenth-century French script, the "8" was pronounced as a long "o." The word would have been pronounced as "oo-emis-ooray." The "e" was later

Pere Marquette and the Indians, original painting by William Lamprecht at Marquette University. *Wikipedia*.

dropped by French mapmakers; subsequently, the first syllable was dropped as well. Thus, the people became known as the Missouria, and the river—and, ultimately, the territory and state—became known as "Missouri."

By whatever name it was known, the Missouri River presented a challenge to travelers who sought to go upstream, especially in the spring, when, as an early chronicler noted, "The river is frightfully swift...passing over the islands when it overflows and carries off trees." Bark canoes common on the Upper Mississippi could not be used on the Missouri because of the prevalence of snags. Thus, the Missouria instead carved logs from cottonwood, sycamore or walnut trees to make dugouts that could withstand the battering from the debris in the river.

Although no one then knew the extent of the Mississippi and Missouri River basin, in 1682, René-Robert Cavelier, Sieur de la Salle, claimed the entire area for France and named it La Louisiane in honor of King Louis XIV. French hunters and trappers entered the Missouri wilderness almost as soon as it was discovered by the Europeans. By 1684, two Frenchmen were already living with the Missouria. By 1704, the governor of Louisiana reported that there were about 110 French traders along the Mississippi and Missouri Rivers.

A Brief History

Whether the meeting of Louis Blanchette and Bernard Guillet was true or the stuff of legend, Guillet was not alone in taking a Native American woman as a guide, a companion and a wife—although others likely did so in less dramatic circumstances. There were, after all, no white women accompanying the traders. The male traders' relationships with Native American women were informal, at least from the French point of view, because there were no priests in the wilderness at that time, either. Indeed, even nearly one hundred years later, most of the marriages of the inhabitants of St. Charles had not been consecrated in the church; the offspring of these unions were, in the eyes of the law, illegitimate. That situation was remedied by a flurry of marriages conducted after the church became established in the village.

In the first one hundred years after the voyage of Marquette and Joliet, the French were more interested in obtaining furs than in the settlement of the Missouri River Valley. An abortive attempt to establish a fort near present-day Carrolton failed. Individual traders and those sanctioned by trading companies sought to establish trading partners among the various Native American inhabitants.

At first, traders came with trinkets—beads, necklaces and medals. These items had little monetary value in the European economy, but they appealed to Indians, who used them as gifts for their dead. In return, the French traders received beaver pelts, deerskins and buffalo robes and meat—items of great value to the Europeans but so abundant in the wilderness that the Indians placed little value on them. As Henry Martin Chittenden wrote about the fur trade:

> *The white man valued the native furs altogether beyond what the Indian was able to comprehend, and the latter was only too happy to trade them for that gaudy and glittering wealth which had been brought from a great distance to his country. Thus, in the early intercourse of the white man with the Indian, each gave to the other something he valued lightly, and received in return something he valued highly, and each felt a keen contempt for the stupid taste of the other.*

Louis Blanchette, *Fundador y Primero Habitánte*

In 1769, four years after his encounter with Guillet, Louis Blanchette returned to Les Petite Côtes. This time, instead of fellow hunters, he brought

St. Charles, Missouri

Left: Statue of Louis Blanchette at Blanchette Park, St. Charles, Missouri. *James Erwin collection*.

Right: Plaque at the site of Louis Blanchette's cabin on South Main Street. *Vicki Erwin collection*.

with him his wife and children. Little is known of Blanchette's early life. He was born in 1736 in the Parish of St. Henry, Diocese of Quebec, to Pierre Blanchette and Mary Gensereau. He met and married a Native American woman, Tuhomehenga, around 1758. Tuhomehenga was later described as "sauvagesse, nativois des Panis Piques d'autre part," or part Pawnee. She is also said to have been Osage. She may have been captured by an Osage war party and incorporated into that tribe.

Blanchette and Tuhomehenga built a rude log hut on what is now Main Street near where a spring-fed creek (later named for Blanchette) emptied into the Missouri below the first range of steep hills upriver from the Mississippi. It was likely in the French style, with vertical logs bearing in the ground instead of horizontal logs, as the Americans built. Louis and Tuhomehenga had four children: twins Pierre and Louis, born about 1759; Baptiste, born in 1763; and Marie, born in 1766. There were perhaps other settlers who accompanied them, but if so, their names are lost to history. In

A Brief History

any event, Blanchette is now and was then regarded as the founder of Les Petite Côtes.

Other than sporadic forays up the Missouri River, the French had done little to cement their claim to land west of the Mississippi. Until 1764, when St. Louis was founded, the nearest French outposts were at Kaskaskia and Fort Chartres on the east bank of the Mississippi in today's southern Illinois and at St. Genevieve on the west bank. Relations between the English colonies on the Atlantic coast and New France west of the Allegheny Mountains had been smoldering for nearly a decade as the English sought to push into the Ohio River Valley. Finally, war broke out in 1754 and spread to the European continent two years later. The French and Indian War (known to Europeans as the Seven Years' War) had significant consequences for French colonial ambitions and for Blanchette and fellow French Canadians.

The Treaty of Paris, signed in 1763, provided for the transfer of New France from the Alleghenies to the Mississippi River to Britain, along with the transfer of its claim to the land west of the Mississippi to Spain. Thus, while Blanchette may have believed he was founding a French village on the banks of the Missouri, it was in fact in a colony claimed by Spain. The Spanish did little to consolidate their gains. Spain did not even occupy New Orleans until 1768 and did not come to Les Petites Côtes until 1771.

Not only were Spanish authorities likely unaware of the existence of Blanchette's little village, but they also did not even know of the extent of the land they claimed. When they finally got around to dividing Upper Louisiana into administrative districts, the northernmost one—St. Charles—extended from the Missouri River north and west for some distance that was not defined or known.

Life in Les Petite Côtes proceeded with little interference or protection from the government. There may well have been the usual problems experienced by early river settlements: disease, flooding or other natural disasters. Possibly the village experienced trouble with marauding Indians. If so, these events were not recorded. The inhabitants were more interested in survival than in documenting their activities for history. Blanchette and other men in the village probably continued their hunting, trapping and trading forays into the unsettled land to the west. The settlement grew slowly. By 1781, it still had only six dwellings. A 1787 census showed there were eighty persons living in the village.

Les Petite Côtes had no resident priest. Father Sebastian-Louis Meurin first visited St. Louis in 1766; he likely performed the first baptism in that city. He is said to have first visited Blanchette's village in 1772. We know Father

Meurin baptized Blanchette's sixteen-year-old twins, Pierre and Louis, on October 5, 1775. (This document described their mother, Tuhomehenga, as an Osage.) The date of Baptiste's and Marie's baptisms isn't known. From 1776 to 1789, the village's spiritual needs were taken care of by Father Bernard de Limpach, a missionary from St. Louis who visited Les Petites Côtes and "neighboring stations" from time to time.

The residents may have built a chapel as early as 1780, but the formal sanction for the construction of the church was not given until 1789, when Blanchette and thirty others from the village signed an agreement approved by Lieutenant Governor Manuel Perez to build a rude log building. It soon rotted away and was replaced with another church that survived until at least 1825, by which time it was described as "an old rickety log building." The church was located on today's Jackson Street between Second and South Main Streets. (A replica was erected on the site in 2008.) A cemetery was "blessed in [the] same place" on December 7, 1789. Once completed, the church was consecrated on November 7, 1791. An order was entered requiring the citizens to attend Mass each Sunday on penalty of paying a fine, to be collected by "Mr. Blanchette, to whom [the church]...has given power and who will inflict punishment."

On the same day as the church's dedication, Lieutenant Governor Perez changed the name of the village from Les Petite Côtes to San Carlos del Misury. Perez reported that the "people have decided to choose as a patron, St. Charles, in the name of our august sovereign." This wording has led to some confusion about exactly who was being honored by the renaming of Les Petite Côtes. Although Charles IV was the reigning king of Spain, "Saint Charles" was St. Charles Borromeo, a reformist archbishop of Milan in the later sixteenth and early seventeenth centuries. St. Charles Borromeo was also the name chosen for the church, which remains active today.

Blanchette's daughter, Marie, married Etienne Pepin in 1788, and they had a daughter born in September 1789. Louis and Tuhomehenga's granddaughter was baptized in October 1789. Tuhomehenga was also baptized with the Christian name of Angelique. And the marriage of Louis and Angelique was formalized in a Catholic ceremony. Thus, the priest declared their children legitimate in the eyes of the church.

Blanchette, described in a 1787 census as a "Labrador," or farmer (his son Baptiste was a "Cazador," or huntsman), was recognized by Lieutenant Governor Perez as "fundador y primero habitánte de S[a]n. Carlos del Misury" (founder and first inhabitant of St. Charles). Angelique died on

A Brief History

Replica built in 2008 of the Old San Carlos Borromeo Church, erected in 1791. *James Erwin Collection.*

February 11, 1793, and was buried in the church. Louis Blanchette survived her by only a few months, although, as a church historian notes:

> *the precise date of Commandant Blanchette's death I could not ascertain. He was highly respected and dearly beloved by the people, for having erected the first church for their use and having caused it to be renewed and enlarged three times. His grave was dug under the church floor, and his mortal remains deposited there.*

Charles Tayon, a son of Joseph Tayon, was named commandant in Blanchette's stead. Joseph Tayon owned a mill near Fort de Chartres in French Illinois country when he was recruited by Auguste Chouteau and Pierre Laclède to accompany them to found a new town on the west bank of the Mississippi they called St. Louis. Joseph quickly became the largest slaveholder and one of the wealthiest men of the town.

Although a French Canadian, Charles Tayon served honorably in the Spanish army for more than twenty years. He was the commandant in San Carlos until the Americans acquired the territory. His superiors reported that Tayon "is a brave officer and zealous in obeying orders he receives

Charles Tayon Home at 119 McDonough. *St. Charles County Historical Society.*

when he comprehends them"—a potential problem, "as he neither reads nor writes." Moreover, "he gives himself to drink," not an unusual vice for soldiers stationed in wilderness backwaters.

The new commandant proceeded to nullify much of Blanchette's work. He took for himself the government buildings and land Blanchette had granted to the village. He took away all the land claimed by Blanchette and his children (except for one tract on the prairie) and gave it to his own followers. He granted the lot on which Blanchette had built the church to two private citizens, requiring the church's trustees to buy it back to keep the church going.

San Carlos experienced a small boom, increasing in population to about 450 by 1797. There were about one hundred houses along a single street that stretched between the hills and the river for nearly a mile from Blanchette Creek to the north. By 1799, there was a Second Street; there was a Third Street by 1800. Town records also show a Water Street, east of Main Street, running along the river bank, with a small row of buildings and lots extending west to Main.

Although a Spanish colony, the residents of San Carlos followed the tradition of medieval France by holding land outside the village proper in common fields. This land was not "owned" by any individual in the American sense of private property. Rather, the entire community was its owner.

A Brief History

There were two types of commons: land used to cultivate grains and land used as pasturage and for the gathering of firewood. The plowlands were located on the Prairie Haute west of San Carlos. Each farmer had a strip one arpent wide and forty arpents long, or 192 feet by 7,700 feet (or 1.46 English miles). The practical reason for such narrow strips of land was that it was difficult to turn the teams of oxen used to plow the fields—the long and narrow strip made for fewer turns. After the harvest, the entire prairie commons were used by all the residents for the grazing of their livestock.

The second common land was located downriver, or north, of the village, extending from Les Mamelles to the Missouri River. Les Mamelles (French for "woman's breasts") were two conical mounds rising 150 feet above the plain about three miles north of the village "so beautifully...paired and rounded, that it would hardly require a Frenchman's eye...to detect the resemblance designated." Visitors vied for the most poetic description of the view from the heights. One compared the long waving prairie grass on the plain below to a green sea; another said that from the mounds one could see "a scene of surpassing loveliness." Yet a third writer described it as a

> *beautiful level plain spread out...for miles, east, west and north, dressed in living green, variegated with many hued prairie flowers; the whole encircled by the bluffs of the two rivers, whose crags and peaks, reflecting the rays of the evening sun, presented the appearance of towns and villages and ruined castles. To the north lay the Marais Croche lake, like an immense mirror set in emerald.*

The view is no longer available; a subdivision sits on Les Mamelles today.

In 1797, Tayon asked Lieutenant Governor Don Zenon Trudeau for a grant of land six arpents in width between Les Mamelles and the river to be used as common fields for San Carlos. However beautiful the view, the ground below the mounds was not suitable for agricultural purposes, as Trudeau recognized in approving the grant. It could not be improved, he said, "on account of the inundations to which it is subject every year." Moreover, there was only scrub timber below the mounds, good only to burn. Accordingly, "the said land being in the vicinity of the village of St. Charles and of various farms, in the prairie of its dependency, which would have to go a great deal further to procure wood; said tract shall remain...in the royal domain, and for the common use of the said village of St. Charles."

In 1800, Pierre Chouteau, son of the powerful fur trader Auguste Choteau, wrote to the new lieutenant governor, Don Carlos Dehault Delassus, seeking

a grant of land in the same area to complete the building of a gristmill. Chouteau claimed that the documents he sent to New Orleans with "a friend" had become inexplicably lost. Delassus asked Tayon to provide "information of all he knows upon what is here asked." Tayon affirmed Chouteau's claim. Because Tayon was illiterate, it is not known whether he failed to read and understand the village's conflicting claim made under his auspices only three years before, or if he took Chouteau's side due to ignorance or as a favor to one of the most prominent citizens in Upper Louisiana. In any event, Delassus granted the concession almost immediately, setting in motion litigation, typical of many disputes that would later develop over Spanish land grants. The issue would not be settled until a decision of the United States Supreme Court in the village's favor in 1844.

The Boone Family Finds "More Elbow Room"

Settlers from the United States began to trickle into Spanish Louisiana in the 1780s. John Coontz, for example, lived in the Illinois Country for fourteen years. But when the United States adopted the Northwest Ordinance of 1787 prohibiting slavery in the land north of the Ohio River and east of the Mississippi River, he brought his slaves to St. Charles.

The most prominent immigrants were the Boone family. Daniel Boone, a former Virginia legislator, Indian fighter and already legendary frontiersman, was experiencing hard times in Kentucky. By 1798, he and his wife, Rebecca, were living with his youngest son, Nathan. Morgan Boone came to Upper Louisiana and discovered rich farmland west of San Carlos along Femme Osage Creek. He met with Lieutenant Governor Zenon Trudeau, who assured Morgan that he and his family would receive generous land grants if they settled in the area. Moreover, Trudeau said he would not enforce a law (the enforcement of which was already lax) requiring new settlers to accept the Catholic faith. He promised Morgan a grant of 1,000 arpents (about 850 acres)—more than the usual 850 arpents—and a grant of 400 to 600 arpents to any family members who accompanied him. Morgan agreed to the proposal. He left four slaves behind to build a cabin on the Femme Osage and returned to Kentucky to bring the family's large clan to their new home.

In preparation for the trip, the Boone men cut down a large poplar tree. With an adz, axe and fire they fashioned it into a pirogue "five feet

in diameter and between fifty and sixty feet long." Nathan said it held "five tons of our goods and family merchandise." The work was complete by fall, and in September 1799, Nathan, Morgan, their sisters Susanna and Jemima and Isaac Vanbibber and his family set out on the Ohio River for St. Charles. Daniel went overland with other settlers to drive cattle and hogs to the new settlement, allegedly saying that he was going west because Kentucky was "too crowded—I want more elbow room."

Nathan Boone was not himself on the trip downriver. The others noticed that he was clearly unhappy about something. What they didn't know, but likely suspected, was that he had fallen in love. Before the trip, Nathan spent a lot of time with Isaac's cousin Olive Vanbibber, who was known as "the handsomest woman north of the Ohio River." He had promised to write her while he was gone, but the thought of leaving Olive behind overcame him.

Daniel Boone. Engraving by J.B. Longacre, after a painting by Chester Harding. *Library of Congress.*

Just seventy-five miles downriver, Nathan announced to his family that he was turning back to marry Olive and would bring her to Missouri with him. A few days after he left the old homestead, Nathan showed up at Olive's door with a marriage license. They were married on September 26, 1799. Nathan was eighteen; Olive was sixteen. Five days later, they left for Missouri.

Nathan and Olive had few possessions. Nathan recalled that Daniel lamented that "he had nothing to give me and my new wife with which to start our new life." But that was all right with the newlyweds. They left with a musket, an axe, some blankets and parched corn. They made their way to Vincennes, Indiana Territory, where one of the horses came up lame. After it healed, the couple set off again for St. Louis, arriving in late October. There, Nathan was offered eighty acres west of the town for one of their horses. Olive recalled years later that Nathan laughed "and said he wouldn't give one of our ponies for the whole town."

Nathan and Olive arrived across from St. Charles with their horses and goods. They took a skiff, and with Olive holding the reins of the horses as they swam across the Missouri River, Nathan rowed furiously to get

them to the other side. They rested for a time and then struck out west to find the family's new homes. A few miles upriver from St. Charles, Nathan and Olive found the mouth of the Femme Osage and the rest of the new settlers in Upper Louisiana.

Nathan did not get a land grant from Lieutenant Governor Trudeau. He did have to give up one of his horses, complete with saddle and bridle (worth about $120), to Robert Hall for 800 arpents (680 acres) six miles up the Femme Osage from the Missouri River. Nathan and Olive spent the winter with Morgan. In the spring, Nathan built a rude cabin on their land; it lacked a floor and chimney, and the roof leaked when it rained. He hustled off to the woods to hunt with his father and brothers, leaving Olive behind.

Nathan Boone. *Missouri History Museum.*

But while Nathan was away hunting and trapping, Olive (pregnant with their first of fourteen children) was working to improve the place. With the help of her slave servant, she added a floor and chimney to the cabin. Nathan later said, "With stones for the fireplace, sticks for the chimney, and mud for the mortar these lone women erected a chimney, the draft of which proved decidedly the best of any on the farm." Daniel and Rebecca lived in one side of a dogtrot cabin, the frontier equivalent of a duplex, and Daniel Morgan lived on the other side with his fourteen-year-old wife. Later, Daniel moved to his own place.

Daniel was treated royally in his new home. He was received with honors in St. Louis by the Spanish lieutenant governor, who appointed him "syndic," a combination justice of the peace and administrator for St. Charles. In that post, Daniel dispensed justice—ruled "more by *equity* than by law," Nathan said—under a large elm tree, which became known as the "Judgment Tree." It was a rough, frontier justice. A man charged with stealing a hog was given the choice to go to trial in St. Charles or be whipped. He chose the latter, and when he returned home was proud to announce that all went well with syndic Boone, because he was "whipped *and cleared.*"

A Brief History

Daniel Boone's "Judgment Tree." *St. Charles County Historical Society.*

St. Charles, Missouri

In 1809, Daniel and Rebecca moved to St. Charles for a time, but they returned to their cabin until the threat of Indian attacks during the War of 1812 caused them to leave for a safer spot. Daniel had dictated his autobiography, but unfortunately, during the trip, the canoe in which he was riding capsized and the manuscript was lost. He never wrote another.

Rebecca died in 1813. Daniel moved in with his children. In 1816, Nathan and Daniel began building a stone house on the banks of the Femme Osage. Although tradition says Daniel made the pegged wooden doors, he likely supervised the rest of the tasks while Nathan did the hard work. And it was hard. He cut blue limestone into blocks three feet wide, weighing several hundred pounds, and painstakingly dressed each one with a hammer and chisel. Once prepared, the stones were dragged by sled to the homesite. Using a block and tackle, the blocks were set into the side of a hill overlooking the creek. When finished, the home had a full basement for the kitchen and dining room, two full floors above that and a large attic. Two full-length porches faced the creek. The first floor's windows doubled as gun ports with heavy shutters. The place was not just a home, it was also a fort. It was, as Robert Morgan called it, "a kind of American castle."

Nathan Boone Home (front). *Vicki Erwin Collection.*

A Brief History

Nathan Boone Home (rear). *Library of Congress*.

Daniel spent his final years in the magnificent place he and Nathan built, planning for his funeral and enjoying his grandchildren. Daniel ordered a Cherrywood coffin and placed it under his bed. He liked to show it off, and many visitors came to admire it. He was said to pull it out and take a nap in it, scaring the children. He was laid in it for the final time on September 26, 1820, when he died at the age of eighty-six. Nathan and Olive lived in the house until 1837. By then, Nathan, who joined the regular army in 1832, sought a place closer to his duty stations at Fort Leavenworth in Kansas and Fort Gibson in Indian Territory. He and Olive sold the house and moved to Ash Grove, Missouri.

The lives of the Boone family were much like those of the French who preceded them to St. Charles. The men hunted and trapped for weeks or months at a time, while the women stayed home to take care of the children, grow the crops and mend and make the clothes.

Although more bustling Americans began to settle in St. Charles, the village's French inhabitants still maintained a leisurely lifestyle. Visitors thought little of the place, characterizing it as the home of "savages,

mongrels and the worst scoundrels" in the district. A French traveler wrote of the residents in 1796, "The ordinary occupations are hunting and trading with Indians, and it would be difficult to find a collection of individuals more ignorant, stupid, ugly and miserable."

But events in Europe were leading to momentous changes.

2

A BARGAIN FOR THE UNITED STATES

The Louisiana Purchase

The One Single Spot We Must Have

Spain's relations with the new United States were benign. As more Americans settled into the Ohio River Valley, the importance of navigation from that region to the port of New Orleans became the focus of the American government's interest in Spanish Louisiana. In 1795, the Spanish agreed to allow Americans free passage on the Mississippi River to New Orleans. This was important because Spain controlled both banks of the river below Kentucky. In 1798, Spain allowed Americans the right of deposit at New Orleans—the right to land their goods pending their shipment elsewhere.

In October 1800, Spain agreed to retrocede the colony of Louisiana to France. Although the treaty was secret, rumors of its existence began to circulate in Europe and Washington shortly afterward. The new American president, Thomas Jefferson, sent Robert R. Livingston to Paris to find out whether Spain in fact had transferred Louisiana to France. If it had not yet happened, Livingston was to try to persuade the French not to go through with the agreement. If the transfer could not or would not be rescinded, then Livingston was to seek the transfer of Florida to the United States. Jefferson spelled out his worries to Livingston in an April 18, 1802 letter.

> There is on the globe one single spot, the possessor of which is our natural and habitual enemy. It is New Orleans, through which the produce of

> three-eighths of our territory must pass to market, and from its fertility it will ere long yield more than half of our whole produce and contain more than half our inhabitants. France placing herself in that door assumes to us the attitude of defiance. Spain might have retained it quietly for years. Her pacific dispositions, her feeble state, would induce her to increase our facilities there, so that her possession of the place would be hardly felt by us, and it would not perhaps be very long before some circumstance might arise which might make the cession of it to us the price of something of more worth to her. Not so can it ever be in the hands of France. The impetuosity of her temper, the energy and restlessness of her character, placed in a point of eternal friction with us, and our character, which though quiet, and loving peace and the pursuit of wealth, is high-minded, despising wealth in competition with insult or injury, enterprising and energetic as any nation on earth, these circumstances render it impossible that France and the U.S. can continue long friends when they meet in so irritable a position.

Jefferson warned Livingston that if France could not be dissuaded from the retrocession, the United States would have no choice but to join with Great Britain in the next European war—a warning that he wanted leaked to the French. A Jefferson biographer, Dumas Malone, noted that this was an extraordinary statement by a man who had spent years attacking Britain and trying to free the United States from "British commercial thralldom."

On October 18, 1802, the Spanish intendant at New Orleans, Juan de Dios Morales, terminated the right of deposit at that port, setting off alarm bells in the United States. Ostensibly, he did so because the 1798 treaty granted the right of deposit for only three years. This was not quite accurate; it guaranteed the right of deposit at New Orleans for three years, but if that port was closed to the Americans, Spain was supposed to make another one available. But no other port was as convenient or well established as New Orleans. Jefferson told the House of Representatives that Morales had acted on his own. Historians now believe that the Spanish government secretly ordered him to revoke the right of deposit—not for any nefarious diplomatic purpose, but because American smugglers were abusing the privilege.

The dispute over the right to deposit spurred the American desire to acquire Florida and New Orleans so that the Mississippi could be reopened to American shippers. The United States' urgency to satisfy its citizens in the West coincided with Bonaparte's decision to drop his dreams of a colonial empire in the New World. With a renewed war with Britain looming, France needed money. French continental concerns thus matched the American

desire to secure its position on the Mississippi. Napoleon authorized his ministers to ask whether the United States wished to acquire all the French possession on the North American continent. Livingston and James Monroe (who had been sent to assist the negotiations) leaped at the chance to buy all of Louisiana, even though they had no explicit authority to do so. No matter. They knew a good deal when they saw it, and there were worries that the French might change their minds. The Treaty of Cession was signed on April 30, 1803. The news reached Washington on July 4.

The United States had vastly increased its territory, acquiring an area west of the Mississippi River stretching from the Gulf of Mexico to the headwaters of the Mississippi River on the north and to the headwaters of the Missouri River and the Rocky Mountains to the west. The exact boundaries of the Louisiana Purchase were left vague because the treaty provided only that France was ceding to the United States whatever it had acquired from Spain, and France acquired from Spain whatever land Spain had acquired from France in 1763. The price was $15 million (about $240 million in today's dollars). While it was a steep price for a government remarkable for its stinginess, it was still a bargain.

The public generally received the news favorably. Certainly, westerners who had been up in arms over the closure of New Orleans to the right of deposit were relieved that the government would now be able to control both banks of the Mississippi from its origin to its mouth. Federalists in New England formed the chief opposition, worried that the creation of new states from this vast territory would weaken their power in the republic.

There were concerns, however, even among the proponents of the treaty. Jefferson himself worried that the acquisition of Louisiana was unconstitutional and proposed a lengthy amendment to address the situation. It was met with stony silence. In the end, Congress merely recognized that the area was part of the United States and authorized the president to establish a territorial government.

Spain had not actually transferred control of Louisiana to France in the three years after entry into the secret agreement to do so. Thus, it must have come as a shock to the isolated residents of Upper Louisiana to learn that the country changed hands twice without their knowledge and that they were now to be the newest Americans. But Article III of the Treaty of Cession had a special provision to protect the former Spanish (and French) subjects, one that would be cited again and again to support their claims to statehood, land claims and right to own slaves:

Map of Louisiana Purchase (1804). *Library of Congress.*

> *The inhabitants of the ceded territory shall be incorporated in the Union of the United States and admitted as soon as possible according to the principles of the federal Constitution to the enjoyment of all these rights, advantages and immunities of citizens of the United States, and in the mean time they shall be maintained and protected in the free enjoyment of their liberty, property and the Religion which they profess.*

Victor Nicollot wrote that the citizens of St. Louis received the report of their new citizenship "on the 9th day of July, 1803, at seven o'clock p.m.—and the precision with which this date is registered indicated the profound sensation with which the news was received." When the residents of San Carlos—soon to be St. Charles—found out is not recorded, but it must have been shortly afterward.

Legions of Lawyers and Flocks of Vampires in the Shape of Land Speculators

The reaction of the newest "republicans" was mixed. Many American settlers were apprehensive because they feared (rightly so) that the new regime would bring with it taxes—the avoidance of which was one of the reasons some had moved west of the Mississippi. Other Americans "were pleased greatly with the transfer of the country and seem to have been decidedly hostile, if not to the Spanish Government, then to the Spanish officers." Most of the French "neither rejoiced nor were they even reconciled" to the cession. Other observers claimed "the French inhabitants are in general enemies to the change of Government." The rapid transfer from Spain to France to the United States made some residents feel "they had been sold on the open market, and by this means degraded."

Again, the reaction of the inhabitants of St. Charles was apparently not recorded. Given that the village was largely French, we may assume that there was at least apprehension, if not hostility. Spain had ruled Upper Louisiana with a relatively light hand. It allowed the residents to pursue their French customs by, for example, granting the village common land. It encouraged the Catholic faith; many of the faithful were concerned about coming under the rule of a predominately Protestant country. Spain had imposed no taxes. Its governors were generous in making land grants, although they failed to follow the technicalities of Spanish law, a matter that would plague land titles and American courts for decades. Although Spain recognized African American slavery, it prohibited (or at least restricted) Indian slavery and did not interfere with the intermarriage of whites and Indians. Spain did not require military service, and it provided some protection against Indian raids.

Changes were looming. There would be a new set of governors, most from Virginia or elsewhere. They would bring with them new laws, new

customs and new cultural attitudes. The new rulers also brought with them "a legion of judges, lawyers, notaries, collectors of taxes, etc, etc., and, above all, a flock of vampires in the shape of land speculators."

The Senate approved the treaty in October 1803 and authorized the president to set up a temporary government pending legislation for a more permanent arrangement. Jefferson appointed Captain Amos Stoddard, an artillery officer in the army, as the interim commandant of Upper Louisiana. Having taken no steps to assume control of Louisiana after the retrocession, the French had no one in St. Louis to participate in the transfer ceremony there. Captain Stoddard therefore represented France in accepting the formal transfer from Spain on March 9, 1804, and took the transfer from France to the United States on March 10.

In accordance with his instructions, Stoddard kept the existing officials in office until the president could appoint replacements. Stoddard was instructed to investigate the land title situation, where he found indications of widespread fraud. Once rumors surfaced of the retrocession of the colony to France, Spanish officials in cahoots with many prominent Frenchmen in Upper Louisiana made many large land grants, backdating them to before 1800. To forestall further fraud and to commence the investigation into land titles, Stoddard issued a proclamation directing that all original land grants and other documents be surrendered to the office of the commandant where the land was located. The government would either give attested copies to the claimants or, after recording them, return the originals to the owners. Holders of the grants were wary of turning over their documents, perhaps because of the possibility of the discovery of fraud.

Subsequently, Congress divided the territory into two districts: Orleans, most of which was later incorporated into the state of Louisiana; and Louisiana, everything else from the Arkansas River as far north and west as the Louisiana Purchase might extend.

Residents in Upper Louisiana, and particularly the French who received large land grants from Spain (or claimed they did), were unhappy with the legislation. First, Congress extended the authority of governor and judges of Indiana Territory to Upper Louisiana. Second, all male inhabitants of the district between the ages of eighteen and forty-five were required to join a militia to be prepared to fight if there was a "sudden invasion or insurrection" and to assist the regular military in arresting "unauthorized settlers." Third, the law authorized the president to negotiate with eastern Indian tribes to allow them to exchange their land east of the Mississippi River for land west of the river.

A Brief History

There was some concern about what would happen to the slaves owned by longtime residents and those brought into Spanish Louisiana by recent immigrants from the United States. "Leading citizens" of St. Louis advised Captain Stoddard that there was among the blacks "a fermentation which may become dangerous"; they requested that he keep in place the black codes Spain had enacted. Stoddard agreed. But Congress failed to address the question of slavery at all in the 1804 statute, leading some to fear that slavery might become prohibited in the district, as it was in the Northwest Territory of which Indiana Territory (the locus of the new government) was a part.

These worries, however, paled in comparison to the anxiety arising from the law's provisions regarding Spanish land grants. Section 14 of the statute provided that all land grants made after October 1, 1800, when France obtained title from Spain, "are hereby declared to be, and to have been from the beginning, null, void, and of no effect in law or equity." It preserved land grants to "an actual settler on the lands…for himself, and for his wife and family" where the grant was made in conformity to Spanish law or customs "if such settlement in either case was actually made" prior to December 20, 1803 (when American authorities took actual possession of the territory in ceremonies in New Orleans).

The recipients of Spanish land grants were alarmed. The perfection of land claims under Spanish law was a cumbersome process seldom followed in practice. Indeed, one Spanish colonial official said that the best way to claim land in the colony was with an axe and a hoe. Holders of large grants were speculators who acquired their claims, honestly or not, to sell to new settlers. They certainly lacked any interest in turning the soil themselves. Many new Americans of French heritage fell into this category. American settlers and longtime French residents banded together to fight the new law by electing representatives to a convention called to file a petition protesting it. The delegates from St. Charles were Warren Cottle, Timothy Kibby, F. Saucier and A. Reynal. Cottle and Kibby were among the first Americans to settle north of the Missouri River. Saucier and Reynal were described by historian Louis Houck as "among the richest, most influential, and intelligent representatives of the French element."

Two days prior to the effective date of the statute and the assumption of control by the new territorial government, the convention published its objections. Historian Floyd Shoemaker called this document one of the most interesting in the territorial period because it "involved the first successful wire-pulling in Missouri history." As first drafted, it called for a

military government. Some of the delegates supposedly even threatened to ask France to enforce Article III of the Treaty of Cession. Cooler heads prevailed, largely due to the efforts of a former schoolmaster—unidentified to this day—who, by the "flame of his eloquence and unparalleled knowledge of American politics changed the tone" of the petition from one of ridicule of Congress to a more respectful but earnest request for changes.

The petitioners pointed out that the new governor did not live in the territory and, in fact, lived 165 miles from the nearest point in Louisiana. The failure of the legislation to deal with the issue of slavery was also a sore point. Although Article III preserved the inhabitants' property rights, the petition asked Congress to "acknowledge the principle of our being entitled, in virtue of the treaty, to the free possession of slaves, and to the right of importing slaves" subject to general congressional restrictions imposed on the states regarding the slave trade. Moreover, the petitioners were dissatisfied with Congress's approval of Jefferson's proposal to relocate Indian tribes from east of the Mississippi to Upper Louisiana—a feature of the legislation they denounced as "an incalculable accession of savage hords to be vomited upon our borders!"

These were matters important to at least some of the inhabitants, but the heart of the petition was its argument against the law invalidating most land titles acquired from the Spanish after October 1, 1800. The legal argument was grounded on the contention that the king of Spain did not renounce his sovereignty over Louisiana on the date the treaty was signed. Thus, it was entirely proper for Spanish colonial officials to believe they had the power to make land grants until they received official notice of the retrocession of Louisiana to France. Given that, under Spanish law, the grantees had three years to perfect their claims, and that it took several months for the United States to take possession of the territory after its treaty with France was signed, "there may have been grants of land obtained from the Spanish government, as to which, those who have obtained them, may yet have more than one year to comply with the laws, usages and customs of the Spanish government." Further, they argued, there might be Americans who "might have bought" land from the original grantees who might have taken it for granted that Congress would allow them the same amount of time to perfect their title. And these American emigrants "might have returned to the eastern part of the United States in order to prepare everything necessary for their removal, and with the intention of coming back to Louisiana in the following spring, to settle upon these lands."

The petition invoked the image of "hard laboring men" confused by conflicting information who might become "discouraged at first from exhausting their whole in making improvements on lands to which they had obtained incipient title, from what they conceived the precariousness of those titles." Now, "whatever they do [they are] liable to be punished by a free and enlightened nation, for having listened to the dictates of prudence and placed confidence in the United States."

The petition did not identify any such pathetic cases (and none has been turned up subsequently by historians, although it is entirely possible that there were some persons who fit the description). At best, the claim was that there "might have been" persons who "might have" found themselves in that plight. But many of the petitioners did claim to own land granted to them by the Spanish government after 1800. The petition asked Congress to confirm all titles whenever acquired from Spain that were "conformable" to Spanish law and to affirm the validity of any judgments already issued by Spanish courts.

The petition arrived in Washington along with Eligius Fromentin, a French Creole selected to deliver it. Auguste Chouteau had also been picked as a delegate to present the petitioners' case, but he could not make the trip due to an attack of gout. Members of Congress listened to the objections, but they were wary of accepting all the proposals, particularly those about confirmation of Spanish land claims, in large part due to an inflammatory letter from a recent American immigrant to Upper Louisiana, Rufus Easton.

Easton, born in Connecticut in 1774, studied law and practiced in New York before moving to Upper Louisiana in the winter of 1803–4. He was hardly neutral in the land claim dispute. He and fellow American John Rice Jones competed with French Creoles in snapping up land claims.

In a letter dated January 17, 1805, Easton wrote to President Jefferson to describe what Floyd Shoemaker called the "inner history" of the petition. Easton claimed that the whole thing was arranged by a cabal of French Creoles who made the annexation of Upper Louisiana to Indiana Territory the "ostensible objection to the law of Congress tho' that clause

Rufus Easton. *Missouri History Museum.*

which affected the titles to Land was the real ground of dissatisfaction." He claimed "that they [French residents] are in general enemies to the change of Government requires no argument to demonstrate—it depends on fact." Many were happy when it was rumored that the colony might become Spanish yet again. But a few—Easton's political and land claimant rivals—preyed on the "labors of the more ignorant and industrious…whom they prejudice and influence as they please." On the other hand, Easton praised the American immigrants as "good citizens…as might be expected."

Easton accused the last Spanish lieutenant governor, Don Carlos Dehault Delassus, of selling at least eight grants of property at a price of $60 for each five-hundred-acre tract and $100 for each one-thousand-acre tract. In June 1803, Easton alleged, "instructions were given to the various agents of the Governor as well as several deputy surveyors that grants and concessions to be dated back to the year 1799—(which was the general antedate tho some were dated farther back)." The schemers were confident that the "records were kept in such form that it would be utterly impossible for the United States to detect the fraud." Easton further alleged that some documents were altered by erasing the names of the original grantees, who for one reason or another never actually settled on the land, and inserting the name of the current actual resident.

And indeed, on later examination, many of the original documents collected by Stoddard showed signs of fraud. According to the American surveyor general:

> *There has been Leaves cut out of the Books and others pasted in with Large Plats of Surveys on them….The dates have been evidently altered in a large proportion of the certificates. Plans have been altered from smaller to Larger. Names erased and others incerted and striking differences in collour of the ink etc.*

Territorial complaints about the 1804 law did not fall on deaf ears. Congress did act to repeal and revise the structure of the territorial government. First, Upper Louisiana was taken from the yoke of Indiana Territory and given its own government. The newly named Territory of Louisiana would have a governor (who was required to live in the territory), a secretary and three judges, all of whom were to be named by the president in recess appointments, to be voted on by the Senate at the next session of Congress in 1806. There was to be a legislature of sorts, composed of the governor and the three judges. They would pass the necessary laws subject

to later congressional approval. Nothing in the statute expressly approved of the institution of slavery, but it did continue existing laws and regulations in force. This had the effect of preserving slavery because Stoddard had kept the Spanish and French black codes. Likewise, there was no mention of the 1804 provision authorizing the transfer of Indians from east of the Mississippi to government lands west of the river.

Easton's correspondence was effective enough to block the attempt to have all Spanish land claims confirmed. The legislation established a land commission to investigate and recommend approval or disapproval of individual claims to Congress. But the only claims that had a chance of confirmation were those held by persons who occupied and cultivated the land before October 1, 1800. Congress answered the complaint that some persons who occupied their land after October 1 in good faith reliance on the ability to confirm the title under Spanish law by allowing those who fell into this category to confirm their titles as well—but only to a tract with a maximum area of one square mile. Congress's first stab at solving the Spanish land grant problem was unsuccessful. Several pieces of legislation and numerous lawsuits later, the last such claim was resolved in the 1880s.

An Artist in Treason Versus Pettifoggers

President Jefferson named the new officials who were to take their office in October 1805. The first governor was Major General James Wilkinson. It was a curious choice. Wilkinson was the son of a Maryland planter. Throughout his military career he cultivated powerful friends, but only so long as they could help his ambitions. Wilkinson was chronically in debt. Moreover, at the time of his appointment to the governorship, rumors of his involvement with Spain were circulating in Washington. He was in fact a spy for the Spanish government at the same time he served as commander in chief of the United States Army. Wilkinson, whose Spanish code name was "Agent 13," was paid substantial sums of money by Spanish colonial officials. In return, he supplied inside information about American plans and actions. He counted among his friends Vice President Aaron Burr, with whom he conspired to split off a portion of the United States into a separate country (while serving in the army and as governor of the Louisiana Territory). Described as an "artist in treason" by historian Frederick Jackson Turner,

Wilkinson was condemned by one of his contemporaries as "the only man I know who is rotten from bark to core."

Jefferson appointed Jackson Browne to be the territorial secretary. Browne was Burr's brother-in-law and, not surprisingly, an ally of Wilkinson. The three judges appointed to the territorial court were a different matter. John B.C. Lucas was born in France and came to the United States in 1784 with a letter of introduction from Benjamin Franklin in his pocket. He was elected to Congress from Pennsylvania. Albert Gallatin, a close friend and secretary of the treasury, recommended him for the judgeship. The president also appointed Lucas to the all-important Board of Land Commissioners, whose duties were to resolve the disputes over Spanish land grants. James Donaldson, an ally of Governor Wilkinson, was another member of the commission.

General James Wilkinson. Original painting by Charles Wilson Peale. *United States Army Center for Military History.*

The president selected as the second territorial judge Rufus Easton, who had already incurred the enmity of the French elite in St. Louis by his efforts to thwart their attempt to have their large Spanish land claims confirmed. The third judge was Return J. Meigs Jr., originally named commandant at St. Charles in 1804. Meigs was the most experienced of the three, having served as a territorial judge in the Northwest Territory, legislator and chief justice of the Ohio Supreme Court.

Upon Wilkinson's arrival in St. Louis, Auguste Chouteau hosted a dinner for the new governor at which many leading members of the community attended. They praised him for his "known principles and worth." On the Fourth of July, the French Creole elite provided yet another dinner and a grand ball.

The leaders of the new territory were a very small group, perhaps no more than thirty or forty, and far fewer exercised real power. Politics in early Missouri were, therefore, as William Foley notes, "intensely personal" and characterized by "individual feuds and personal grudges." Fistfights were common, and some disputes were settled in a deadlier way on the "field

of honor." Rufus Easton, for example, was offended by a statement made by James Donaldson at a dinner and had to be talked out of challenging him to a duel. Later, Easton marched into a public meeting and hit Donaldson with his cane at least five times. Donaldson reached for his sword cane, but the two parties were restrained. Later, a friend of Easton's chastised him, not for attacking Donaldson, but for not carrying it out in the street, "where the whole community would have approved."

Despite Wilkinson's professions of his intention to "expel the gall of Party spirit," his administration was characterized by bitter divisions. Wilkinson aligned himself with the French Creoles who sought to preserve their status as the leaders of the territory. But many recent immigrants and a group of American lawyers such as Easton, William C. Carr and Edward Hempstead (all of whom Wilkinson dismissed as "pettifoggers") opposed his policies and the efforts of his supporters to obtain confirmation of large Spanish land grants.

Return J. Meigs, the first American commandant of St. Charles and one of the first territorial judges. Unknown artist. *Ohio Statehouse Governors' Portraits*.

Lucas and Easton asked Governor Wilkinson to convene the legislature to pass laws essential to administering the territory. Wilkinson agreed to do so but then postponed the session several times. In retaliation, at the first session of the territorial court, Lucas and Easton refused to recognize the governor's appointment of James Donaldson as the "district attorney" because the law provided for an "attorney general" to act as the territorial prosecutor. They asked Donaldson to accept the court's appointment to the post, but he refused. The next day, Wilkinson sent Donaldson back to court, this time with a commission as "attorney general." The judges once again refused to accept the appointment, this time ruling that the governor only had the power to appoint district officials and that the attorney general was not in that category. They asserted that the territorial legislature needed to meet to pass, among other things, a law authorizing the post of attorney general.

Wilkinson was furious. He empaneled a grand jury packed with his supporters. The grand jury criticized the judges for blocking Donaldson's appointment. The governor evidently viewed Easton, a man already warmly disliked by Wilkinson's supporters, as the principal roadblock. After a late-night meeting at the governor's residence, the grand jury indicted Easton the next day for allegedly having obtained six hundred acres of his own through fraudulent means. A minority of the grand jury issued a statement that the charges were "made more to gratify personal hatred and cruel Revenge."

Wilkinson did not stop there. He wrote to Secretary of the Treasury Albert Gallatin disputing Easton's charges of fraud in "antedating land Concessions & even…the forgery of names.…*The falshood of this report* can only be equaled by its malevolence." Wilkinson mustered other cronies to help discredit Easton with the president. One of Wilkinson's allies wrote Jefferson upon returning from a tour of the territory that, while Wilkinson was held in high regard, Easton was spoken of "as A Man Wanting principal and integrity"

All the territorial officers were recess appointments—the president named them when Congress was out of session. Therefore, Jefferson was required to submit nominations for the posts to the next Congress in early 1806. He re-nominated Wilkinson, Browne, Lucas and Meigs—but not Easton.

Easton was stunned. Rather foolishly, he wrote the president asserting that "no charge can be maintained against me with truth and justice." He demanded that Jefferson tell him why he declined to reappoint him as territorial judge. Perhaps miffed by Easton's presumptuousness, Jefferson replied coldly:

> *It has never been, nor can be admitted, that after a selection made of one of the competitors, all those who are unsuccesful shall have a right to have the reasons specified for which they have been pretermitted, & to be heard in justification, on the ground of protecting their reputation. I always…seek the best information I can otherwise get, make up as honest an opinion as I can, and say no more about it.*

Despite the president's rebuff, Easton was not finished in defending his reputation. A jury found at trial that the allegedly fraudulent contract was "perfectly fair, honorable, and honest, and that Mr. Easton is in no manner guilty of the charges." Shortly afterward, Easton sent a copy to Jefferson, pointing out that the grand jury that indicted him included a man Easton had accused of fraud in his controversial 1805 letter.

3
THE LEWIS AND CLARK EXPEDITION

Long before he became president, Thomas Jefferson was intrigued by the possibility of having an American mission explore the land west of the Mississippi River to discover a water route to the Pacific and document the persons, plants and animals living in the vast unknown land. In December 1783, he wrote to Revolutionary War hero George Rogers Clark of rumors that persons in England were raising money to send a party for just such an exploration. "They pretend it is only to promote knolege. I am afraid they have thoughts of colonizing into that quarter." Would Clark be interested in leading such a party? Clark replied in February 1784 that such a proposal was "extreamly agreeable to me," but he had to decline because of personal financial troubles. Clark offered the advice that the notion of sending "large parties will never answer the purpose. They will allarm Indian Nations they pass through. Three or four young Men well qualified for the task might perhaps compleat your wishes at a very Trifling Expence." He pointed out that they should learn the native language of the "distant Nations they pass through, the Geography of their Country, antient Speech or Tradition." Clark estimated that it would take four or five years to complete the trip.

In 1801, a report was published of an expedition across the Canadian Rockies to the Pacific led by Alexander Mackenzie. Jefferson got his copy in the summer of 1802, at about the same time the controversy over the withdrawal of the right of deposit by the Spanish intendent in New Orleans exploded. Whether motivated by the distinct possibility that Mackenzie's trip was the precursor to British commercial exploitation of the Northwest

and a possible expansion of Canada in that area, or by the New Orleans controversy, in late 1802, Jefferson approached his personal secretary, Captain Meriwether Lewis, with word that he wished to send an American expedition to the Pacific.

Lewis, a fellow Virginian, volunteered for the militia just in time for the repression of the Whiskey Rebellion. Afterward, he joined the regular army as an ensign. His rise in the army, partly fueled by his support of Jefferson's Republicans against the Federalists, was meteoric for the time—he made captain by 1800, a mere five years after his first commission in an army where promotions were rare.

Jefferson directed Lewis to prepare a budget for submission to Congress to authorize an appropriation for a "literary expedition" through Spanish Louisiana to the West Coast. Such an expedition, the president claimed, Spain was "in the habit of permitting within its own dominions." To Jefferson's disappointment, the Spanish ambassador told him that "an expedition of this nature could not fail to give umbrage to our Government."

Jefferson was not discouraged. He submitted a secret proposal to Congress to fund $2,500 for an exploration of the West to promote commerce, a power within those granted to Congress—thus satisfying Jefferson's scruples about the constitutional authority for such a trip. Despite Jefferson's efforts at keeping the proposed venture a secret, James Wilkinson, the commanding general of the United States Army, spy and soon to be governor of Upper Louisiana, told Spanish colonial authorities about it. He urged the Spanish to "detach a sufficient body of chasseurs to intercept Captain Lewis and party…and force them to retire or take them prisoners." (Spain sent troops after Lewis and Clark, but they couldn't find the Americans.)

Lewis threw himself into both educational and logistical preparations. Realizing he needed someone to help manage the day-to-day tasks, he wrote to an old army friend, William Clark, to see if he would be interested in joining the expedition as co-leader. Clark was so anxious to go that he wrote three acceptance letters, replying that he would "cheerfully join" Lewis.

Clark was the youngest brother of George Rogers Clark, whom Jefferson had sought to lead such an expedition years earlier. William served with James Wilkinson while in the militia and joined the regular army in 1792. He fought at the Battle of Fallen Timbers in 1794 but resigned due to poor health in 1796. He traveled to New Orleans in 1797, where he became involved in what historian Jo Ann Trogdon calls "dubious pursuits," including smuggling Spanish pieces of eight in the bottom of a barrel of coffee to

A Brief History

Left: Meriwether Lewis. *Right*: William Clark. *Library of Congress.*

the United States, likely intended as a payoff to Wilkinson for espionage activities as "Agent 13."

After months of gathering supplies, boats and men, Lewis and Clark finally arrived in St. Louis in time to witness Stoddard's receipt and transfer of the territory to the United States. It was too late to start the trip, because winter was coming on. On December 12, 1803, Clark led the men to a campsite

> *nearly opposit the Missouries I came to in the mouth of a little River called Wood River, about 2 oClock and imediately after I had landed the N W wind which had been blowing all day increased to a Storm which was accompanied by Hail & Snow, & the wind Continued to blow from the Same point with violence.*

The next day, the men set to clearing a campsite and cutting logs for huts for Camp Dubois. This site at the mouth of Wood River on the Illinois side of the river no longer exists, although there is a memorial to it there today. Drastic changes in the courses of the Missouri and Mississippi Rivers since 1803 have moved both channels, making the actual location of the camp today in St. Charles County—on the west side of the river.

St. Charles, Missouri

At Camp Dubois, the enlisted members of the Corps of Discovery prepared for the trip while Lewis and Clark made frequent trips to St. Louis to seek further supplies and men. Lewis and Clark also conferred about the vast territory they were about to enter with French traders such as Auguste and Pierre Chouteau (with whom historian William Foley says they "got along famously"). The Chouteaus and others were happy to entertain the president's personal secretary and his friend as part of their "adaptation" to a new culture and government.

Clark made a trip up the Missouri River to St. Charles in mid-March, returning on March 21. He then recorded his impressions of the area in his journal:

> *The Country about the Mouth of Missouri is pleasent rich and partially Settled. On the East Side of the Mississippi a leavel rich bottom extends back about 3 miles, and rises by Several elevations to the high Country, which is thinly timbered with Oake &. On the lower Side of the Missouri, at about 2 miles back the Country rises graduilly, to a high plesent thinly timberd Country, the lands are generally fine on the River bottoms and well Calculating for farming on the upper Country.*
>
> *in the point the Bottom is extensive and emencly rich for 15 or 20 miles up each river, and about ⅔ of which is open leavel plains in which the inhabtents of St. Charles & potage de Scioux had ther crops of corn & wheat. on the upland is a fine farming country partially timbered for Some distance back.*

After five months at Camp Dubois, Clark and thirty-eight men started for St. Charles, where they were to rendezvous with Lewis, who was making last-minute preparations in St. Louis. The men traveled in three craft: Clark and twenty-three men in a large keelboat sporting twenty oars (although they proceeded under sail this day), a sergeant and seven men in a large pirogue and a corporal and six men in another pirogue. It was cloudy and rainy. Their progress was hampered by numerous sandbars and trees that had fallen into the river. One of Clark's intentions was to test the best way to load the keelboat. He had it packed so that it was heavy in the stern on this leg, but he soon discovered that

> *persons accustomed to the navigation of the Missouri and the Mississippi also below the mouth of this river, uniformly take the precaution to load their vessels heavyest in the bow when they ascend the stream in order to*

avoid the danger incedent to runing foul of the concealed timber which lyes in great quantities in the beds of these rivers.

At noon on May 16, Clark and his men arrived at St. Charles. He noted that it contained "about 100 indefferent houses, and abot 450 Inhabetents principally frinch, those people appear pore and extreemly kind, the Countrey around I am told is butifull. interspursed with Praries & timber alturnetly and has a number of American Settlers." Clark measured the river at St. Charles and found it to be 720 yards wide. Word of their arrival brought the sleepy little village to life. A "number Spectators french & Indians flocked to the bank to See the party."

After the boats were moored and the men set up camp, Clark went to the home of François Duquette to dine. Duquette was a French Canadian from Quebec. He had met and married Marie Louise Beauvais (he was twenty, and she was eighteen). They moved to St. Charles from St. Genevieve in about 1794. Duquette acquired an old stone fort built by the Spanish soldiers and converted it to a wind-powered gristmill. Over the next ten years he became one of the leading citizens of the village, making his living as a fur trader, miller, land speculator and merchant.

The home in which the Duquettes hosted William Clark was on the outskirts of town, high on a wooded hill reached by a trail leading up a gully. (It was at present-day Third Street; the gully became Decatur Street.) The house was built in the traditional French style, called *poteaux en terre* ("post in ground"), with walls of vertical logs set in the ground instead of American-style horizontal logs. It was large for its day, with a main room, a loft and two fireplaces. Among the slaves living at the house was Marie Louise, a mulatto who had been sent from St. Genevieve to live with the Duquettes (they rented her services from the owner, Marie Louise's father) because of a notorious relationship she carried on with Antoine Janis, Marie's uncle. Antoine followed his lover to St. Charles and married her. They had eight children.

Although Duquette at this point was a bit down on his luck due to a reversal in business fortunes, Clark nevertheless found him to be an "agreeable man." Clark was especially taken with Duquette's wife (a "more agreeable Lady" and "Charming wife"). The Duquettes' home was surrounded by orchards (a "Delightful situation & garden").

The men took the opportunity for one last fling before setting off into the wilderness. The inhabitants gave a ball on Saturday night "which was attended by a number of the French ladies, who were remarkably fond of

dancing." Some of the men enjoyed themselves a bit too enthusiastically, resulting in courts-martial and fines. But it was not all fun waiting for Captain Lewis to join the crew. Clark had the men repack the keelboat so that it was heavy in the bow instead of the stern to correct the troubles encountered on the trip from Camp Dubois.

On Sunday, May 20, some of the men attended Mass, which Joseph Whitehouse noted "was a novelty to them." At noon, Lewis set out from St. Louis with Captain Amos Stoddard, Auguste Chouteau, Charles Gratiot and other worthies. A violent thunderstorm hit the party, but Lewis was determined to push on. He and his companions arrived at St. Charles at about three o'clock. Lewis had supper with Charles Tayon, the former Spanish commandant of the village, and left at an early hour to rest on the boat. Lewis left a detailed and less-than-flattering description of the town as he found it:

> *St. Charles is situated on the North bank of the Missouri 21 Miles above it's junction with the Mississippi, and about the same distance N.W. from St. Louis; it is bisected by one principal street about a mile in length runing nearly parrallel with the river, the plain on which it stands—is narrow tho' sufficiently elivated to secure it against the annual inundations of the river, which usually happen in the month of June, and in the rear it is terminated by a range of small hills, hence the appellation of petit Cote, a name by which this vilage is better known to the French inhabitants of the Illinois than that of St. Charles. The Vilage contains a Chappel, one hundred dwelling houses, and about 450 inhabitants; their houses are generally small and but illy constructed; a great majority of the inhabitants are miserably pour, illiterate and when at home excessively lazy, tho' they are polite hospitable and by no means deficient in point of natural genious, they live in a perfect state of harmony among each other; and plase as implicit confidence in the doctrines of their speritual pastor, the Roman Catholic priest, as they yeald passive obedience to the will of their temporal master the commandant. a small garden of vegetables is the usual extent of their cultivation, and this is commonly imposed on the old men and boys; the men in the vigor of life consider the cultivation of the earth a degrading occupation, and in order to gain the necessary subsistence for themselves and families, either undertake hunting voyages on their own account, or engaged themselves as hirelings to such persons as possess sufficient capital to extend their traffic to the natives of the interior parts of the country; on those voyages in either case, they are frequently absent from their families*

> *or homes the term of six twelve or eighteen months and alwas subjected to severe and incessant labour, exposed to the ferosity of the lawless savages, the vicissitudes of weather and climate, and dependant on chance or accident alone for food, raiment or relief in the event of malady. These people are principally the decendants of the Canadian French, and it is not an inconsiderable proportion of them that can boast a small dash of the pure blood of the aboriginees of America.*

All was in readiness to leave the next day, May 21, 1804. In the morning, the adventurers filled their vessels with last-minute necessities. Clark recorded that he dined with Duquette one more time before boarding the boat. The party fired a salute from the swivel cannon in the bow and, giving the assembled inhabitants three cheers, set off for the unknown lands of the West at about three o'clock in the afternoon. They did not get far that day, for yet another strong storm blew through from the southwest. A couple of days later they passed a place called Boone's Settlement, where Whitehouse said Daniel Boone was residing with family and friends. If Boone was there that day, the crew apparently did not meet him, for none recorded that fact, as would have been expected if they had encountered such a storied person. The Corps of Discovery continued its journey upstream and disappeared into the wilderness, scarcely to be heard from for the next two and a half years.

Rumors floated back to the president in the fall of 1804, but he received no definitive word on the progress of the expedition until the next year. On April 7, 1805, Lewis sent Corporal Richard Warfington back to St. Louis with the keelboat and a collection of specimens for Jefferson. Warfington arrived in St. Charles on May 20, where he was greeted by a party that included Return Meigs and Edward Hempstead. They eagerly went on board to look at some of the trove that Lewis sent back and to meet an Arikara chief, described by one of the diners as "a Very Large fat man Very much pitted with the Small Pox." (The chief died later in Washington, D.C.)

The explorers returned down the Missouri River much faster than they had ascended. On September 21, 1806, Lewis and Clark rose early and roused the men. At 4:00 p.m., the company caught sight of St. Charles. According to Clark:

> *the party rejoiced at the Sight of this hospital village plyed thear ores with great dexterity and we Soon arived opposit the Town, this day being Sunday we observed a number of Gentlemen and ladies walking on the bank, we*

St. Charles, Missouri

Statue of Meriwether Lewis, William Clark and Seaman in Frontier Park. *James Erwin Collection.*

> *Saluted the Village by three rounds from our blunderbuts and the Small arms of the party, and landed near the lower part of the town. we were met by great numbers of the inhabitants, we found them excessively polite. we received invitations from Several of those Gentlemen a Mr. Proulx, Taboe, Decett, Tice Dejonah & Quarie and several who were pressing on us to go to their houses, we could only visit Mr. Proulx and Mr. Deucett in the course of the evening. Mr. Querie under took to Supply our party with provisions &c. the inhabitants of this village appear much delighted at our return and seem to vie with each other in their politeness to us all.*

Sergeant John Ordway noted that "the people of the Settlements were making inqueries of us & were Surprized to See us as they Said we had been given out for dead above a year ago…the people of the Town gathered on the bank and could hardly believe that it was us for they had heard and had believed that we were all dead and were forgotton."

With everyone being "Sheltered in the houses of those hospitable people" that night, the travelers were reluctant to leave the next day. A hard rain that began the night of September 21 finally ceased in mid-morning of the next day. Lewis and Clark once again took to their canoes and continued toward St. Louis. Ordway wrote in his journal:

> *About 12 oClock we arived in Site of St. Louis fired three Rounds as we approached the Town and landed oppocit the center of the Town, the people gathred on the Shore and Huzzared three cheers. we unloaded the canoes and carried the baggage all up to a Store house in Town. drew out the canoes then the party all considerable much rejoiced that we have the Expedition Completed and now we look for boarding in Town and wait for our Settlement and then we entend to return to our native homes to See our parents once more as we have been So long from them.*

Lewis and Clark took rooms at Pierre Chouteau's residence and called that evening on Auguste Choteau. The trip that took two years, four months and ten day days and covered nearly eight thousand miles was over.

Both Meriwether Lewis and William Clark would return to Missouri. The president appointed Lewis territorial governor of Upper Louisiana in 1807. Lewis's term was cut short when he died in 1809 on a trip to Washington to defend himself against accusations by territorial secretary Frederick Bates that he had improperly profited from the expedition. The cause of Lewis's death is not definitively known and has been a matter of controversy

ever since. Some claimed he committed suicide and others that he was murdered. Historian Thomas Danisi offers evidence that Lewis died from complications related to malaria.

Clark was appointed brigadier general and Indian agent for Upper Louisiana Territory at the same time as Lewis was appointed governor. He established Fort Osage, near present-day Sibley in eastern Jackson County, in 1808. The fort was to be a "factory," or trading post, where the powerful Osage tribe could bring their furs and be treated fairly. Clark spotted the future location of Fort Osage in 1804, a seventy-foot bluff in a bend of the river that provided a sort of harbor. Clark led a company of soldiers up the river from St. Louis in boats while Nathan Boone led a company of rangers overland from St. Charles. At the new fort, Clark signed a treaty with the Osages in which they gave up their claims to eastern Missouri in exchange for a payment of $1,000 per year and some guns and blankets. Clark promised that the United States would protect the Osages from marauding tribes. Many Osages objected to the treaty, and it was later renegotiated by Pierre Chouteau on essentially the same terms and signed by them only after they were threatened by him with dire consequences if they failed to do so.

President James Madison later appointed Clark governor of Missouri Territory in 1813, a post he would hold until 1820. Clark ran for governor of the new state, losing decisively to Alexander McNair. Clark remained in St. Louis. President James Monroe appointed him superintendent of Indian affairs for the entire western United States, a position he held until his death in 1838. Clark is buried at Bellefontaine Cemetery in St. Louis.

4
ST. CHARLES DURING THE TERRITORIAL PERIOD

"Intensely Personal Politics"

In response to many petitions from the inhabitants of Louisiana Territory (including one from a grand jury sitting in the District of St. Charles), in 1812 Congress upgraded the government to a second-class territory and changed its name to the Territory of Missouri. As a result, inhabitants received the right to vote for a legislature, although the president appointed a nine-member Legislative Council from a group of eighteen persons proposed by the territorial legislature. In 1816, Congress upgraded Missouri to the highest class of territory, which made the Legislative Council also elected by popular vote. The law gave the territory the right to select a nonvoting delegate by popular election to represent it directly in Congress. Voter qualifications were liberal for the day: all free white males, age twenty-one or older who had lived in the territory at least one year before the election were eligible to vote. They did not have to own real property but did have to pay a poll tax.

St. Charles County (which then included everything north of the Missouri River and west of the Mississippi River) elected John Pitman and Robert Spencer to the territorial House of Representatives. Benjamin Emmons and James Flaugherty were appointed to the Legislative Council. Together, these men were known as the "Irresistible Four" because of their influence over early legislation.

Emmons was the first of a line of distinguished members of that family in St. Charles. He was born in New England and came to Missouri long before there was a territorial government. The *History of St. Charles* describes

him as "a man of unimpeachable integrity, great public spirit, and, withal, of a genial disposition and pleasing manner." Flaugherty is described by the same author as an Irishman from Virginia who had the gift of blarney, but he was of such modest and retiring disposition that he did not make good use of his oratorical talents. Pitman was not blessed with Flaugherty's eloquence but was renowned as hardworking, "careful, painstaking, and judicious." Spencer was a lawyer and former territorial judge. He got by on his talent, not his effort.

Despite the praise for at least the St. Charles legislators, many of their contemporaries had little use for the territorial legislature. Letters published in the *Missouri Gazette*, one signed "Seven Eighths of the People" and another signed "Aldiberata Foscofornia," complained that the House and council were do-nothing bodies that failed to address local needs, such as the improvement of roads. When the assembly passed a defective law that was supposed to outlaw counterfeit banknotes, vigilantes sprang up to hand out justice on their own. Their private law enforcement quickly spread to punishing gambling, hog stealing and arson, even though the territory's laws prohibiting those crimes were perfectly serviceable.

The prior territorial government was sympathetic to the commercial and business interests of the area, led largely by French Creoles such as Auguste Chouteau, Charles Gratiot and Bernard Pratte. Not much changed with the new structure. The elected legislature was controlled by the same group and pursued policies that minimized taxes and put responsibility for caring for the poor as well as economic development on local governments. The most controversial issue facing the legislature in its early years was the creation of two circuit judgeships to replace the county courts of common pleas, which, in turn, replaced a prior judicial system of multiple specialized courts for probate, orphans, court of common pleas, court of quarter sessions and district auditors. The judges were to be paid $1,200 per year, which was believed to be excessive. Suspicions were further aroused when a legislator resigned his post to take one of the appointments. Opponents of the new judicial system claimed that it was formed to pay off the legislative leaders' friends.

But the major clash of interests came in the election for the territorial delegate to Congress. The two principal candidates were very similar in background and experience. Edward Hempstead was born in Connecticut in 1770. After practicing law in Rhode Island for three years, he came to St. Charles in 1804. The next year, he moved to St. Louis. Hempstead served as a territorial representative and territorial attorney general. His opponent,

A Brief History

Rufus Easton, was also from Connecticut. Easton practiced law in that state and in New York before moving to St. Louis in 1804. (Easton moved to St. Charles in 1817 or 1818 and lived there until his death.)

Both candidates argued for increased federal financial assistance to provide for defense against Indian raids, which had been a problem for a decade. Settlers built a string of homes that doubled as forts, but Indians still swept down from the north to commit massacres of isolated families. Both also were in favor of speedy confirmation of land titles, but for different factions. Hempstead was the candidate of those holding large Spanish land grants—largely the longtime French residents—who sought to have them confirmed. Easton, on the other hand, was anathema to the French, having alienated them with his incendiary letter to President Jefferson attacking their bona fides in 1805. Himself a land speculator, Easton favored speedy confirmation of land titles of the type he held. Easton supporters accused Hempstead of being in thrall to "fifteen or twenty great folks in St. Louis [who] wanted to dictate and govern the territory."

Hempstead won the election and served capably, although (as William Foley points out) the voters sent a "sobering message" to his advocates when "not a single French Creole was elected to the lower house of the territorial assembly."

Fort Zumwalt, home of Jacob Zumwalt, was one of many houses providing protection against Indian raids. It was recently rebuilt; only the chimney is original. *James Erwin collection.*

Hempstead declined to run again in 1814, and this time Easton was elected, defeating among others Alexander McNair (later to be the state's first governor). Easton's term was less than successful. The anti-Easton faction decided to get a head start on the 1816 election. The challenger was John Scott, an attorney from St. Genevieve. He published a pamphlet that promised something for nearly everyone, from renewed pressure for statehood to working for the sale of public lands. Scott, not surprisingly, chastised Easton for opposing the claimants of Spanish land grants, but he also opposed the government's efforts to remove squatters from public land.

Unlike those in some states, Missouri election procedures of the time called for voting by secret ballot, rather than voice voting. (Missouri later switched to voice voting and kept that system until the Civil War.) The territorial law also provided for a complex system of appointing election judges and clerks and for counting and certifying the vote.

The vote was extremely close. The certified vote count was 1,800 for Easton and 1,793 for Scott—a victory margin of only 7 votes. But before Governor William Clark (himself closely aligned with the French Creole faction supporting Scott) issued a certification, more votes came in. Supposedly realizing he was behind in the vote, Scott rode out to Côte Sans Dessein in what was then St. Charles County (today Callaway County). He asked for a copy of the election returns. Scott then proceeded to St. Louis, where he gave the copy to Governor Clark. The return from that township showed 23 votes for Scott and only 1 for Easton. Clark accepted the return and declared Scott the winner over Easton by 15 votes, 1,816 to 1,801.

Easton and his backers were outraged that the winning votes were produced at the last minute by the opposing candidate himself. The *Missouri Gazette* printed several blistering editorials. Easton, no shrinking violet, filed an election contest with the U.S. House of Representatives alleging numerous violations of the election laws, from permitting underage and unqualified voters to participate to highly technical claims about whether the election judges and clerks were properly chosen. One of the knotty problems the committee appointed by the House had to try to resolve was whether it was permissible or even possible to ask the voters whom they voted for so that an accurate count could be made of the valid and invalid votes. Because the vote was by secret ballot (or was supposed to be—one of the complaints was that some votes were made *viva voce*), it would be a violation of the voters' rights to make them reveal the candidate they voted for. Adding to the problem was the vast area encompassed by the territory.

The committee refused most of Easton's claims but did recommend that the votes from Côte Sans Dessein be rejected, leaving Easton the winner. The full House debated the committee's report but did not at first reach a conclusion. Some members argued that the body had no business even ruling on the matter because territorial delegates were not members of the House of Representatives but "mere agents for the Territories, allowed, by courtesy, to sit and speak." The House sent the committee back to work. In its second report, the committee threw up its hands and said there was no evidence presented by either side to sustain its position and that it was impractical for the committee to continue the investigation. The House declared the election illegal and directed Governor Clark to hold another ballot.

Clark announced in July 1817 that the special election would be held the first Monday in August. Easton supporters howled at the late notice. This was a harbinger of an election that was to be even more rowdy than the last.

Two of Governor Clark's nephews, John and Benjamin O'Fallon, put up a tent near a polling place from which they handed out food and whiskey to the prospective voters. Armed soldiers paraded by "with labels or tickets on their caps, on which was printed JOHN SCOTT." A military band played nearby. When Clark arrived at the polls, he announced in a loud voice that he intended to vote for John Scott, infuriating Easton voters. John O'Fallon got into a scuffle with Dr. Robert Simpson, Easton's brother-in-law, over articles Simpson wrote for the *Missouri Gazette* attacking Clark. O'Fallon shoved Simpson, and Simpson drew a pistol. O'Fallon shouted insults, causing Simpson to "demand satisfaction" to redeem his honor. It was, all in all, "a most violent [and] turbulent" election.

This time the official and undisputed count was 2,406 votes for Scott to 2,014 for Easton.

But the fallout from the Election Day troubles was not over. A few days later, O'Fallon saw Simpson on the streets of St. Louis and demanded to know why he had heard nothing further from him about the challenge issued on Election Day. O'Fallon denounced Simpson as a liar and coward. Simpson drew his pistol again, but this time O'Fallon took it from him and proceeded to give the man a beating.

More deadly consequences were to result from another election dispute. Charles Lucas, son of John B.C. Lucas, was a hothead. He nearly fought a duel with John Scott over newspaper articles he wrote about the 1814 election. In the end, friends intervened to mediate the affair without gunplay, but Lucas sneered that "Mr. Scott thought it better that his honor should bleed, than that he should."

Thomas Hart Benton. *Library of Congress.*

Lucas's next opponent was not swayed from taking up arms. Lucas claimed that Thomas Hart Benton, an ambitious young attorney and Scott supporter, failed to pay the taxes due on his three slaves in time to qualify to vote in the 1817 re-rerun of the Scott-Easton election. When queried about the allegation, Benton replied, "Gentlemen, if you have any questions to ask, I am prepared to answer, but I do not propose to answer charges made by any puppy who may happen to run across my path." Being called "a puppy" was more than enough of an insult to merit a dual. Lucas demanded satisfaction.

On August 12, 1817, Lucas and Benton met on Bloody Island, in the Mississippi River near St. Louis. Both men fired. Benton was grazed just below the right knee. Lucas, however, was seriously wounded when the ball entered his neck. There was talk of a second shot, but Lucas's doctor said he was in no condition to continue even at a shorter distance that some accounts say was proposed. Lucas pronounced his honor satisfied, but Benton insisted on a second meeting—"a gross violation" of the code duello.

During the next six weeks, charges and countercharges were exchanged. Lucas was reluctant to pursue the matter of a second duel, but neither he nor Benton could back down gracefully enough to satisfy their notions of honor. And so, they met again on Bloody Island on a typically hot and sticky Missouri morning. This time the men would face off at only ten feet, almost assuring that the outcome would be fatal to one of them. The count was supposed to go "Fire, one, two, three," with the men not supposed to shoot before the count of one or after the count of three. But the second failed to say the word "fire." Both men hesitated a beat, then shot. Lucas was hit in the side and his shot went wild. Benton was unhurt. Lucas was mortally wounded. He initially refused Benton's request to forgive him, but just before he passed away he acquiesced, saying, "I can forgive you—I do forgive you." Benton regretted his actions for the rest of his life.

A Brief History

Saints and Lawyers, Hunters and Educators

In the dozen years after Lewis and Clark returned from their expedition to the coast, St. Charles grew little because most of the settlers were seeking land farther west. What was once a French town was changing to a predominately American one. The territorial government incorporated St. Charles in 1809, but the records (such as they are) do not show any activity until an election in 1818 to choose the town's trustees.

As the areas to the west became settled, St. Charles County was whittled down to its present size. Howard County was created in 1816, leaving St. Charles County's western border at what is today the eastern border of Boone County. In 1818, Warren, Callaway and Montgomery Counties were organized, leaving St. Charles County with its present borders.

Among the Americans moving into St. Charles during this time was Timothy Flint. A young Presbyterian minister sent to St. Charles to build a church and congregation there, Flint and his family went to live with Madame Marie Louise Duquette in September 1816.

Madame Duquette had fallen on hard times since hosting William Clark on his travels to and from the coast. She was still charming but now a widow because François died earlier that year. All he left her after payment of his debts were household goods valued at $442.50, a slave named Mary and the house at the top of the hill that her distinguished visitors found delightful in 1804.

The Flints rented half the house, which Timothy said was still "delightful" twelve years later. It remained set off from most of the village, surrounded by apple, pear and yellow Osage plum trees. Above the house was a prairie where grew wild hops, grapes and plums. From the house one could see part of the town, but the view was dominated by the Missouri River, which "spreads out below…in a wide and beautiful bay, adorned with an island thick set with…regular cotton trees." It was a "peaceful and pleasant residence."

In his capacity as a minister, Flint traveled widely throughout Missouri, visiting many isolated settlements and farms. In his letters, he defended the "backwoodsmen," who (he said) were regarded with "horror" by folks from back east as persons whose lives were characterized by drunkenness, brutality and violence. Flint, however, found the backwoodsman to be "an amiable and virtuous man."

His manners are rough. He wears, it may be, a long beard. He has a great quantity of bear or deer skins wrought into his household establishment,

> *his furniture, and dress. He carries a knife, or a dirk in his bosom, and when in the woods has a rifle on his back, and a pack of dogs at his heels....Enter his door, and tell him you...wish the shelter of his cabin for the night. The welcome is indeed seemingly ungracious: "I reckon you can stay," or "I suppose we must let you stay." But this apparent ungraciousness is the harbinger of every kindness that he can bestow.... [W]hen you depart, and speak about the bill, you are most commonly told with some slight mark of resentment, that they do not keep tavern.*

When the Flints moved to their own farm, Madame Duquette was unable to find new boarders. Rather than let the place stand empty, she offered it to Bishop Louis Dubourg, newly arrived in St. Louis, for use as an academy for girls.

Dubourg was in Europe on a fundraising trip in 1817. There he met Madeleine Sophie Barat, the mother superior of a recently founded religious community, the Society of the Sacred Heart of Jesus. Rose Philippine Duchesne, a forty-eight-year-old communicant, was an admirer of the Canadian missionary Marie de l'Incarnation, who was known for her work among Native Americans. Duchesne "burned with the desire" to emulate Incarnation by "devoting her life for the salvation of the Indians." When Dubourg arrived for a visit to the society, Duchesne confided to Mother Barat that she hoped the bishop had come to seek sisters willing to come to America to work in his diocese. Barat told her, "If the Bishop asks for us to go to Louisiana, Philippine, I will take it as an indication of God's will." Bishop Dubourg did ask for sisters to come to America. Duchesne got her wish.

After a difficult trip, Duchesne and four other women—Octavie Berthold, Eugenie Aude, Catherine LaMarre and Marguerite Manteau—arrived in St. Charles, which Duchesne described to Mother Barat as "the remotest village in the United States." Duchesne was taken aback by the rude frontier community, so different from her hometown of Grenoble, where she grew up the daughter of a wealthy lawyer.

Either the Duquette house had fallen into significant disrepair or the description of it by the historians of the Academy of the Sacred Heart illustrated the difference between sophisticated European tastes and those of less refined residents of the New World. What William Clark and Timothy Flint described as a "delightful" home, the dour author of the sketch supplied to the 1876 *Pioneer Families of Missouri* called a "humble dwelling, a log hut, containing two rooms; it stood in the midst of two acres of barren soil."

Saint Rose Philippine Duchesne. *James Erwin collection.*

In later years, one of the nuns gave a more detailed description. The building had one large room across the front of the house, about twenty-eight feet square, with three eight- by five-foot rooms on either side. It had a gallery (we would call it a porch) that entirely circled the house, with doors opening on to it from each of the rooms. The rooms must have been airy, for each had two windows. The large central room had two fireplaces and a loft reached by a ladder against one wall.

Regardless of the condition of the building, the sisters were unprepared for the winter that followed their arrival. Their diet was spartan. Rice and spoiled fish were staples. Potatoes and cabbages were regarded as "rare delicacies." Fresh meat such as venison and duck was available in the fall from hunters, but otherwise they had to live on salted fish and meat—which was complicated by the lack of water because their well dried up. They had to pay twelve cents for each trip to get two small buckets of water from the river. During Lent, Duchesne worried about surviving "with only fish cooked without butter and oil" because the only oil available was bear grease, "which is disgusting."

In December, Duchesne wrote that the Missouri River was choked with ice. "I never dreamed that on the banks of the Missouri we should lack water with such an abundant flow of it in sight." The wind came through the chinks in the logs so freely that the water they did retrieve froze by the fire. There were logs, but they had no tools with which to cut them. Apparently, they could neither persuade their neighbors to help them nor afford to pay them. In any event, Duchesne complained that "laziness is the vice of this region; it belongs to the way of life. People work only when obliged to do so, and pride keeps many from working for wages."

Despite the hardships, the sisters did open a school for girls in October 1818. It had only three paying students, daughters of the wealthy Pratte

and Chouteau families of St. Louis who boarded with them. Within a week, there were twenty-two other girls enrolled in the free school, residents of the neighborhood who were not boarders. As for blacks and mulattos, the bishop "said positively that we may not admit them to either of our schools, and he had appointed one day a week to the instruction of the colored people; otherwise, he says, we should not hold the white children in school." All the children—even those from the rich St. Louis families—were ignorant of Christian doctrine and had not even heard of Jesus, let alone his birth and death. Duchesne came to America to teach Indians the Catholic religion, but there were none in St. Charles. When she complained that she had no "savages" in her school, the bishop replied, "Indeed, you have, and your work among these children will be wider and more lasting because the influence of the rich over the poor." Just a few months later, Duchesne reported that the children made amazing progress.

> *We see the poor children coming, famished and barefoot, to school along frozen roads and wearing only the lightest of dresses. You see, Reverend Mother, that, obliged as we are to give up our boarding school here, it would be dreadful to leave these poor children without giving them instruction. In four months many have learned to read and to write. They now know the whole little catechism, a number of hymns and prayers for Benediction and they are able to do all the singing.*

Before the lease was up on the Duquette home, Mother Duchesne's little group was ordered to move to quarters in Florissant. She wrote to Mother Barat begging her to allow Sisters Eugenie and Marguerite to stay in St. Charles. Some of the older children said that if the sisters were going to leave, they wanted to go with them "and the younger ones ask to be taken along, saying that they are begging this of the Sacred Heart of Jesus." But the mother superior back in France refused, and the town was left without sisters from the Society of the Sacred Heart for nearly ten years.

Mother Duchesne made a triumphant re-entry into St. Charles in 1828. Along with two other nuns, she crossed the Missouri River early in the morning. They entered a carriage and rode down Main Street while "[a]ll the ladies of the city were at their windows" to see them pass. Although Duchesne had been given assurances that the old Duquette home was to be renovated, when they arrived the building proved to be worse than ever. It had no glass in the windows, and the floor had partially rotted away. Mother Duchesne returned to St. Louis County, leaving behind

her companions. They managed to clean the place up well enough to reopen the school two weeks later with thirty pupils. Eventually, a new building was erected and the old place relegated to a wash house. The school became the Academy of the Sacred Heart, which is still operating today on the same site.

Mother Duchesne realized her dreams of ministering to young Indian students—up to a point. The Jesuits asked the Sisters of the Sacred Heart to provide instruction to members of the Potawatomi tribe in eastern Kansas in 1841. Although seventy-one years old and frail, Mother Duchesne persuaded church authorities to send her along to "assure success to the mission by praying for us." She did not learn the language and so could not teach, but she made up for it by devoting long hours to prayer. To the Potawatomie children she was known as Quah-Kah-Ka-num-ad, or "Woman Who Prays Always."

Her health worsening, Mother Duchesne returned to St. Charles in 1842. She lived out the rest of her life in a small room under a stairway near the chapel at the school she helped to found. She served as an inspiration to other religious who stopped in St. Charles on their way west to receive her blessing. Rose Philippine Duchesne died on November 18, 1852, blind and feeble. She was canonized by Pope John Paul II in 1988. Her remains and artifacts from her life are in a shrine on the Academy of the Sacred Heart campus.

St. Charles was also the home of several Missourians who became prominent in the state's political and legal arenas. Edward Bates's brother Frederick was the territorial secretary and frequently served as acting governor in the absence of the appointed governors Meriwether Lewis, Benjamin Howard and William Clark. Edward moved to St. Charles in 1814 after a brief service in the Virginia militia during the War of 1812. He studied law with Rufus Easton and later joined him as his law partner. In 1817, Edward and Easton organized the James Ferry, providing service between St. Charles County and Alton, Illinois, a town Easton founded and named after his son. Edward married Julia Coalter of St. Charles County in 1823. They had seventeen children.

Edward Bates was a member of the "lawyer junto" credited with writing the first Missouri Constitution. When Missouri became a state, Edward served briefly as attorney general. He was elected to the Missouri House of Representatives, the state senate and the U.S. House of Representatives. Edward became a prominent member of the Whig Party until it fell apart. He then migrated to the new Republican Party and sought its presidential

Edward Bates. *Library of Congress.*

nomination in 1860. Abraham Lincoln appointed him attorney general of the United States, a post in which he served until 1864.

The stories of other longtime but less renowned families were gathered by William Bryan and Robert Rose in the 1870s. Dorris Keeven-Franke writes that Rose traveled throughout St. Charles County and surrounding

areas to interview residents. He sent his notes on "little slips of paper" to Rose at the printers. Ultimately, they were all collected and published in 1876 as *A History of Pioneer Families of Missouri*. Some of the stories are quite colorful, and many are probably even true.

Justice in territorial Missouri could be rough and ready, as exemplified by the decisions of Daniel Colgin, justice of the peace in St. Charles. Colgin, a tailor by trade, came to the District of St. Charles in 1806. He built his cabin with a deep cellar whose access was a trapdoor in the middle of the floor. Colgin left it unlocked at night and kept an axe and sledgehammer by his bedside in case of Indian attack. Fortunately, he never had to use his weapons or trapdoor for that purpose. In 1812, he moved to the town of St. Charles. Colgin was noted for keeping a pet bear in his yard. He also assisted the Reverend James Craig, a son-in-law of Daniel Boone, in conducting the first Protestant baptism in St. Charles. The congregant was a black woman named Susan Morrison. Colgin waded into the Missouri River to measure the depth with his cane, all the while singing hymns.

In 1814, he was elected justice of the peace. He brought his eccentric ways to the court. The nature of his jurisprudence is shown by two decisions highlighted in the 1885 *History of St. Charles*.

In the first case, a man named Miller sued one Kirkpatrick for money he owed on account. After Colgin entered judgment in his favor, Miller sidled up to him and whispered that he just remembered that Kirkpatrick also owed him for a buffalo robe. Colgin nodded and turned over the paper on which he had written the decision. On the back he wrote "Mr. Miller says that Kirk[patrick] got a buffalo skin for $8, that he forgot to charge on the account, therefore, I Daniel Colgin, justice of the peace of this court, believe that Miller tells the truth about the skin, and I do hereby put it down on the back of the judgment, for to be collected at the same time as the balance is paid." Kirkpatrick was peeved and is supposed to have said that if he was going to heaven and saw Miller there, he would turn around and go to "the other place."

In the second case, the two parties got into an argument about whether a block of ice one of them purchased was one-half pound short of what he paid for. As they argued, the evidence melted away. The seller took the buyer to court. Colgin rendered judgment for the price of the ice, six and a quarter cents, but he made the plaintiff pay half the court costs (seventy-five cents.) He thought it right that the court costs should be divided between them, because they were "such blamed fools as to quarrel about a little piece of ice

that he could eat in five minutes any warm day." Colgin later moved to Côte Sans Dessein in Callaway County.

General Amos Burdine (or Burdyne) was the subject of several tall tales—*very* tall tales. The "general" wasn't really a general but a corporal in the Missouri mounted militia during the War of 1812. He was born in Virginia in 1780. He married Jennie Davidson (or Davison) in Kentucky in 1803. They moved to Dog Prairie in northern St. Charles County in 1811.

Supposedly, when one of the New Madrid earthquakes struck in 1812, it so rattled the roof of his cabin that Burdine thought Indians were attacking. He and his sons got out their muskets and blew so many holes in the ceiling that it leaked profusely from the rain.

Burdine was just as deadly to St. Charles's wildlife. A renowned hunter, he frightened deer out of the brush by imitating the cry of a wolf or panther. Supposedly, on one occasion, Burdine saw a buck and a turkey, but he only had a single-barreled musket. He knew if he shot one, the other would immediately flee. He loaded a second musket ball on top of the one already in the barrel. He shot the turkey and "in the twinkling of an eye" dropped the muzzle so that the second ball hit the deer. When he crossed the river to gather his game, "he caught the seat of his buckskin pants full of fish, which he carried home along with his turkey and deer."

His wife, Jennie, was a large and heavy woman. One day, another story goes, Amos decided to weigh her. He perched himself on one end of a balance scale. When Jennie sat on the other, Amos was shot to the roof, where he remained until a family member helped him down. The final Burdine stories are sad: Jennie died in a cholera outbreak in 1832; Amos lost his land in a lawsuit and moved to Arkansas.

Other residents' stories were more down to earth and certainly more inspiring.

Catherine Collier's husband died, leaving her with two young boys, John and George. To support herself and her family, Collier bought two milk cows and opened a small dairy. Her business grew until the dairy had one hundred cows. But Collier was restless. She decided to sell the dairy and leave New Jersey for the West. She arrived in St. Charles in 1815 with $40,000 in cash—a sizable sum equivalent to over $600,000 in today's terms.

The boys (presumably with their mother's financial help) started a merchandising business. At first, they traveled the countryside as itinerant peddlers. In a few years, they opened stores in St. Charles, Troy and St. Louis. Their mother hired slaves (a common practice in antebellum Missouri) to make shirts and other garments to sell in her sons' stores.

A Brief History

Collier was a devoted Methodist who kept a room in her house for ministers who were making the circuit of small towns bringing the gospel to the residents. She helped establish a Methodist congregation in 1821. In 1830, Collier built a church made of handmade brick (probably by slaves) to house Methodist services, rent free. The building still stands at 617 South Main Street. Whites and blacks attended the same services, but the slaves and any free blacks were segregated in a separate room (also a common practice in antebellum Missouri). On weekdays, the building was used as a school. The "rent" was the privilege of sending four students of her choice at a tuition of $1 per month each. The school was so successful that she approached her son George about establishing another school in town. George contributed $10,000 and Catherine $5,000 to build and operate St. Charles College for boys, which opened in 1835.

Another early and longtime resident of St. Charles also founded a college, one that has grown into a vibrant and expanding university. Mary Easton was the daughter of Rufus and Abial Easton. Rufus was, as noted elsewhere, a prominent judge, lawyer and politician. Born in Rome, New York, in 1800, Mary was the eldest of the Eastons' seven daughters (they also had four

Methodist church built by Catherine Collier, 617 South Main Street. *St. Charles County Historical Society.*

St. Charles, Missouri

St. Charles College, founded by Catherine and George Collier. *St. Charles County Historical Society.*

sons). The daughters were, as one historian wrote, "one of the most notable groups of young women" in Missouri.

Mary attended the Shelbyville Female Academy boarding school in Lexington, Kentucky, for a time but rejoined the family in Missouri in 1813 or 1814. There she met George Sibley, a prominent government official and friend and business colleague of her father. Sibley, born in Massachusetts in 1782, came to Missouri in 1805. In 1808, the president appointed him the government factor (or agent) for the fur trade at Fort Osage. Sibley's job was not only to monitor the trades to make sure the Indians were not cheated but also to look out for their welfare in general and to keep watch over possible British incursions into the American fur trade. Sibley remained at Fort Osage until June 1813, when he was forced to leave because of threats from Indian allies of the British during the War of 1812. In 1814, he found himself at the Easton home, where he became entranced by young Mary. Writing to his family in the summer of 1815, George said: "*I flatter myself that there is a certain fair one, whose beauty, amiable disposition, and elegant accomplishments would adorn a Palace:* who will go with me into the forest and share with me whatever hardships and whatever pleasures are incident to a life of seclusion among the Indians." Mary was equally taken with Sibley and not at all put off by his age. They were married in 1815. She was fifteen and he was thirty-three.

A Brief History

Left: Mary Easton Sibley. *Right*: George Sibley. *Lindenwood University*.

In March 1816, Sibley returned to Fort Osage with his young bride and her sister Louisa. Mary, an accomplished musician, insisted on taking her piano, saddle horse, library and furniture to the frontier outpost. Once settled there, George wrote to his brother that "Mary amuses me and herself every day for an hour or two with her piano, on which she performs extremely well." She even began to teach Louisa how to play. James Michener has a delightful scene in his 1974 novel *Centennial* in which young Mary Sibley plays the piano for travelers at Fort Osage. (The 1978 television miniseries of the same name depicts this scene in episode two, which can be viewed on YouTube beginning about 25:10.)

The Sibleys lived at Fort Osage until it closed in 1822. They moved to Howard County, where George was appointed postmaster. In 1825, he was selected to head a commission to survey the Santa Fe Trail established by legislation championed by Missouri senator Thomas Hart Benton. The commissioners finished their work in 1827 and met at Eckart's Tavern in St. Charles to complete their report. The first report was lost in transit. Sibley made another copy, but it, too, was lost. Not taking any chances this time, Sibley hand-delivered a third copy to Washington. However, upon arrival,

he was quizzed closely about cost overruns incurred in the project, leaving him to grumble about "Benton's d----d Santa Fe road."

The Sibleys moved to St. Charles in 1828 to a house just down the street from Mary's father and mother. Mary began to give lessons to local children, including two younger sisters. In about 1830, Mary came under the influence of the Second Great Awakening, a period of religious revival that had begun a few years earlier. Mary became an ardent Presbyterian, and she and George became moving forces behind the furtherance of religious education and worship in town.

Mary and George owned property at the top of the hills on the western outskirts of St. Charles. There they built a log cabin to provide Christian education to young women in a school they named Linden Wood Female Academy for the grove of trees in which it was built. It was the first school of higher education for women west of the Mississippi.

Linden Wood was in and out of financial difficulties in its early years, causing the Sibleys to look for support from the Presbyterian Church. In 1853, George and Mary Sibley donated the school to the church. In 1857, George completed Sibley Hall to house a kitchen, dining room, dormitories and offices. A time capsule containing documents George believed key to the school's history was placed in the building. Mary retained her interest in the school and the girls' well-being, frequently touring the campus in a carriage the students called Aunt Mary's "Ship of Zion." She died in 1878. Today, Lindenwood University—no longer church affiliated—is the fastest-growing university in the Midwest, with over eleven thousand full- and part-time students on multiple campuses.

Another famous resident of St. Charles, although probably not recognized as one at the time, was Jean Baptiste Point du Sable. Point du Sable is credited with being the founder of the city of Chicago, Illinois. Little is known of his early years. There is even a dispute about where and when he was born. Most authorities say that Point du Sable (French for "sand point") was likely born in Haiti about 1750, possibly to a French father and African mother. (Others say he was born in Canada.) He traveled to New Orleans and then up the Mississippi River, most likely to what is present-day Peoria, Illinois. In notes to a speech given in 1779, the British commandant at Michilimackinac described Point du Sable as "handsome" and "well educated" and noted that he settled in "Eschecagou." However, he was probably then living at the mouth of Trail Creek in what is now Michigan City, Indiana (about sixty miles east of Chicago). While living there he was arrested by British authorities on suspicion of aiding the Americans in the Revolutionary War.

A Brief History

Sibley Hall. *Lindenwood University*.

Sometime in the 1780s, Point du Sable moved to the mouth of the Chicago River. He married a Pottawatomie woman named Kittihawa, or Catherine, probably in a traditional Native American ceremony. He became a devout Catholic, and the two were married in a Catholic ceremony in 1788 in Cahokia. They had two children, Jean and Suzanne. By 1790, he was a wealthy trader, providing supplies to travelers to the interior after they landed from Lake Michigan. In 1800, he sold his place for 6,000 livres (about $15,000 in today's terms). The bill of sale shows that the property included a twenty-two- by forty-foot log house with four or five rooms that served as the trading post, two barns, a blacksmith shop, a poultry house and a smokehouse.

Point du Sable may have returned to the Peoria area for a few years. Around 1807, he and his son settled in St. Charles (his wife apparently having died before they left Chicago). They lived in the house later occupied by Governor Alexander McNair when the town was the first capital of Missouri. Point du Sable had a farm outside town and was licensed to run a ferry across the Missouri River. His son died in 1814. He and another black man, Pierre Rodin, were recorded as the only two free men of color in St. Charles in 1817. He sold his house to Eulalie Barada on condition that she care for him in his final illness and arrange for his burial. Point du Sable

died in 1818 and was buried in the first St. Charles Borromeo Cemetery in an unmarked grave. His remains were supposedly moved twice thereafter to the second and third (present-day) St. Charles Borromeo Cemeteries. His grave is marked by a tablet from the Illinois Sesquicentennial Commission. (However, a 2002 archaeological study failed to find evidence of any human remains in the grave; he may still lie where originally buried.)

5

THE STRUGGLE FOR STATEHOOD AND THE TWO MISSOURI COMPROMISES

By 1817, the citizens of Missouri believed they were overdue for admission to statehood. Article III of the Treaty of Cession guaranteed them the same rights as other citizens of the United States. In their view, that meant self-government through their own constitution. In November 1818, the Missouri Legislative Council and House of Representatives formally sought the admission of Missouri as a state.

When the Missouri statehood bill came before Congress, James Tallmadge, described by historian Robert Pierce Forbes as "a maverick single-term Republican congressman from Poughkeepsie," rose on February 13, 1819, to propose an amendment providing "that the further introduction of slavery or involuntary servitude be prohibited…and that all children of slaves, born within the said state, after admission thereof to the Union, shall be free at the age of twenty-five years." Upon learning of this proposal, Missouri's territorial representative, John Scott, blasted the Tallmadge Amendment as a "suspicious, shameful, unconstitutional inhibition." He pointed out that such a prohibition was an "imbecility" as a condition of admission because the state could draft a new constitution allowing slavery without restrictions. Why, he demanded, "induce the people to an act of chicanery?"

There followed during the summer and fall of 1819 a debate foreshadowing the same controversies that arose in 1860 and the same arguments: pro-restrictionists argued that Congress had the power to prohibit slavery as a condition to admission, while proslavery advocates said that states were equals—Missouri thus could not be denied the right

to have slavery when other states had it as well. Both sides deplored slavery as an "original sin" (an argument that would not be repeated in 1860), but southerners, including Thomas Jefferson, argued that the spread of slavery would ultimately make it less harsh. Besides, they claimed, blacks were better off as slaves than as free men and women. Pro-restrictionists pointed to the Declaration of Independence's proclamation that "all men are created equal," a founders' statement that the defenders of slavery tied themselves in knots trying to explain.

While this debate was going on, the Massachusetts legislature acquiesced to the longstanding desire of the District of Maine to become a separate state, with one important condition: Congress had to pass such a bill before March 4, 1820. But a clear majority in the Senate opposed the admission of Maine if Congress was going to prohibit the admission of Missouri over the question of slavery.

Northern congressmen were more concerned with the extension of slavery into the other territories that composed the Louisiana Purchase than into Missouri, where it had already existed for years. To answer these worries, Jesse Thomas of Illinois proposed that slavery be prohibited in all territories and new states north of the line 36° 30′ (Missouri's southern border as first proposed; the bootheel was added later). Nonetheless, this amendment was initially rejected by the North as a "Southern measure." It passed the Senate but was defeated in the House.

Ultimately, a compromise—the Missouri Compromise—was reached, although the House did not vote on both aspects of the compromise at the same time. Rather, in one vote, it eliminated the antislavery provision by a margin of 90 to 87. In a second vote, it approved the 36° 30′ line by a vote of 134 to 42. Maine was admitted to the United States on March 3, 1820. With the Missouri Compromise on the 36° 30′ line and the admission of a free state to correspond with the admission of Missouri as a slave state (thus preserving the political balance), it appeared that Missouri would forthwith become the twenty-fourth state.

But it was not to be.

An election to select the delegates to draft a state constitution began almost immediately. Some Missourians, most notably John B.C. Lucas, were restrictionists, but nearly all candidates were proslavery. The bitter personal rivalries that characterized other elections continued. Joseph Charless, editor of the *Missouri Gazette*, attacked lawyers Thomas Hart Benton, David Barton, Duff Green and Edward Bates as "depraved" and "bachelors and immoral men." Lucas, of course, hated Benton for killing his son. He also

drew bitter opposition for his anti–land grant policies. Such no-holds-barred campaigning was typical of territorial Missouri elections.

The newspapers were also overwhelmingly proslavery. One of the few antislavery and pro-restrictionist advocates was an anonymous writer known to history only as "A Farmer of St. Charles County." He penned several articles published in the *Missouri Gazette*. Shoemaker points out that the "Farmer" argued that his neighbors "were opposed to the further introduction of slavery into Missouri" and that "slavery was admitted to be an evil and a curse even by its advocates." He further contended that Congress had the constitutional right to restrict slavery because "[i]f slavery is anti-republican (and who but a madman would deny that it is?) Congress have the right to refuse their sanction to any constitution that tolerates it." Indeed, it appears that the St. Charles Farmer was possibly the person who coined the term "lawyer junto" to describe the bevy of attorneys running for election to the convention. The *Missouri Gazette* made a last Election Day plea, stating that the citizens were

> *now called upon for the last time to say whether aristocracy and tyranny shall prevail—whether a few nabobs selected by a secret caucus, shall be forced upon you or whether you will exercise the proper persons to frame your mode of government. You are now called upon for the last time to declare whether yourselves, and your children, to the latest generation, will be cursed with slavery…; or whether you will elect men who will take measures gradually to extinguish the evil, without interfering with the existing rights of property, or injuring the growth of the country. Your destiny is fixed by the result of this day's vote.*

The proslavery candidates swept the field. The forty-one delegates elected to the constitutional convention reflected the American elite of the territory. Nine lawyers, eight businessmen, nine large landowners and six other professionals made up a majority of the delegates. St. Charles sent Nathan Boone, Benjamin Emmons and Hiram H. Baber. Most of the delegates were originally from Upper South states such as Virginia and Kentucky. Only two were of French heritage. The convention was dominated by the lawyer junto, with lawyers chairing seven of the eight committees chosen to draft sections of the constitution.

The convention met for thirty-eight days in St. Louis. David Barton was chosen president and William Pettus secretary. The records of the convention were, as Floyd Shoemaker called them, "ridiculously defective."

There is virtually nothing about how or why the delegates came to their decisions. The St. Charles representatives played minor roles. Emmons was on the committee to draft the provisions relating to the legislature. Boone offered a measure to name St. Charles as the temporary capital, but it was defeated. The convention decided to allow the first legislature to determine where the permanent seat of government would be. Boone was involved in submitting other proposals, all but one of which were defeated. But there was no record of the vote on any of them. Edward Bates was influential, but he was too young (age twenty-seven) to hold any state office under the qualifications as proposed.

When the convention was over, the constitution was complete. It was not submitted to a popular vote. Missouri proceeded to hold elections in 1820 for state offices. Alexander McNair was elected governor over explorer and territorial governor William Clark. John Scott was elected to the House, and David Barton and Thomas Hart Benton were chosen for the Senate.

The 1820 Missouri Constitution was typical of the times, except for two provisions that raised objections from northern antislavery congressmen. The first prohibited free blacks from entering the state, and the second prohibited the legislature from emancipating the slaves unless owners consented. The first proviso violated the privileges and immunity clause, Article IV, Section 2 of the U.S. Constitution, which guarantees that the "Citizens of each State shall be entitled to all Privileges and Immunities of Citizens in the several States." Under this provision, free blacks had the same right to travel to and own property in any state as they had in their own state. Missouri could not prevent a black citizen of, say, Massachusetts from exercising the same rights as white citizens of Missouri. (At least, that was the belief until the *Dred Scott* decision in 1857 held that blacks were not citizens at all, a holding superseded by the Fourteenth Amendment.) The prohibition on emancipation—for that was the practical effect of requiring slaveholder's consent—was constitutional but harsh. Supposedly, both John Scott and David Barton were privately opposed to the provisions, but politics demanded that they publicly endorse them.

Congress had avoided a possibly irretrievable split by "elaborate rules of circumlocution" that allowed the Missouri Compromise to be adopted. But, Robert Pierce Forbes says, Missourians "rejected the genteel contradiction that most other southerners lived by and confronted the anomaly of America's revolutionary heritage head on." Opposition to these two provisions threatened Missouri's statehood.

Henry Clay. *Library of Congress.*

Missouri's leaders proclaimed that they had a constitution and that they *were* a state, Congress be damned. Indeed, Missouri had already elected a governor, legislature, two senators and a congressman. Its citizens voted in the 1820 presidential election, raising the question of whether to count Missouri's electoral votes. New putative senator Thomas Hart Benton pointed out that other states, including some northern states, had similar clauses prohibiting the entry of blacks. The *St. Louis Inquirer* was outraged that Missouri was being denied recognition as a state to preserve the "rights of a few vagabond negroes."

Senators Barton and Benton and Representative John Scott were prevented from assuming their seats because Missouri was not officially a state. Henry Clay finessed the issue of the presidential vote by counting the electoral votes with and without Missouri. (The result was the same; James Monroe was decisively elected president.)

Seeking a more permanent solution, Clay convened a committee of legislators to propose another compromise. Their first effort was rejected. The committee got its heads together again and came up with a Second Missouri Compromise, no doubt drafted by Clay himself.

Robert Pierce Forbes characterized this proposition, finally passed by Congress, as "a landmark in deliberately obfuscatory legislative language." Missouri would be admitted on an equal footing with other states on two conditions. The first condition was that the "fourth clause of the twenty-sixth section of the third article of the [Missouri] constitution…shall never be construed to authorize the passage of any law, and that no law shall be passed…by which any citizen [of another state] shall be excluded from the enjoyment of any of the privileges and immunities to which such citizen is entitled under the Constitution of the United States." Second, the legislature shall "by a solemn public act" agree to the condition. If that act was submitted to the president by November 1821, the president would announce its receipt, and Missouri would become a state without further ado.

Did this solve the knotty problems presented by the Missouri Compromise controversies? No, of course not.

While the contentious Missourians were delighted (in their view) to have defeated the eastern antislavery interests, they did not particularly rejoice in getting conditional approval for statehood, because they believed Missouri was already a state, and nothing Congress could do would change that. They regarded the Second Missouri Compromise as "absurd to the extreme." Congress was requiring the legislature to pass a law that contradicted the express provisions of the state constitution. The legislature certainly had the power to repeal any such law (and it did a few years later). Once Missouri became a state, Congress could no longer order it to pass laws governing its internal affairs.

Moreover, Henry Geyer, one of the state's foremost lawyers, applied his legal skills to identify what he thought was a fatal loophole. In examining the text of the constitution as published in the St. Louis newspapers, he discovered that the "fourth clause of the twenty-sixth section of the third article of the [Missouri] constitution" was *not* the offending provision that caused the prolonged gnashing of teeth in Washington. He argued that the reference was to a provision that did not exist or possibly to the provision prohibiting emancipation. The version Congress used, however, was *not* the same as that printed in the St. Louis papers, and the reference was correct. In any event, the legislature passed the "solemn public act," and President Monroe declared Missouri a state on August 10, 1821.

The two Missouri Compromises calmed the slavery controversy and served to keep it under control for thirty years. But it also laid the groundwork for later controversies that would not end as peacefully.

6
ST. CHARLES, THE FIRST CAPITAL OF MISSOURI

Sixty-Six Days to Compromise

With the initial approval of Congress for the admission of Missouri as a state and the adoption of a constitution, the first election for state officers and the first Missouri General Assembly were held in August 1820. One writer urged the voters not to send persons like those composing the last territorial legislature: "a set of ignoramuses, hardly capable of reading, much less comprehending the English language, and woefully deficient in every qualification necessary to constitute a legislator." Alexander McNair, campaigning against the constitutional provisions allowing what many considered excessive pay for the governor and judges, defeated William Clark handily. St. Charles sent Joseph Evans, Uriah Devore and William Smith to the House of Representatives and Benjamin Emmons to the Senate. The general assembly convened in St. Louis on September 18, 1820.

One of the first orders of business was the election of U.S. senators. (Senators were elected by state legislatures until the passage of the Seventeenth Amendment in 1913.) David Barton received the most votes. Thomas Hart Benton was elected with the second most votes, but only after Barton twisted arms to secure them. In addition, it was said that one legislator rose from his deathbed to vote for Benton and a second, of French extraction who hated Benton, was persuaded by his friends to vote for him.

But the most contentious issue before the general assembly was the location of the temporary seat of government. The federal government

promised Missouri four sections of land for a permanent capital, which was required by Missouri's new constitution to be centrally located and accessible by the best means of transportation then available—"situated on the Bank of the Missouri River within forty miles of the mouth of the River Osage."

It was not easy selecting the temporary capital, as sectional interests postponed the decision for weeks. Indeed, the general assembly spent part or all of sixty-six of its eighty-six days in session on this question.

Uriah Devore started the controversy by proposing that the legislature adjourn to "_____." The House inserted Potosi (the center of an important mining area) in the blank. The Senate struck Potosi and inserted Côte Sans Dessein. From there, the proposed location bounced back and forth across the state. The House struck Côte Sans Dessein by a vote of 24 to 11. St. Louis was proposed and soundly defeated. St. Charles was put forward and lost. Franklin lost, Florissant lost, St. Charles was proposed again and lost again and Boonville lost. Exhausted for the moment, the House left the Senate bill as it was but did not approve it.

Ten days later, the House took up the issue again. Franklin, St. Charles, Boonville, St. Louis, Ste. Genevieve and Herculaneum were all proposed and lost. Finally, the House approved Franklin by a vote of 20 to 19 and sent the bill back to the Senate, which refused to agree to Franklin. A joint committee of the House and Senate was appointed, but they could not agree, either.

It was now the Senate's turn to consider multiple options. St. Louis was proposed and lost. St. Charles, Franklin and Potosi were all defeated. A resolution to postpone the question until the next meeting of the general assembly in March 1821 was defeated. St. Louis was proposed again, resulting in a tie vote broken by the affirmative vote of the president of the Senate. The issue was reconsidered. St. Louis and Potosi lost yet again. St. Charles achieved a 6 to 6 vote, but the president of the Senate voted against it, and St. Charles lost again. Someone proposed Newport, a town in Franklin County, but it lost decisively.

After all these machinations, the Senate went back to its original choice of Côte Sans Dessein; the House returned to *its* original choice of Franklin. The House appointed another committee, which compromised on St. Charles as the choice. The bill was sent to the Senate, which approved it, 7 to 5. The House concurred, and the governor at last signed the bill on November 25, 1820, making St. Charles the temporary capital of the State of Missouri until October 1, 1826. The secretary of state was directed to take all the "laws, journals, records, public documents and furniture" to St. Charles by November 1, 1821.

A Brief History

Lawmakers and Laws during the First Capital Era

After the special session in which the Missouri General Assembly passed a "solemn public act" ostensibly approving the Second Missouri Compromise and the president's declaration that Missouri was finally a full-fledged state, new elections were held in the summer of 1821 for the first state general assembly. The forty-three members of the new state's legislature gathered in St. Charles in November 1821. The town of about 1,100 souls prepared to receive them.

The members of the first state government might have been an improvement over the "ignoramuses" of the last territorial body, but many were still "rough characters." According to the 1885 *History of St. Charles*, "they all dressed in primitive style, either in homespun and homemade clothes, or in buckskin leggings and hunting shirts. Some wore rough shoes of their own manufacture, while others encased their feet in buckskin moccasins. Some had slouched hats, but the greater portion wore caps made of the skins of wild cats or raccoons." Governor McNair "endeavored to carry himself with the dignity becoming a man in his position," And, indeed, he stood out

Assembling of the First Legislature, St. Charles, MO, 1821, from a mural by Richard E. Miller at the Missouri State Capitol. *Photograph courtesy of Jim Steinhart of TravelPhotoBase.com.*

sartorially as a man with a beaver hat and a "fine cloth coat…cut in the old 'pigeon-tail' style."

The members' conduct was sometimes as rough as their dress. There was a supply of spittoons, but it was inadequate, or the legislators just missed—tobacco juice flowed so freely that it seeped into the rooms below the legislative hall. Arguments on the floor on occasion sparked fisticuffs. One day, Andrew McGirk and Duff Green got into a quarrel so heated that McGirk threw a pewter inkstand at Green. The two came to blows. Governor McNair emerged from his office next door to attempt to stop the fistfight by grabbing Green. Another legislator pushed McNair aside and said, "Stand back, governor, you are no more in a fight than any other man. I know that much law. I am at home in this business. Give it to him, Duff!"

Some members boarded at the few hotels in town for $2.50 per week. Others went to live in private homes. Uriah Devore, who had been a member of the interim legislature that picked St. Charles for the temporary capital, may have regretted that hard-won victory; he is said to have lost everything he had when he boarded members of the newly elected body. William Christy and his wife kept so many boarders that they had to rent additional beds from their friends at $0.25 per week per bed to accommodate their guests. Young William Christy Junior showed his entrepreneurial side by selling apples to the legislators at $0.25 per dozen. Many of the legislators kept their horses on Archibald Watson Sr.'s farm, about four miles downstream on the "point" near the confluence of the Mississippi and Missouri Rivers.

It was necessary for statewide officials to have permanent residences in St. Charles because they were required to live in the capital city. Governor McNair lived in a stone house at what is now 701 North Second Street that had previously been the home of Jean Baptiste Point du Sable. Secretary of State William G. Pettus, finding his capitol quarters too crowded for his duties, moved into the house Madame Duquette had built near the corner of Clay and Main Streets (now 307 South Main Street), a few doors south of the capitol building.

Because St. Charles was only the temporary capital, there was no need to construct a capitol building or a permanent home for the governor. But a meeting place was, of course, essential. The legislators settled on three rooms above the Charles and Ruluff Peck Store on Main Street, just north of Clay (now First Capitol Drive). The northernmost room was the governor's office. The next two rooms, separated only by a folding door, were the chambers of the House and Senate. There was one small committee room. At the next session, a committee examined the possibility of moving the general

A Brief History

assembly to a house owned by William Eckhart, but ultimately, the legislature decided to stay put, partly because Eckhart's place was located at the upper end of town at an "inconvenient" distance from the boardinghouses of most of the members. The Pecks agreed to be paid what the state deemed "just and reasonable at the end of the present session." (That turned out to be two dollars per day.) As a consolation prize, the House elected Eckhart as its sergeant-at-arms.

Among the major issues confronting the legislature was the amendment of several provisions of the state constitution that had not found favor with the public. These included the appointment of judges, the creation of the position of chancellor to handle nonjury cases and what was regarded as excessive compensation for the governor and judges. Perhaps these provisions had been written into the constitution by the so-called lawyer junto, whose members hoped to be selected for these lucrative positions in the future. McNair ran on a platform seeking to change these provisions, and the legislature indeed adopted the necessary amendments to remove the offending language from the document.

Another major problem the legislature sought to deal with, but with much less success, was debt relief. There was no national bankruptcy law. The

The legislative hall of the first Missouri General Assembly above Charles and Ruloff Peck's Store. *Vicki Erwin collection.*

country, and Missouri along with it, was still experiencing the effects of the Panic of 1819. The law allowing imprisonment for debts on contracts was abolished. A law allowing a stay of foreclosures was passed. The legislature also passed a scheme creating a state loan office that issued certificates in denominations ranging from fifty cents to ten dollars backed by land or personal property. The certificates were declared to be legal tender for the payment of taxes and state officers, but merchants and creditors refused to accept them in payment of private debts. Ultimately, the laws staying foreclosures and creating loan office certificates were declared unconstitutional. By that time, the state economy had recovered.

While the legislators did not come to blows over the issue, a seemingly insoluble question was the design of a great seal for the state. This embarrassed Governor Alexander McNair and Secretary of State William Pettus to no end. They were rescued by an up-and-coming young man living in St. Charles, Robert Wells. Born in Virginia in 1795, Wells may have been a fellow student of another important Missouri figure born in Virginia, Hamilton Gamble. As with many public men in Missouri history, Wells started out as a surveyor in Missouri in 1816. After an interlude in Ohio, where he began the study of law, Wells returned to Missouri and surveying. By 1820, he gave up surveying and entered the practice of law in St. Charles, serving as the circuit attorney.

Wells's proposal for a great seal was accompanied by a lengthy and learned explanation of the heraldic principles represented by the images. The grizzly bear was included because it was "the most honorable" quadruped, and its "strength and courage…is borne as the principal charge of our shield." The crescent moon represents the "growing situation" of the state. On the right half is the seal of the United States, and the whole is circled by the motto "United we stand, divided we fall." At the bottom is a ribbon with the state motto, "*Salus populi suprema lex esto*" ("Let the good [or welfare] of the people be the supreme law"). The whole is supported by two large grizzly bears. Above them are twenty-three stars in a blue cloud, representing the states admitted to the Union before Missouri and the difficulties it encountered in being admitted. The Roman numerals MDCCXX (1820) indicate the year the first constitution was adopted and Missouri began to function as a state.

Wells presented his proposal to the legislature, which adopted it without change, except to add the Roman numerals. The governor signed the bill on January 11, 1822. The original seal was lost in a fire in 1837. Later versions included one called the "Monkey Seal" because of the unfortunate

A Brief History

An imprint of the original Great Seal of the State of Missouri. State Historical Society of Missouri.

resemblance of the animals to monkeys instead of the "honorable quadruped."

Wells later became one of twelve candidates for three posts in the state legislature from St. Charles County in 1822. He was elected, along with Felix Scott and Joseph Evans. They defeated, among others, Nathan Boone. Wells added to his reputation by his work on the impeachment of Judge Richard S. Thomas. Judge Thomas, appointed by Governor McNair to the circuit court bench, overstepped his powers when he decided to replace his clerk with his son—a move that landed him in trouble with the legislature. He was tried and found guilty of misconduct in 1825. Wells was rewarded with the appointment as attorney general, a post he held for ten years.

The selection of a permanent capital began with the appointment of a committee by the first general assembly in September 1820 to recommend a site. There were no suitable places on the banks of the Missouri River east of the mouth of the Osage River. West of the Osage, there were three sites on the south bank, but two were owned by private parties and thus not public land. At the third site, there were four natural, but narrow, openings in the high bluffs in Sections 6, 7 and 8 in Township 44, Range 11—but these did not constitute four complete sections that the federal government seemed to have specified.

Another candidate was the existing town of Côte Sans Dessein in Callaway County, across the river from the mouth of the Osage River. Its strongest proponent was Angus L. Langham, who just happened to own the land under consideration. He offered to donate 446 acres that included a narrow hill 1,800 feet long that culminated in a height of 150 feet above the river, and surrounding bottomlands. But there was some question about the soundness of Langham's title. In the meantime, the federal government clarified that its offer of four sections of public land for the capital meant land whose acreage *totaled* four sections, not necessarily four entire sections. On December 28, 1821, Governor McNair signed a bill approving the selection of the land in parts of Sections 6, 7 and 8 and four other sections in Township 44, Range 11. The committee proceeded to lay out the streets for the "City of Jefferson"—still the legal name, but much better known today as Jefferson City.

St. Charles, Missouri

Langham did not give up so easily, however. He filed a "New Madrid" claim in the name of John Baptiste Delisle to Sections 6, 7 and 8—the three sections on the Missouri River. The government issued "New Madrid certificates" to persons whose property had been destroyed in the New Madrid earthquakes of 1811–12. This gave the holder the right to replace their destroyed land with an equal amount of public property anywhere else in the state. The matter lay dormant until 1844, when a speculator bought the lot on which the Missouri Supreme Court building, then and now, sits. He sued to quiet his title. If successful, it would have called into question the title to the land on which not only the courthouse sat, but also the Governor's Mansion and the State Capitol Building. Fortunately, these complications were avoided when the court held that the plaintiff's predecessor in interest did not file his claim until after the state had appropriated the land for the capital. Moreover, it turned out that Delisle's land in New Madrid was perfectly fine, and Delisle himself knew nothing about any claim to land on the Missouri River.

One of the lawyers in the Delisle litigation was Abiel Leonard. Leonard was lucky to still be practicing law, because years earlier he barely escaped being convicted of murder. A Yankee from Vermont, Leonard was not an imposing physical specimen. He was only five feet, four inches tall and weighed less than one hundred pounds. Moreover, even his friends said he was "so ugly as to attract attention" because his face was "a compound of wrinkles, jaundice and jurisprudence."

But Leonard had a sharp legal mind. Just a few years after moving to Missouri from Vermont, he was appointed prosecutor for Howard County. In that capacity, he represented the state in a case against Major Taylor Berry in which Berry was charged with forgery and perjury. Berry, a respected veteran of the War of 1812 and one of the founders of Columbia, Missouri, was acquitted. Leonard dismissed the perjury charge, but Berry was not mollified. He accosted Leonard in the courthouse corridor and beat him with a whip. Leonard responded with a challenge to a duel. This was the accepted reply among Missouri "gentlemen" who were humiliated or insulted by another man of the same class. There was just one problem for a man who was a lawyer: it violated a Missouri statute passed in 1822 prohibiting duels. Leonard was arrested and required to give bond. That did not deter Leonard, who said, "Name the amount of the bond, for I am determined to keep my appointment with Major Berry."

On September 1, 1824, they met on the "field of honor" on an island near New Madrid. It took two rounds to resolve the issue. Berry missed with

both shots—whether deliberately or not, no one knows. Leonard refused to reconcile after the first round, and his second shot found its target. Berry was shot in the lungs. He survived three weeks, dying officially of pneumonia and thus saving Leonard from a murder charge.

In October, Leonard went on trial for violation of the dueling statute. He was convicted, fined $150 and, per the statute, barred from holding public office, voting or practicing law. The ugly little man's standing in the community suddenly soared. Over fourteen hundred persons signed a petition to the state legislature asking to lift the sanctions on Leonard.

At the legislative session in St. Charles the following month, many of the members of the general assembly, especially those from western Missouri, attacked the law as unconstitutional. No one regarded a duel as a form of murder. Historian Dick Steward points out that one senator argued that only "members of the gentry" would be harmed by a prohibition on dueling. Thus, the law would deprive the state of needed talent and—horrors!—would place all the citizens of the community on "equal footing." "An Act for the Relief of Abiel Leonard" passed on December 24 by a 26 to 23 vote. Curiously, a few weeks later, the general assembly passed a law requiring that anyone convicted of participating in a duel be publicly flogged.

The duel boosted Leonard's reputation, which he fortified by stellar representation of his clients, topped by his election to the Missouri Supreme Court. Leonard became one of the largest landowners in Missouri, accumulating sixty thousand acres, and he became one of its largest slave owners.

In 1826, the state moved all its "laws, journals, records, public documents and furniture" to Jefferson City. William Pettus gave a farewell party at his home for the state officials who would now have to reside in the new capital. Pettus remained behind in St. Charles. Thus, the town that for five years "flourished and promised to be a place of very great importance" gave up its most prominent citizens. But it was about to experience an influx of immigrants who would influence its development for decades: the Germans.

7
GERMAN IMMIGRATION

A few Germans lived in St. Charles almost from the time of the first Europeans in the town. John Coontz migrated from Illinois to St. Charles and bought land from Louis Blanchette in 1790. He built a mill on Blanchette Creek and two more on Dardenne Creek outside of town. But it would be forty years before any significant number of immigrants would arrive from Germany. Then, they flooded the area. By 1860, one-sixth of all Germans in Missouri lived in St. Charles and Warren Counties. Indeed, the counties of St. Charles, Warren and Montgomery north of the Missouri River along with and Franklin, Gasconade and Osage south of the river became known as the "German belt," or as social historian Walter Kamphoefner calls it, "Duden country."

The Duden he refers to is Gottfried Duden, a young German lawyer whose 1829 travel book helped to stimulate a mass emigration from the villages and countryside of northwest Germany—especially Hanover, Oldenburg and Brunswick—that flowed into the Missouri River Valley. Duden was born in 1789 to a middle-class family. His father, Leonhard, was an apothecary. When Leonhard died, his will emphasized that he wanted his children well educated. Duden attended the gymnasium and later studied law at Dusseldorf, Heidelberg and Göttingen. He began practicing law in 1810 and became a justice of the peace in 1811. He volunteered to serve in the German army during the latter part of the Napoleonic Wars. The idealistic young man believed that immigration would alleviate what he saw as the overpopulation in Germany that was causing economic, social and

political turmoil. Duden, however, was dissatisfied with the available travel books, viewing them as deficient in detail about possible destinations. He decided to make the trip himself and write about it.

In 1824, Duden and two traveling companions, Ludwig Eversmann and Gertrude Obladen (Duden's cook), set off for Baltimore. After arriving there, they traveled overland until they came to St. Louis in October. On October 15, he purchased 160 acres in Montgomery County (now Warren County) near the present-day town of Dutzow. On the advice of acquaintances, he contacted Nathan Boone and "traveled about with him for several days in order to become acquainted with the region and the salable land." They also found time to go duck hunting. While Eversmann farmed and Obladen cooked, Duden gathered information for his book, taking extensive notes on slavery, Indians and farming. A little over a year later, in 1827, Duden returned to Germany, never to set foot in Missouri or the United States again.

In 1829, Duden published his *Report on a Journey to the Western States of North America*. In the form of thirty-six letters, he combined practical tips such as how to buy land with lyrical descriptions of the freedom immigrants would enjoy. Duden's first biographer, William Bek, said that he achieved his goal of giving "his countrymen a fairly comprehensive, and reasonably accurate, first-hand account of conditions as they obtained in the eastern part of the new state of Missouri." Mack Walker said that the "enthusiastic book…fit its time with a gratifying neatness." "Duden," he wrote,

> *found American economic, political, and social conditions better than those of the Fatherland, and American intellectual and moral conditions just as good. The color, timing, and literary qualities of Duden's report made it unquestionably the most popular and influential description of the United States to appear during the first half of the century. It was an important factor in the enthusiasm for America among educated Germans in the thirties; it served for decades as a point of departure for hundreds of essays, articles, and books, and innumerable thousands of conversations; it was a landmark in the life and memory of many an Auswanderer.*

Duden emphasized that immigrants would enjoy everyday freedoms as well: to kill all the meat they could eat, to cut the wood needed and to vote for their leaders. As historian Dorris Keeven-Franke wrote, there was "no military draft, no inheritance taxes, and no high taxes." America was "a virtual *Schlafferenlande*—a Garden of Eden."

The book was an immediate bestseller. It fell upon fertile ground, for Germany was undergoing yet another social and political upheaval in 1830. Emigration societies were organized to bring groups to settle in the new utopia. First came the Berlin Society; then the Giessen Society was established in 1834. Those arriving in Missouri wrote back to their families and friends in Germany, confirming the good news proclaimed by Duden. Members of their families and their neighbors packed up and left to join them in America. This process, referred to as "chain migration" by academicians, resulted in virtually whole villages and neighborhoods being transplanted to the Missouri River Valley.

The industrious Germans looked down on their neighbors. The French were frivolous, given to music, dancing, playing cards, hunting and fishing, rather than engaging in "serious" farming. The Yankees were sharp traders, religious hypocrites and advocates of temperance. The poor southerners were ruffians, and the rich southerners were an aristocratic closed society of slave owners. American frontiersmen were "rough, brutal, ignorant, and ashamed of their ancestry if they are still aware of it." There was little intermarriage between the Germans and other ethnic groups. And, indeed, German culture persisted into the twentieth century. The German language was spoken at home, in schools and in churches by second-, third- and even fourth-generation German Americans. Kamphoefner points out that in New Melle, for example, the Lutheran church "felt constrained by patriotic duty to suspend German services for the duration of the war: World War II!"

Some of the early immigrants associated with the emigration societies were middle-class intellectuals, "Latin farmers" who knew more about the classics than farming. But most immigrants were actual farmers, land-hungry and very poor. Government land could be had for $1.25 per acre, but that might use all the money they had. Many settled for less than quality land. One memoirist recalled, "These guys will clear any land where the rocks aren't lying three feet deep." The men worked as hired hands for other farmers, while the women and children cleared the underbrush. But they created prosperous farms, vineyards and businesses.

A second wave arrived from Germany after the failed Revolution of 1848. By the 1850s, first-generation German Americans were important members of the commercial and political elite of St. Charles. Their strong support of the Union during the Civil War led to nearly complete dominance of political and business affairs for the next one hundred years.

The *St. Charles Demokrat*, the county's German-language newspaper, urged its readers:

The offices of the *St. Charles Demokrat*, an influential German-language newspaper founded and edited by Arnold Krekel. *St. Charles Historical Society.*

A Brief History

Recognizing that which is good and better here, which is not hard to find, we Americans of German extraction should make it our own, without thereby thoughtlessly and childishly throwing overboard the genuine good of the old homeland. If we instead…make the effort to hold up before our eyes of our fellow citizens of English extraction that which was really better in Germany, our skill, our diligence, our festivities, our schools, then these will certainly also find recognition.

Arnold Krekel, one of the newspaper's editors who may have written that exhortation, was an example of a man who followed the path it suggested. Krekel was born in Langenfeld, Germany, on March 12, 1815. When he was seventeen, his family immigrated to the United States, ending up in St. Charles in December 1832. Krekel went through several jobs before finally settling into the practice of law. He worked at a silk dyeing firm in Cincinnati while studying English at night. He purchased a stock of goods, resold them in New Orleans, bought more and returned to Missouri. Krekel attended St. Charles College, studying to become a surveyor. He held that post for St. Charles County and later became a deputy U.S. surveyor. He began the practice of law in 1844 and was a justice of the peace in St. Charles. Krekel opened the influential *St. Charles Demokrat* in 1850. He sold the paper four years later but continued as an editor for several years. Krekel served in the Missouri legislature. He was a delegate to the Republican convention in Chicago, giving a speech in favor of St. Charles resident Edward Bates in his candidacy for president. But when Abraham Lincoln was nominated, Krekel was an enthusiastic supporter. And he would play a leading role in St. Charles—and Missouri—during the Civil War and afterward.

Arnold Krekel was just one of many German Americans who, by dint of their diligence and skill, obtained the fruits of political freedom and economic prosperity promised by Gottfried Duden.

8
THE SLAVERY QUESTION RETURNS

A Mob on Main Street

Although slaves had lived in St. Charles since its European origins, the area avoided the kind of violence seen elsewhere in Missouri as the issue began to heat up again in the years leading up to the Civil War. There was one exception—one that foreshadowed an even more violent outburst a few months later in Alton, Illinois, the town founded by Rufus Easton and named for his son.

In May 1836, a free black deckhand by the name of Francis McIntosh got into a scuffle with one of his shipmates on the St. Louis riverfront. McIntosh was arrested. While being transported to jail, he pulled out a knife and stabbed one of the escorting officers to death. Shortly afterward, a mob gathered. They hauled McIntosh from the jail, tied him to a tree and set him on fire. The mob refused his pleas to end his misery by shooting him. It took twenty minutes for him to die. When the matter was brought before the grand jury, Judge Luke Lawless instructed them not to return any indictments because, as an "act of the populace," it "would be impossible to punish, and absurd to attempt it." It was, Lawless ruled, "beyond the reach of human law."

Elijah P. Lovejoy was the editor of the *St. Louis Observer*, which was, according to Leonard Richards, a "mildly antislavery and vehemently anti-Catholic" newspaper. Lovejoy denounced Lawless as a foreigner (Lawless was born in Ireland) and a Papist whose charge to the grand jury exhibited the "cloven foot of Jesuitism." Lovejoy's editorial stirred such an outcry that

he decided to move to a more congenial place—Alton. By the following summer, Lovejoy had created a furor in his new hometown for his fierce antislavery and abolitionist editorials.

In October 1837, Reverend William Campbell of the Presbyterian Church in St. Charles invited Lovejoy to preach to his congregation. Lovejoy agreed, and he and his wife stayed with his brother-in-law Dr. Seth Millington at his home on Main Street (now 301 South Main Street). Millington and his brother Jeremiah had obtained a modicum of fame in the castor oil business. They had a botanical garden with fifty acres of plants outside of St. Charles and for a time were a major supplier of castor oil, thought to be a cure-all for many ailments. They provided a supply of castor oil to Lewis and Clark before they embarked on their voyage of discovery in 1804.

After giving two fiery sermons, Lovejoy prepared to retire for the night. But before he left the church, someone handed him a note: "Be watchful as you come from church to-night. A Friend." He returned to the Millington home and sat for an hour in his rooms on the second floor conversing with the Reverend Campbell.

Seth Millington Home at 301 South Main Street, where a mob attacked Elijah Lovejoy in October 1837. The building still stands. *Bill Goellner Collection.*

About ten o'clock they heard a knocking at the door. Someone in the dark called, "We want to see Mr. Lovejoy, is he in." To which Lovejoy answered, "Yes, I am here." Suddenly, two men rushed up the stairs and tried to pull him down to the ground floor. "We want you down stairs, d---n you," they cried. They began to beat Lovejoy with their fists. When Mrs. Lovejoy entered the room to see what the commotion was about, one of the men pulled a knife on her and shoved her back. She slapped the man and ran to her husband. She "smote" Lovejoy's attackers with her hands and clung to his side. The attackers retreated, but not for long. When they came back, Campbell sprang into action and helped drive them back.

Lovejoy recounted that the "drunken wretches, uttering the most awful and soul-chilling oaths and imprecations, and swearing they would have me at all hazards" refused to leave the yard below. The mob rushed upstairs a third time. David Knott handed Lovejoy a note signed "A citizen of St. Charles," demanding that he leave town by ten o'clock in the morning. Lovejoy did not want to reply, but his friends persuaded him to tell the crowd that he had already booked passage on the stage the next day. At first he refused to leave Millington's house that night, but again his friends persuaded him to go when he had the chance. He managed to slip away to the home of George and Mary Sibley up the hill.

The Lovejoys returned to Alton, but they had been followed by some of the attackers from St. Charles. An armed guard stood by his house for days. Lovejoy wrote that "I feel I do not walk the streets in safety, and every night when I lie down, it is with the deep settled conviction, that there are those near me and around me, who seek my life." Lovejoy's premonition was to come true. On the night of November 7, 1837, Lovejoy was killed defending the warehouse where his printing press was located.

Robert Wells, Dred Scott and the Trial that Helped Bring Civil War

Robert Wells, the designer of the state's great seal, moved to Jefferson City in 1826 and continued to serve as attorney general of the state. He ran twice for Congress as a Jacksonian Democrat, both times unsuccessfully. In 1836, President Andrew Jackson rewarded Wells's politics by appointing him to the federal bench, replacing the state's first federal judge, the eccentric James Peck, who tried lawsuits with a handkerchief tied around his eyes to protect them from the light—blind justice, indeed!

Wells was a respected judge who served until his death in September 1864. Although a federal judge, Wells continued to take an active role in Missouri politics and public life. He was a member of the first board of curators of the University of Missouri and a drafter of a proposed new Missouri Constitution in 1845. He met privately with a group of Unionists in 1860 to provide advice to counter "the treasonable designs" of Governor Claiborne Jackson.

Wells was a bit reclusive, with few "warm personal friends." Rather, he was more of a "lawyer's lawyer" noted for his "general learning and legal erudition." W.V.N. Bay, a judge of the Missouri Supreme Court, recalled Wells as

> *a close, logical reasoner, and always secured the full attention of his hearers, but he had few of the elements of oratory. His voice was sharp, shrill, and effeminate, and he was anything but graceful in his gesture or delivery. He never spoke without ample preparation, and was happy and effective in his illustrations.*

Seventeen years after taking the bench, Wells presided over one of the most significant trials in American history: *Dred Scott v. Sandford*, the Supreme Court decision that was one of the flash points sending the nation toward civil war.

In 1824, Missouri passed a law allowing slaves to seek their freedom. Petitioners could sue without payment of fees; they were entitled to the appointment of counsel, and they could prove they were free by oral evidence of manumission, that they were born free or that they had resided on free soil. The law also protected them from reprisals while the suit was pending. The petition itself was required to allege that the person holding them as a slave had committed a trespass, assault and battery or had falsely imprisoned them, for which the plaintiff could recover damages. The person seeking their freedom was not required to prove that they had been physically assaulted or the traditional elements of false imprisonment. The proof focused on the facts establishing or contradicting whatever the petitioner claimed as the basis for freedom. In any event, if the person was validly held as a slave, the master could not be liable for assault, battery, false imprisonment or trespass, because the petitioner would have been found to be his or her property, to be treated as the owner wished (at least within bounds).

Dr. John Emerson bought Dred Scott from Peter Blow or his estate (the records aren't clear). Emerson received an appointment as an assistant

surgeon in the United States Army. He took Scott with him to Illinois, a free state, and later to Fort Snelling, near present-day St. Paul, Minnesota, part of the Louisiana Purchase and, of course, north of the 36° 30′ line established by the Missouri Compromise above which slavery was prohibited.

While at Fort Snelling, Scott met and married Harriet Robinson, a slave owned by an Indian agent, Major Lawrence Taliaferro. (Unlike most slave marriages, which were common-law or slave custom affairs, the Scotts were legally married by the justice of the peace, her owner, Major Taliaferro.) Emerson returned to St. Louis, where he met and married Irene Sanford. Dr. Emerson died in December 1843, and Irene became the Scotts' owner.

Dred Scott. *Library of Congress.*

In 1846, the Scotts filed suit for their freedom in the St. Louis circuit court. Under the law as it then stood, they had a strong case. The Missouri Supreme Court had decided a case with virtually identical facts several years before, holding that a slave taken to live in a free state or territory was deemed to have been freed by operation of law. At the first trial, the Scotts ran into an insurmountable (although temporary) roadblock. None of their witnesses could testify from personal knowledge that Irene Emerson owned Dred Scott. Thus, the jury was instructed to return a verdict for the defendant, which it did. As Don Fehrenbacher points out, Emerson could keep the Scotts as slaves because there was no proof that they were her slaves!

The court cured this silliness by promptly granting a new trial, but Emerson delayed matters by taking an unsuccessful appeal that ran two years off the clock. At the second trial, the requisite proof was offered; this time, the jury returned a verdict for the Scotts—they were free. Emerson took a second appeal to the Missouri Supreme Court, where it languished until 1852.

In a decision that was more a "political tract" (as Fehrenbacher calls it) than a legal opinion, the Missouri Supreme Court reversed the judgment in favor of Scott. Justifying its overruling of decades of precedent, the court said:

> *Times are not now as they were when the former decisions on this subject were made. Since then not only individuals but States have been possessed*

St. Charles, Missouri

> *with a dark and fell spirit in relation to slavery, whose gratification is sought in the pursuit of measures, whose inevitable consequences must be the overthrow and destruction of our government.*

Hamilton Gamble was the lone dissenter, writing, "Times may have changed, public feeling may have changed, but principles have not and do not change, and in my judgment there can be no safe basis for judicial decisions, but in those principles which are immutable."

Scott's attorneys decided not to seek review of the decision by the U.S. Supreme Court. The next move in the tangled history of this case brought Robert Wells into the picture. Dred, Harriet and their daughters filed suit in federal court seeking their freedom.

This time, the defendant was not Emerson (who had remarried and moved to Massachusetts), but her brother John Sanford. The question of Sanford's ownership is murky, but Fehrenbacher concludes that it made no difference—Sanford treated the Scotts as slaves, and that was all that was required to bring the matter to issue.

There was another problem, and this one could have derailed the case at the outset. In the U.S. Constitution, federal courts have limited power to decide cases that do not arise under a federal law or treaty. As relevant here, the case had to involve citizens of different states. But was Dred Scott—a black man and allegedly a slave—even a citizen at all? Judge Wells said Scott was a citizen of Missouri because he resided there and could own property. In short, he was enough of a citizen, despite other restrictions on his rights, to sue in federal court. Sanford himself was a citizen of Massachusetts; the case could thus proceed. Curiously, Sanford did not raise as a defense the argument that the issue of Scott's freedom had just been decided by the Missouri Supreme Court. In fact, that wasn't even mentioned by anybody until the U.S. Supreme Court had its say in 1857.

Unlike the prior two trials in state court, the attorneys in this case took no chances that witnesses might say something that would screw up the chance for a definitive ruling by filing an agreed statement of facts. Judge Wells gave the jury instructions that were favorable to the defense; sure enough, the jury returned a verdict in favor of Sanford: Dred Scott and his family were not free because of their prior residence in Illinois and Minnesota.

The case reached the U.S. Supreme Court in December 1854 under the name *Dred Scott v. John Sandford* (somebody misspelled Sanford's name in the court records, and it stuck for all time). And there it languished once again until four days of oral arguments were held in February 1856. And even that

was not enough, for the court brought the attorneys back in December 1856 for twelve more hours of argument over four days.

Dred Scott got caught up in the heated political atmosphere of the slavery controversy in Missouri, and it cost him victory in the Missouri Supreme Court. The same happened on the national stage. By the time a decision was reached, Congress had passed the controversial Kansas-Nebraska Act. Proslavery and antislavery elements had flooded into Kansas, and each set up their own state government. The nation was presented with "Bleeding Kansas" as the two sides clashed, fueled in part by violent incursions by Border Ruffians from Missouri. John Brown and his sons murdered five men in the Pottawatomie Massacre; Senator Charles Sumner had been severely beaten on the Senate floor by a South Carolina congressman. By making it possible (if not probable) that slavery could be introduced north of the 36° 30′ line by popular sovereignty, Congress repealed the Missouri Compromise.

On March 6, 1857, the justices of the Supreme Court gathered to issue their opinions in the case that would decide whether Dred Scott was a free man or a slave.

Chief Justice Roger Taney delivered the opinion of the court. Today, the justices announce their opinions by reading brief summaries. The results are awaited breathlessly while reporters live-blog the proceedings. The full text of the opinions is posted on the court's website and is available almost as soon as the decision is announced. In 1857, the procedure was far different.

Taney droned on for two hours, reading his opinion in a barely audible monotone. Two other justices read their concurrences. The next day, the two dissenting justices read their opinions in proceedings that took a total of five hours. Despite the intense public interest the case had aroused, the court did not release the full text of the opinion. Indeed, all the public had (and all historians have of those two days) were newspaper reports. The failure of the court to make public an authoritative text of Taney's opinion was itself something of a scandal. One of the dissenting justices, Benjamin Curtis, asked the clerk of the court for a copy of Taney's opinion and was refused access to it. Curtis suspected, with good reason, that Taney was revising it to answer criticisms in the dissents. At last, the majority opinion was made public in late May 1857, almost three months after it was delivered.

It was a complete and utter defeat for Dred Scott and those—by now mostly members of the newly formed Republican Party—who hoped the court would allow congressional restrictions on slavery. Taney held that African Americans were not citizens at all. In a famously nasty phrase, he

said that blacks "had no rights which the white man was bound to respect." If Scott was not a citizen, one would think that ended the matter, because the federal courts only had the power to adjudicate disputes between citizens. But Taney had other weighty issues to opine upon. Congress, he said, did not have the power to prohibit slavery in the territories, and thus the Missouri Compromise was unconstitutional. Therefore, Scott could not rely on his residence at Fort Snelling as a basis for his freedom. As for his residence in the free state of Illinois, whether that was sufficient was a matter of Missouri law, and its highest court had ruled against him.

Southerners praised the decision because it adopted every principle they had argued for during the prior decade. Northerners condemned it. They argued that a majority of the justices did not agree with Taney on the issue of Negro citizenship and that Taney's opinion regarding the Missouri Compromise was merely *obiter dictum* (reasoning not necessary to the decision). The Latin phrase entered the public consciousness and became a curse word in some circles.

The nation had taken another step toward civil war.

John Sanford, the winning party, died on May 5, 1857. Irene Chaffee (née Emerson) and her family executed a quitclaim deed to Taylor Blow, allowing him to free the Scott family. Blow signed the deed of manumission on May 26, 1857. Dred Scott died in 1858. He was buried at Wesleyan Cemetery, near Lindell's Grove on the western edge of St. Louis. His remains were moved to Calvary Cemetery in St. Louis in 1867. Harriet Scott died in 1876 and was buried at Greenwood Cemetery in St. Louis County.

9
THE CIVIL WAR IN ST. CHARLES

Election, Secession, War

St. Charles was spared the violence that plagued western Missouri after the passage of the Kansas-Nebraska Act in 1854. But as secession became more of a reality, the city was not spared the political turbulence. Arnold Krekel, who had been a Benton Democrat, switched to the Republican Party. At the 1860 Republican Convention in Chicago, he made a speech in support of fellow Missourian Edward Bates. The election of 1860 saw the country split along sectional lines. Republican candidate Abraham Lincoln won the states north of the Ohio River and California and Oregon. John Breckinridge, the proslavery Democratic candidate, carried eleven of the fifteen slave states. John Bell, the Constitutional Union candidate, carried three border states. Stephen A. Douglas, the Northern Democrat, carried only two states, one of them Missouri.

In St. Charles, the *Demokrat* urged its readers to "buckle on your sword and march stalwartly" to "cleanse [the county] of its political garbage." Its German readers did vote mostly for Lincoln; historian Steve Ehlmann puts Lincoln's support among them at about 60 percent, but it wasn't enough. Although Lincoln polled the second most votes in St. Charles County of any county in the state (after St. Louis County), it gave him only 26 percent of its total vote. Statewide, Lincoln received an even lower percentage—about 10 percent—and in some counties there was not a single Lincoln voter to be found. Stephen Douglas, the Northern Democratic candidate, barely carried Missouri with 35.5 percent of the vote. Bell finished second, just a

fraction of a percentage point behind Douglas. The results in St. Charles were similar: Douglas carried the county with 40 percent of the vote, with Bell finishing second, Lincoln third and John Breckenridge a distant fourth.

Missouri overwhelmingly rejected secession and sought to avoid war. But on April 12, 1861, Confederate forces bombarded Fort Sumter. The country's—and Missouri's—four-year nightmare began. On April 15, President Lincoln called on the states for 75,000 volunteers, including 3,123 from Missouri. On April 17, Missouri governor Claiborne Fox Jackson fired back his response: Missouri would not furnish one man for this "illegal, unconstitutional and revolutionary…inhuman and diabolical" requisition.

Matters became even more tense when Governor Jackson ordered Daniel Frost to gather about nine hundred men of the Missouri Militia at Lindell's Grove—across the road from where Dred Scott was buried—ostensibly for "training." City clerk Benjamin Emmons swore in fifty men from St. Charles who answered the governor's call. This was not yet a rebellious act, because the militia they joined in St. Louis was the state's authorized military force. The militia established Camp Jackson (named for the governor) and named the streets after various Southern military men. Years later, Edward Lewis recalled traveling to St. Louis as a thirteen-year-old with his father to watch and admire his brother Walter "in his gray uniform, in front of the 'Rue de Beauregard'" in Camp Jackson.

The Union commander in St. Louis, Nathaniel Lyon, suspected that Jackson and Frost intended to take the St. Louis Arsenal's cache of weapons and ammunition for the rebel cause. Supposedly, Lyon himself toured Camp Jackson in a carriage disguised as a woman. Perhaps young Edward Lewis saw him on the Rue de Beauregard, too. Lyon decided not to chance the possibility that Frost's men would occupy the high ground above the arsenal and seize it.

On May 10, with some sixty-five hundred men, mostly German Americas, Lyon surrounded Camp Jackson and demanded its surrender. Frost, knowing he could not defend against such an overwhelming force, gave up without a fight. But while Lyon's troops were marching the prisoners to town, someone in the crowd of civilians watching the procession fired at the German troops. The Federals returned fire. Before the melee was over, twenty-eight persons were killed. Lyon took the prisoners to the arsenal, where they were paroled. When news of the Camp Jackson affair reached Jefferson City, that very night the legislature activated the Missouri State Guard to defend the state from the Federal "invaders" and named Sterling Price its commander.

A Brief History

"The First Clash West of the Mississippi, Camp Jackson, St. Louis, Missouri, May 1861," from *Photographic History of the Civil War* (1911). *Library of Congress.*

Frost's men were quickly released. But the affair roiled the community. In St. Charles, the men who had been with Frost returned as conquering heroes—at least to the "thousand or more people cheering for the South" who met them at the riverfront. Edward Lewis described the scene:

> *My father leaped from the wharf onto the boat before it reached the shore, to greet his eldest son returning thus to our family after the anxiety of the wild reports of great casualties at Camp Jackson. That night a meeting was held at the Court House in St. Charles and a company of men organized to join the army of the South, my father elected 1st lieutenant.*

St. Charles, Missouri

Great excitement prevailed and the streets were crowded with people anxious to enlist, and other companies were projected. The cadets of our school organized a company, and I was appointed sergeant—we made homemade uniforms. Our haversacks were stamped "Dixie Guards" and we drilled, enthusiastically in Rice's Grove, confident we would soon be on our way to help win the war for the south.

Battle of Mount Zion Church

From the beginning of hostilities, both sides recognized the significant role that railroads and the telegraph would play in the war. Armies could use the railroad to transport men and supplies across great distances at a relatively fast speed. Certainly, the railroads, despite their frequent derailing and sometimes flimsy construction, were a far better method of transportation than using hundreds of wagons pulled by horses or oxen over unpaved, often rutted and muddy roads. The distinct advantages of the new technology of war made it a prime target for roaming bands of raiders and a drain on Union resources, diverting thousands of men from the battlefield to guard the army's line of communications from guerrillas.

The North Missouri Railroad ran from St. Louis to the Missouri River opposite St. Charles and then to Hudson (present-day Macon) through parts of Little Dixie, a stronghold of slavery and secessionist sentiment. On Christmas Day, Caleb Dorsey led a large raid on the railroad, completely disabling it between Hudson and Warrenton by tearing up the rails and burning ties, bridges and culverts. On December 27, Dorsey camped at Mount Zion Methodist Church, four miles southeast of Hallsville and eighteen miles northeast of Columbia on the highest point in Boone County. Doctor Charles Johnson organized a company of secessionists armed with whatever weapons they had at home—hunting rifles, shotguns and personal side arms. Johnson's men probably participated in the bridge-burning raids with the rest of Dorsey's forces, but they may not have joined them until a day or two later.

When reports of the attacks reached headquarters in St. Louis, General Henry Halleck sent a flurry of orders for troops from Palmyra, Jefferson City, Hermann, Warrenton and Troy to converge on the railroad between Montgomery City and Hudson. The weather was cold and blustery. Six inches of snow fell on December 24. Ice clogged the Missouri River, delaying troops trying to cross from the south bank.

A Brief History

Mount Zion Church. The original building was destroyed in 1863. This structure was built in 1903. *James Erwin collection.*

After two days' march over the bitter cold prairie from Palmyra, General Benjamin Prentiss arrived with a cavalry regiment at Sturgeon. There he met a battalion of Birge's Western Sharpshooters, who came by train from St. Louis. Each sharpshooter was an expert marksman, able to hit a target at two hundred yards with no three shots more than ten inches apart.

After an initial skirmish with Dorsey's rear guard on December 27, Prentiss set off from Sturgeon the next day. The column pushed through Hallsville. About one and a half miles beyond the village, the Federals found the rebels (possibly Johnson's company) waiting for them in the brush on the east side of the road. A company of cavalry dismounted and launched a frontal attack while two companies of sharpshooters worked around the enemy's left flank. There was a "spirited skirmish" for about thirty minutes before Dorsey's men fell back to the main position in brush and timber one hundred yards east of the church.

The three Union companies charged three times under heavy fire but could not dislodge Dorsey's men. Prentiss ordered the remainder of his men forward. For about half an hour, the battle raged in the woods, the opposing forces close enough that some engaged in hand-to-hand combat. Dorsey retreated, either because his men ran out of ammunition (the Confederate story) or because the rebels were outgunned (the Union story). An "intelligent gentleman" from Boone County (probably Dr. E.W. Herndon) who claimed to be with Dorsey reported after the war that the Federals fired on the church where the wounded had been taken. The firing only stopped when one of the men taken prisoner the day before ran out and said, "There are no fighting men here; this is a hospital." By 11:00 a.m., the battle was over.

Benjamin Prentiss, victor at Mount Zion Church, in December 1861. *Library of Congress.*

Dorsey left behind ninety horses, 105 stands of arms and several wagons. Prentiss lost 3 killed, 17 severely wounded and 46 slightly wounded. He claimed that Dorsey lost 25 killed, 150 wounded and 30 taken prisoner. It is known that 7 unnamed Confederates were buried in the churchyard (their graves are there still). The sharpshooters were credited by General Halleck with taking a terrible toll on Dorsey's forces. Certainly, the St. Charles company was devastated by the battle. Johnson's journal records that his company alone lost 4 men killed, 20 men wounded and 25 men taken prisoner—about half its strength.

Union forces rounded up many of the bridge burners and charged them with crimes that could, and in many cases did, result in the death penalty from military commissions. Perhaps fearful of what their fate could be, the remnants of Captain Johnson's company—about sixty men—surrendered and were treated as prisoners of war rather than as criminals. They escaped further punishment and were paroled on the promise that they would not take up arms against the United States again. Captain Johnson—after his surrender, just Dr. Johnson once more—returned to St. Charles. Despite his parole, Johnson spent the rest of the war secretly sneaking recruits through Federal patrols in the county to join the Confederate army.

A Brief History

Arnold Krekel's Civil War

Arnold Krekel was the most important man in St. Charles during the Civil War. Already a leading citizen of the city when the war began, he was elected colonel of the Home Guard. After that was disbanded, he was appointed commander of a battalion of the Missouri State Militia. Krekel was the provost marshal and, as such, administered martial law for his district. He ran for Congress and the Missouri Supreme Court, albeit both times unsuccessfully. But he became a stalwart of the Radical Republicans in Missouri. Krekel was the president of the constitutional convention elected to draw up a new governing document for the state that, among other things, freed the slaves and imposed severe restrictions on anyone who had shown even a hint of support for the rebellion. The four years were capped off by his appointment as the U.S. district judge for Western Missouri by President Lincoln.

In the summer of 1861, independent companies of Unionists and secessionists sprang up in towns and counties throughout the state. In St. Charles, Unionists, mostly German Americans, formed a Home Guard and elected Arnold Krekel as its colonel. These Home Guards, nearly five hundred men, served until August 1861, when most were incorporated into Krekel's Battalion, Second United States Reserve Corps, and later (Krekel's) First Battalion, Missouri State Militia.

In September, Krekel led his battalion on a scouting expedition to Hudson. On the way back to St. Charles, the train stopped in Mexico. Krekel's men disembarked and commenced to cause trouble. For reasons lost to history, several of the soldiers started firing at the civilians. William Lockridge, described as a known secessionist, tried to escape and was shot off his horse. The men's aim was not good, or they simply did not care, for they also shot and killed Garland Surber—a Union man—and shot at a slave and "a small boy about nine." Colonel Krekel did his best to stop them, but his men were described in the newspapers as "ungovernable." It

Arnold Krekel. *O'Fallon Historical Society.*

would not be the first time "Krekel's Dutch," as they came to be known, would show their undisciplined side.

The First Battalion, Missouri State Militia (MSM), made up of men from Krekel's Reserve Corps battalion, was organized in early 1862. Krekel was named its lieutenant colonel. The battalion was initially stationed in familiar territory—St. Charles County. For the most part, it garrisoned towns and guarded important installations such as the Peruque Creek railroad bridge, but two of its companies saw brief combat at Bob's Creek in Lincoln County when they attacked a suspected secessionist camp.

In July 1862, Confederate colonel Joseph Porter from Ralls County returned to northeast Missouri to recruit and to attack Union army posts to stimulate Rebel enlistments and to keep Union forces from the front. On July 28, 1862, Colonel Odon Guitar, a Boone County lawyer, cornered Porter's men at Moore's Mill, a few miles northeast of Fulton. Porter led Union troops on a chase into northeast Missouri. His pursuers, seeking to trap him, stripped Callaway County of all its Union soldiers. The citizens petitioned for protection, and in early September 1862, Krekel's Battalion was ordered to Fulton. The subsequent experience there was not a happy one for the soldiers or the civilians.

Almost immediately, Krekel's Dutch alienated the local populace. It may not have taken much to alienate them, for many were secessionist sympathizers. But even those who were openly loyal, not to mention anyone who still professed to be neutral, were disgusted by the troops' undisciplined behavior. Almost as soon as they arrived, Krekel's men ransacked private homes and businesses. They had been sent to protect the public, but the outrages soon progressed from seizures of property to what can only be called outright murder. On their first scout, troops under Captain Henry Windmueller killed two civilians and wounded two others who were working peacefully on their farms. About a week later, Krekel at first refused to send troops to ambush rebels reportedly camped on a farm owned by Henry Renoe because he feared it was a "*Secesh*" trick." Two days later, Windmueller led a patrol to the farm, where they found Renoe's son John at work in the fields. They took him prisoner, ransacked the house and, on the way back to Fulton, shot John. In a particularly notorious incident, Krekel led 150 men on a scout through Callaway County, finally stopping at the home of John Creed. Philer K. Dibble, chaplain for the Ninth Cavalry and spokesman for the beleaguered citizens of Callaway County, wrote to Governor Hamilton Gamble: "While Col. K. was eating his dinner at an ambulance, some 75 yards from the house, several of his men entered the house from the

side opposite him, commenced breaking open bureaus, trunks, boxes etc., plundering them of their contents."

The battalion had one serious brush with Confederates, although Krekel was sick and missed it. Surgeon John E. Bruere, a St. Charles doctor, led 120 men looking for Porter, who was rumored to be seeking to cross the Missouri River to make his way back to Arkansas with his recruits. They found him at Portland, a little river port in southeast Callaway County. Porter had commandeered the steamboat *Emilie* when it stopped to drop off two passengers. His men forced Captain Joseph Labarge to unload the deck cargo and take 175 horses and about the same number of men across the river. Bruere's men attacked the guerrillas still on the north shore, killing seven. The rest escaped into the brush. Porter himself made it safely back to Arkansas.

Although Missouri's financial problems for its militia were mostly solved when the national government agreed to pay and equip the troops, Congress limited the number for which the Federal government would pay to only ten thousand men. This necessitated a reduction in force and the reorganization and consolidation of existing units. It also provided an excuse for Governor Gamble to disband troublesome units. One regiment, the Fifth Cavalry MSM—also made up primarily of German Americans who earned a controversial reputation in bitter fighting with guerrillas in western Missouri—was mustered out altogether. The governor made a notation on the back of Chaplain Dibble's memorandum detailing the conduct of Krekel's Battalion in Callaway County: "At the proper time let this Battalion be dismissed."

In November 1862, two companies of the Ninth Cavalry, a central Missouri regiment raised by Colonel Guitar, rode into Fulton to replace Krekel's Battalion, scheduled to be mustered out of the service. Guitar's men seized about twenty former slaves employed as teamsters by Krekel's men and sent some back to their masters and jailed others. Krekel's Dutch were horrified. The battalion was also forced to surrender its weapons and equipment. Although this was standard procedure for any unit mustering out, it enraged Krekel's men nearly to the point of mutiny. The *St. Charles Demokrat* railed against the treatment of the slaves and the soldiers, but to no avail.

Of course, when this incident occurred, Missouri was still a slave state. The return of escaped slaves to loyal masters was required by state law and not prohibited by federal law. Indeed, Krekel himself had ordered the return of escaped slaves in similar circumstances earlier that year.

Congress passed the First and Second Confiscation Acts in 1861 and 1862, which made clearer the question of what to do with runaway slaves owned by rebels in the seceding states. The laws' application in Missouri, especially to runaway slaves owned by persons only suspected of rebel sympathies, was not clear. The resolution of such claims was mostly left to the local commander; many of them in the Missouri State Militia, like Colonel Guitar, decided to return the slaves to their masters.

Arnold Krekel had other duties besides command of the MSM battalion. He was provost marshal for St. Charles, Warren and Lincoln Counties from December 31, 1861, to July 30, 1862. Provost marshals in Missouri exercised "extraordinary power" over both civilians and soldiers. Under martial law, they were charged with the responsibility to protect persons and property from guerrillas and Southern sympathizers. They could (and did) arrest persons suspected of disloyalty, referring them to trial by a military commission or requiring them to take a loyalty oath and post a bond guaranteeing their good behavior. Provost marshals gathered military intelligence, had the power to regulate businesses and were authorized to seize property believed to have been used to support the rebellion or simply based on military necessity. They could require individuals to restrict their movements to certain towns or counties; in many places, they required anyone leaving town to obtain a pass approving their travel. In short, provost marshals were authorized to deny citizens their constitutional rights if they believed it was required by military necessity. By their detractors, they were called (with derision and with no little fear) "Little Gods."

Provost Marshal Krekel issued an order prohibiting "the sale, giving away, bartering or exchanging of powder and lead" in his district without permission from his office. He also ordered that no one should sell or supply ammunition to anyone suspected of disloyalty. Merchants were required to report on the first and fifteenth of each month the amounts of such items sold and the identities of the purchasers. Finally, by July 1862, the government prohibited the sale of powder and lead throughout the state. Krekel removed officials who refused to sign the loyalty oath required by the provisional state government.

Krekel also grudgingly acted against his own men when they were caught stealing civilians' property or openly helped slaves to escape. When some of his men killed several suspected secessionists, Krekel's superiors demanded a full report. Krekel defended the killings. One victim was "one of the most active and noisy secessionists in St. Charles County." He described the second man in similar terms, saying he had taken "an active part on the

Rebellion" and kept skiffs at his farm on the Missouri River for rebels to use to travel to St. Louis County. Two others were "disloyal in every sense" and "as disloyal as he can be." The killing of another he described as "certainly gratifiable." Krekel hastened to conclude his report with the hardly sincere statement that he did not mean to be "justifying the acts of the soldiers" and that he agreed that their conduct was "a legitimate subject of inquiry."

A Revolutionist in the Pulpit

The two major denominations in Missouri, the Methodists and the Baptists, split over slavery into North and South churches well before the war. The third-largest denomination, the Presbyterians, separated over other doctrinal questions into Old School and New School churches, but slavery was not an irrelevant factor. The Old School Presbyterians generally sought to avoid the slavery question altogether, while the New School Presbyterians—like the Northern factions of the Methodists and Baptists—supported antislavery political positions.

On May 21, 1861, six weeks after the war began and only eleven days after the Camp Jackson affair that ignited outright violence in Missouri, St. Charles ministers met and adopted a resolution calling for "Christians of our land to band together to stay, if possible, the further shedding of fraternal blood." They pledged themselves

> *as ministers of the Christian churches, irrespective of our private opinions… to abstain as far as possible from all bitter and exciting controversy upon the questions now agitating the public mind* [and further pledged] *within the sphere of our influence to promote a spirit of brotherly love, and by calm and judicious counsel, animated by the Spirit of Christ, our peaceful Master, suppress every act among ourselves which may have a tendency to increase the present difficulties.*

The Reverend Robert P. Farris, a native Missourian, studied law with Trusten Polk, later a Missouri governor and U.S. senator. Farris decided to go into the ministry and was ordained by the Presbytery of St. Louis in 1852. He moved to St. Charles and was named a director of the Linden Wood Female Academy in 1853. Farris was the pastor of the First Presbyterian Church. It isn't clear whether Farris was a charismatic speaker—Edward

Bates described his Christmas 1859 homily as "solid [and] *dull*"—but perhaps he needed politics to give his sermons passion.

Farris may have attended the gathering of ministers and signed the May 21 pledge. If so, he kept his promise for only two months. On Sunday, July 21, in a church service attended by several soldiers from General John Pope's Union army, Farris fervently prayed that "the State of Missouri might have the power granted to it by the Almighty *'to drive out the invaders.'*" He further prayed that Missourians "might be made strong to resist oppression." Mary Easton Sibley later declared in a letter written to the provost marshal that Farris

> *avowed that he was a secessionist such that he had studied the Constitution of the United States with more attention than any of his congregation and he wound up his speech with the following remarkable words, raising both hands at the same time, "With the bible in one hand and the Constitution of the United States in the other, I am a revolutionist!"*

Sibley also wrote Farris a personal letter admonishing him for "mingling the Gospel of Jesus with the politics of the day." Another church member, Nathaniel Reid, complained to Union authorities that Farris insulted Union officers to their faces, "joked" about poisoning their troops and claimed he would sink their steamboats and send "every soul of them to the bottom" if he had a cannon with which to shoot them. Farris lost the spirit of brotherly love when it came to Reid, whom he called "ugly in body as in soul, [who] filled pages of foolscap with fearful charges against me." When Farris was condemned publicly by the local prosecuting attorney for disloyalty, Provost Marshal Arnold Krekel demanded that he take the oath of allegiance and post a bond of $2,000. Farris refused and found himself hauled before the district commander, Colonel Lewis Merrill.

In a sympathetic postwar portrayal, author William Leftwich said that Farris's accusers were not present but that the reverend brought several friends to attest to his good character. Leftwich recounts that Farris apparently drew on his legal training with Senator Polk and proceeded to school Merrill on the intricacies of the law to the extent that "the prisoner taught Merrill more than he ever before knew about the Constitution of his country." (Farris's invocation of Polk as a legal authority likely fell flat, because Polk had been expelled by the U.S. Senate for his support of the rebellion and joined the Confederate army shortly afterward.) Farris's friends were impressed, but the colonel was not. He sent Farris to Gratiot Street Prison in St. Louis on a charge of "general disloyalty."

Farris did not go quietly. The campaign to get him released began immediately. The day after his arrest, three elders of the church, John Jay Johns, Benjamin A. Alderson and Samuel S. Watson, all Unionists, wrote Governor Gamble seeking his discharge. The elders did not attempt to deny that Farris made some questionable statements—possibly even foolish under the circumstances. But they claimed that "with very few exceptions his ministrations are very acceptable and edifying....He claims to be loyal although he holds some opinions different from those in power." His refusal to take the oath of allegiance was attributed to his being a conscientious objector—to what was not specified, but presumably on religious grounds to taking any oath.

Farris bombarded the authorities with requests for a formal trial. The state provost marshal, Franklin K. Dick, gave Farris six weeks to get out of town. Farris used that time to good advantage, proving that, if one has powerful local enemies, one should have even more powerful national friends.

Farris wrote to recently appointed U.S. Supreme Court justice David Davis, a close of friend of Lincoln's, seeking help. Alerted to Farris's maneuver, Dick wrote to the president directly, arguing that "Farris is one of the most impudent, persistent and ingenious Rebels in the State, and as a Minister, has wielded a powerful influence in aid of the rebellion." Lincoln nevertheless permitted Farris to return to Missouri. Dick refused to allow Farris back in the state, and Farris once again appealed to the president through Justice Davis. Once again, the president ordered Dick to allow Farris to return. This time, Dick complied.

Farris returned to St. Charles on March 18, 1863, but he was re-arrested less than a month later. His nemesis, Nathaniel Reid, urged the authorities to take account of the fact that "there is no Union man or woman that did not regret his return." Farris was released for the final time in June 1863. His troubles were not over. In 1864, the provost marshal in St. Louis ordered the Presbyterian Synod to deny admission to its meeting to anyone who had not taken the loyalty oath. Farris refused to say whether or not he had taken the oath; he was turned away. The synod voted to record him as "present" anyway.

Fighting the Union at the Front and at Home

The Reverend Henry F. Luckett, pastor of the Methodist Episcopal Church South, probably shared Robert Farris's sympathies, but he

managed to avoid trouble with the authorities. However, Luckett's sons, William Chap Luckett and Robert Frank Luckett, enlisted in Company C, Second Missouri (Confederate) Infantry. Joining the Lucketts in Company C were their cousins Henry Luckett, age nineteen, from New Melle, Missouri, and William F. Luckett, age twenty, a freight agent for the North Missouri Railroad in St. Charles County. Another St. Charles resident and former railroad worker, Joseph M. Flanagan, was appointed lieutenant and adjutant of the regiment.

Just before its first major battle at Pea Ridge, Arkansas, the regiment was issued uniforms to replace the civilian clothes that most wore. The shirts and trousers were, however, white, but not for camouflage purposes in the winter weather. Ephraim Anderson of Company G explained:

> *Our regiment was uniformed here; the cloth was of rough and coarse texture…the stuff was white, never having been colored, with the exception of a small quantity of dirt and a goodly supply of grease—the wool had not been purified by any application of water since it was taken from the back of the sheep. In pulling off and putting on the clothes, the olfactories were constantly exercised with a strong odor of the animal.*
>
> *Our brigade was the only body of troops that had these uniforms issued to them, we were greeted with a chorus of* ba-a-a's, *and the salutation, "I say, mister, do you ones belong to Mr. Price's company?"…Our clothes, however, were strong and serviceable, if we did look and feel somewhat* sheepish *in them.*

At the Battle of Pea Ridge, the regiment was part of Sterling Price's force, whose task was to get behind the Union army while other units attacked the Federals in different parts of the battlefield. Price's men made a difficult, twenty-four-hour march over frozen roads without food. Many of them either had no shoes or their footwear was destroyed by the hard ground and left bloody footprints on the frozen mud. The men found some hardtack lying in the road. Hardtack, a three-inch by three-inch army cracker, was not misnamed, for it sometimes had to be broken with rifle butts to be eaten. The men eagerly snatched them up, causing one to remark, "Who would have supposed that men get hungry enough to eat crackers that had been thrown in the dirt and run over by wagons?" To which another replied, "Who the devil would have imagined that an army would be marched all day and night without anything to eat, and then go into a hard day's fight on an empty stomach?"

A Brief History

At last, at 10:30 a.m. on March 7, 1862, Price's men attacked up and alongside a road through deep, rocky hollows covered with scrub oak and thickets of brushy undergrowth. For the next three hours, the Second Missouri was in the middle of the fight for Elkhorn Tavern. The boom of cannons and the crack of rifles was deafening. Minié balls, shell fragments and canister ripped through the woods, thwacking into bodies and trees alike. Rocks, branches and body parts flew about. Smoke filled the winter air, choking throats and concealing the enemy. Company C was finally relieved by other Missouri troops, but at the end of the day, the Confederates were in possession of Elkhorn Tavern and—nearly as important to the men—the rations that had been stored there. The other two Confederate columns, however, failed in their missions.

The Confederates decided to withdraw but needed the rear guard, including the Second Missouri, to hold Elkhorn Tavern as long as possible. The next morning, the Second Missouri formed on the right of the line, to the right of the tavern. At 8:00 a.m., the Union army commenced a bombardment that preceded a charge by its infantry. Company C and its fellows in the regiment held off two Union regiments, the Twelfth Missouri and the Twenty-Fifth Illinois. At last, the entire Confederate army escaped, and the Second Missouri— the last rebel outfit on the field—made its escape as well.

On March 7 or March 8, Henry Luckett fell, wounded in the leg. He was one of 173 casualties the regiment suffered, about one-third of its effective strength going into the battle. The records do not show whether Henry was struck by a musket ball, shell fragment or perhaps one of the rocks shorn off by artillery fire. Any of these could do horrendous damage to the human body. Musket balls were mostly .58 caliber—more than one-half inch across. Ephraim Anderson described the wounds suffered by one soldier of the regiment struck by artillery: "shivered [the leg] to pieces, leaving only some flesh torn into shreds by which it had been held together." Given the primitive state of medicine and sanitation, it is a wonder anyone could survive such wounds. Henry did not. He was left behind in the retreat and died while in Union hands.

The army crossed the Mississippi River and did not set foot anywhere on its western shore for three years. During the dog days of heat and humidity in northern Mississippi, the regiment drilled and drilled again. The generals were pleased with its progress and ordered more drills. The thoughts of the men turned to home, and they wrote letters, hoping they would arrive.

Communication between men serving in the Confederate army and their families back home in Missouri was far more complicated than

merely addressing a letter and mailing it. Correspondence with anyone in the rebellious states was prohibited. A person caught in Missouri sending or receiving a letter to a Confederate soldier was subject to being tried by a military commission and jailed or banished. But family bonds were too strong to let Union soldiers prevent them from seeking news of their kinfolk in the Southern armies.

Lacking a mail service, the soldiers and their families turned to couriers. These men and women slipped across enemy lines carrying letters to families or instructions to or reports from spies. It was a dangerous business. If caught, couriers could be sentenced to death. It could be equally as perilous for civilians, as illustrated by the experience of the Bagwell family in their correspondence with two men from St. Charles in the Second Missouri.

Augusta Bagwell, age thirty-two, and her stepdaughter Alzada (better known as Zaidee), age twenty, were living in a St. Louis hotel. Augusta expressed her forebodings in a letter to the regiment's adjutant, Joseph Flanagan, the former St. Charles railroad worker: "I have been expecting a visitor for the last week—as they have been searching for our last courier. I feel very uneasy for fear they will catch one of our dear messengers of peace, for they are a great comfort to many a lonely hearthstone." Zaidee also feared that the courier carrying her letter would be caught. She noted that "Miss Lucy, 'our intelligent contraband,' watches everything so closely that we do nothing but lie."

Augusta's letter, dated February 4, 1863, was probably written shortly after she and Zaidee arrived in St. Louis from a stay in Hannibal in January. Most likely their visit consisted of more than social calls; they were gathering the letters to be turned over to the courier.

Augusta and Zaidee were right to be worried. Apparently based on a tip from Miss Lucy, the authorities in St. Louis raided their room. There they found twenty-eight letters from various families to soldiers serving in the Confederate army near Vicksburg. Augusta and Zaidee were brought to trial before a military commission.

Augusta admitted writing the letter to Lieutenant Flanagan in response to one of his, but she confessed to little else. When questioned as to how she sent and received the letters, Augusta would only say that she got Flanagan's letter from an "Irish woman whose name I do not know" and gave her reply to "a boy to be sent....I gave him no directions. I do not know in whose employ the boy was." These were obvious lies. She "declined to answer" any questions about the letters she received for forwarding to others. The commission had little difficulty convicting her of the offenses charged.

A Brief History

Searching for Arms by Adalbert John Volck, from V. Blada, *Sketches from the Civil War in North America, 1861, '62, '63*. Library of Congress.

 Zaidee's crime was writing her lover in the army and sending him a pair of gloves and a photograph. The letter was addressed to "W.F. Luckett, Second Missouri Infantry, Price's Division, Army of West." Luckett, the former North Missouri Railroad agent, was now ordnance sergeant for the Second Missouri Infantry. Zaidee called him "Darling Frank" (apparently his middle name) and was by turns coy, flirtatious and gossipy about events and acquaintances. Another letter, written by one of Zaidee's friends to her brother, intercepted by Union authorities and printed in the *St. Joseph Morning Herald*, refers to the Hannibal trip and says: "Give my love to Buck L., and tell him to write Zaidee. She is nearly crazy to hear from him, and is as true as ever....Zaidee has gone home, leaving several breaking hearts behind her."

 In any event, Zaidee wrote Frank (or Buck, as the case may be) that his mother said: "I might love you if I was a real good Rebel, and if that is all she asks of me I think you are my property." She concluded her letter by writing:

We all give much love to you and Mr. Flannagan, and hope you will give the Feds your best Minnie ball, and shoot a few extra balls in revenge for us. You may look for several kisses in this letter, and you will find them. Write soon to your true and devoted rebel, ZAIDEE J. BAGWELL

Zaidee, like her stepmother, was convicted.

Both Augusta and Zaidee were sentenced to banishment, but General Schofield mitigated the punishment to parole, conditioned on the positing of a $10,000 bond for Augusta and $5,000 bond for Zaidee.

The romance between Zaidee Bagwell and Frank (or Buck) Luckett did not end well. In a brilliant campaign, General Ulysses Grant landed his army below Vicksburg and inflicted a series of defeats on the Confederates, driving General John Pemberton's force back into the defenses of Vicksburg by May 18. Thinking he had the rebels demoralized, Grant ordered an assault on the town's fortifications on May 19. The Second Missouri was in the thick of the fight. While carrying ammunition "through very heavy fire," Ordnance Sergeant William F. Luckett received a serious wound to his leg. The records do not reveal the nature of his treatment, but most likely his leg was amputated. Complications set in, possibly gangrene. Luckett died in the hospital in early June.

Vicksburg fell on July 4. By July 10, the entire garrison was either paroled or refused to sign a parole. Those who refused were sent to prison in the North. Those signing a parole could either go home or go to a parole camp, where they would remain until exchanged. William Chap and Robert Frank Luckett chose to stay. William Chap Luckett went on to see further battles in the Atlanta campaign. Robert, suffering from a heart condition, was detailed to serve in the quartermaster corps. The Second Missouri's strength was so low that it was consolidated with the Sixth Missouri. The Second/Sixth Missouri fought its final battle at Fort Blakely, Alabama, on April 9, 1865.

Slaves to Soldiers: The Fifty-Sixth United States Colored Infantry

There was another Luckett who served in the army, but it was the Union army. Hiram Luckett was a former slave who escaped from his St. Charles owner. He and at least fifty-two other African American men from the St. Charles area enlisted in the Third Arkansas Infantry (African Descent).

A Brief History

The Third Arkansas was the first black regiment recruited in Missouri; it was raised as an "Arkansas" regiment to avoid offending loyal Missouri slaveholders. In March 1864, it was re-designated the Fifty-Sixth United States Colored Infantry.

The regiment's duty post was Helena, Arkansas, a spot one officer called "the most deadly place on the river." The low-lying ground was infested with insects, the sanitation was nearly non-existent and the men had to drink "bad swamp water." Some of the regiment's companies were sent to Island No. 63, about twenty miles south of Helena on the east side of the Mississippi. Hiram Luckett died there in a hospital on September 18, 1864, from chronic diarrhea.

Reuben Williams was a slave owned by Joseph McIntosh of Lincoln County. He married before the war "according to slave custom," but his first wife was sold and sent south, never to be heard from again. He then married America Magruder, a slave woman owned by Loyd Magruder, who lived about a mile and a half south of the McIntosh place. McIntosh was apparently a lenient master, for he allowed Reuben to go home to America every night. But lenient or not, the lure of freedom was too much. Reuben escaped to St. Charles and signed up with the Third Arkansas. Reuben also suffered from chronic diarrhea, and he, too, died on Island No. 63, on September 2, 1864.

The Fifty-Sixth USCI saw little combat. Its biggest battle was at Wallace Ferry, a few miles southwest of Helena, on July 26, 1864, when a reconnaissance in force led by Colonel William Brooks, a combat veteran of the Battle of Prairie Grove in December 1862, was attacked by a superior Confederate force. The battle raged for four hours. The regiment managed to cut its way out and retreated toward Helena in a "constant running fight." Colonel Brooks was killed. His brother Joseph, the regimental chaplain, and Joseph's son Joseph Jr. survived. The regiment lost one other officer and eleven enlisted men killed, and two officers and twenty-four men were wounded. Among the mortally wounded was Henry Jones, a private from St. Charles who died in Helena on August 3.

The regiment fought well in difficult circumstances. The district commander, General Napoleon B. Buford, was so proud (and possibly relieved) that he wrote up General Order No. 47. In it, he crowed, "[W]e rejoice in the glory acquired on this well disputed field by our colored troops. Will they fight? Ask the enemy."

The regiment's new commander was Charles Bentzoni, a Prussian. He had served in the Prussian and British armies before enlisting in the

An unidentified African American soldier at Benton Barracks, St. Louis. *Library of Congress.*

U.S. Army in 1857. A sergeant at the beginning of the war, he was commissioned in the Eleventh United States Infantry Regiment in November 1861. He spent most of the war at Fort Independence in Boston Harbor, training recruits. He finally made it to the battlefield and fought with distinction, receiving a brevet captaincy for gallantry at the Battle of Peebles Farm (or Poplar Springs Church) on September 30, 1864, as part of the Siege of Petersburg. One of his fellow officers in the Eleventh Infantry was John Coalter Bates, the son of Edward Bates. (The younger Bates stayed in the army and retired as a lieutenant general in 1906 after serving as the army's chief of staff.)

Charles Bentzoni, colonel of the Fifty-Sixth United States Colored Infantry. *RG262S, Indian Wars Misc., 2.15, U.S. Army Heritage and Education Center.*

Bentzoni and the Fifty-Sixth helped two Quakers from Indiana, Alida and Calvin Clark, move an orphanage and an elementary school for blacks away from disease-infested Helena to a more healthful site nine miles northwest of town. The Clarks expanded this institution into what became Southland College, the first academy of higher learning for African Americans west of the Mississippi.

The regiment was one of the last African American units to enforce Reconstruction policies, but in August 1866, it was ordered to return to St. Louis to be mustered out. By that point it had lost 4 officers and 21 enlisted men in combat and suffered an astounding loss of 474 officers and men to disease, mostly chronic diarrhea or "typho malarial fever." Worse was to come.

The men boarded the steamboats *Continental* and *Platte Valley* for the trip home. Bentzoni noted that "the command had been healthy during the summer." But the colonel told a doleful story of what happened next in his report of August 18, 1866:

> *When I arrived at Cairo, ILL., I was told that the Continental which preceded me a few hours, had thirteen dead bodies onboard, and from fifty to sixty sick, at the same time. The number of sick increased to an alarming*

St. Charles, Missouri

Southland College, from Society of Friends. *From* History of Southland College *(1906)*.

extent on the Platte Valley, which induced [me to] *engage a physician at Cairo who treated about fifty men for various complaints, one of whom died of congestion between Cairo and St. Louis. Arriving at the Quarantine Grounds near Jefferson Barracks, Mo., I found the detachment from the Continental disembarked and Capt. Thos. reported to me that over fifty men died on the passage and the deaths were rapidly occurring since the landing was effected. Brevet Col. Swift, surgeon United States Army, was on the ground, and at my request, inspected the sick on the Platte Valley and reported no cholera among them.*

The Platte Valley then proceeded to the port of St. Louis, arriving about midnight of the 13th. I kept the troops aboard until morning, when the physician reported a "clear case of cholera" onboard. I had them removed by civil authorities; I then reported in person at the headquarters of Lieutenant Gen. Sherman and was ordered to proceed to the Quarantine Grounds. Although I had kept the two detachments in separate camps, the disease seemed to have infected the whole regiment. Everything has been done that medical skill can do to stay the progress of the disease by Surgeon Swift, United States Army, Surgeon D.A. La Force, 56th United States Colored Infantry (reported for duty yesterday morning) with a number of citizens and physicians who are untiring in their efforts to relieve the suffering of the sick.

A Brief History

Another 176 men died of cholera on the voyage and at the hospital, giving the regiment a grand total of 649 lost to disease during the war—two-thirds of its strength.

Included among the dead was Lieutenant Joseph Brooks Jr., age twenty-two. Brooks was buried with military honors in St. Louis, accompanied by an escort and the regimental band.

The enlisted men received no such tribute. They were unceremoniously buried in a mass grave on the quarantine island. An obelisk was, however, erected in their memory. In 1939, due to the efforts of African American civic leaders, the obelisk and the remains of the men were moved to Jefferson Barracks National Cemetery. Working with Dorris Keeven-Franke, then the archivist for the St. Charles County Historical Society, descendants of the soldiers provided documentation to the U.S. government that resulted in the erection of a new monument to accompany the obelisk on which is listed the names of the men buried there.

10
INDUSTRIALIZATION TO SUBURBANIZATION

Emancipation and Ironclad Oaths

In the summer of 1863, Missouri was becoming divided into three camps a wag on a St. Louis newspaper described as Charcoals, Claybanks and Snowflakes. The issue that divided them was slavery. Charcoals sought immediate and uncompensated emancipation of the slaves; Claybanks sought gradual and compensated emancipation; and Snowflakes wanted to keep slavery in Missouri. Although the Claybanks controlled Missouri's wartime government, by 1864, the Charcoals—the Radical Republicans—were rapidly building their power. Their leader was Charles Drake, a St. Louis lawyer who had studied with Hamilton Gamble, the conservative governor and Claybank, who replaced Governor Jackson when the Confederates were driven out of the state. Drake had evolved politically from being a Whig to a Know Nothing to a Democrat supporting Stephen Douglas and Claiborne Jackson in 1860. As late as July 1861, Drake gave a speech opposing abolitionism. But by 1862, he had undergone a fundamental change. He became, as William Parrish described him, an "ardent advocate of emancipation."

The Radicals even initially opposed Lincoln's reelection because he was considered too conciliatory to the South, but they later united behind him when their favorite, John C. Frémont, withdrew from the race. Drake found a kindred soul in, among others, Arnold Krekel. The Radical Republicans swept the 1864 elections, taking control of the governorship, the Missouri General Assembly and the scheduled convention to write a new constitution.

Drake dominated the convention, working tirelessly to press home his two major proposals: emancipation of the slaves and steps to prevent former Confederates from having any power in the new government. The convention met at the Mercantile Library in St. Louis. After electing Krekel as its president, its first order of business was to pass an ordinance emancipating the slaves in Missouri, giving Drake his first major objective. The convention also sent a resolution to the Missouri congressional delegation, urging them to support the adoption of the Thirteenth Amendment abolishing slavery nationally.

The convention then turned its attention to other matters. The new constitution required anyone who sought to vote, to hold public office, to be a corporate officer, to engage in the practice of law, to teach or to act as a minister to take a "test oath," or "ironclad oath," attesting that they had not committed any of eighty-six acts in support of the rebellion. In addition, the convention passed an Ouster Ordinance removing 842 state and local officials effective May 1, 1865, and allowing the Radicals to name their replacements.

These harsh measures stirred statewide opposition, even among those who had been strong Unionists, when they were put to a vote. Edward Bates denounced the proposed constitution in a series of letters. Even some staunchly Unionist German newspapers opposed its adoption. It took several weeks to count the votes. Initially, it appeared the constitution might not receive approval, for St. Louis and St. Charles Counties opposed it. Out of eighty-five thousand votes, the margin was razor thin: only the military vote carried the day for the Drake Constitution, the civilian vote having narrowly decided against it.

The divisive bitterness engendered by war among factions in the churches continued after 1865. Reverend Robert P. Farris, who drew Mary Easton Sibley's ire for his 1861 sermon against the "invaders" of the state and who fought banishment for his refusal to take a loyalty oath, was a defendant in a lawsuit filed in 1867 seeking to kick him off the board of Linden Wood Female Academy for his less than stellar support of the Union war effort. When the Old School Presbyterians split into Northern and Southern factions in 1867, a second lawsuit was filed against Farris seeking ownership of the Presbyterian Church building. Farris was removed from the Linden Wood board, but the Southern Old School Presbyterians kept the church. The two factions would not unite until 1949.

The post of U.S. district judge for the Western District fell vacant when Robert Wells died in September 1864. Arnold Krekel sought to replace him.

He secured the support of Missouri congressmen and the lukewarm support of Edward Bates, lately President Lincoln's attorney general. Bates said of Krekel, "As a business man and politician, he has great tact and adroitness. As a *man*, his private character is fair and good. I make no special claim for him, because I am rather his witness than his advocate." He criticized Krekel for, among other things, supporting a provision in the new constitution that allowed foreigners (especially Germans) who had lived in the state one year to vote when it denied the vote to former slaves. He was also offended when, during a debate about whether atheists should be allowed to testify, "Krekel did not *directly deny* the existence of God, but reserved his opinion on that point, insist[ing] that govt. had no right to enquire of the witness." (Krekel was a "free thinker" and agnostic.) The last straw was Krekel's proposal to elect federal judges. Bates wrote in his diary, "Poor Krekel!—'the higher the bear climbs the plainer he shews his tail.'"

President Lincoln appointed Krekel to the Western District bench, even though he did not live in the district, and he was confirmed in March 31, 1865. He subsequently moved to Jefferson City. Although he had not overtly opposed Krekel's appointment, Bates was not happy with it. "Mr. Krekel," Bates confided to his diary, "is the only prominent man of the party who has secured a safe retreat—U.S. Judge of the Western District. He is wholly unfit for the place, and will not fail to display in it, his ignorance and his perverse notions of law and government."

Bates's prediction did not come true. Krekel served well on the court, albeit with some of the prejudices affecting his performance. In a famous example, he questioned a Mr. Gentry about his fitness to serve as a grand juror and whether he could take the ironclad oath. Gentry explained that he was an "uncompromising Union man," but his brother had joined Sterling Price and lost his leg at the Battle of Wilson's Creek. His brother, on the verge of death, asked Gentry to bring him home so that he could see their mother before the end. Gentry rented a wagon, but the poor man died within a couple of hours of being loaded on it. Gentry paid the teamster and for the funeral out of the brother's estate, not with his own money. "That, sir, is the only time I ever attempted to assist anyone connected with the cause of the South." Judge Krekel replied, "Well, Mr. Gentry, if you did that, you are not qualified to serve on the United States grand jury. Stand aside."

Krekel married Ida Krug in 1845. She faithfully took care of his household and children while he pursued his political, military and legal duties. She died in 1871. Krekel married Mattie Parry in 1880. Mattie Parry Krekel was a well-known lecturer for the Free Thought movement. A

speaker since the age of fifteen, she was "eloquent, scholarly, logical, ready for any hardship" but sympathetic to "those who suffer and toil because of… superstition."

As a legislator before the war, Krekel was instrumental in passing the first laws providing state aid to public schools. He continued his interest in education, being deeply involved in legal education and the establishment of schools for freed slaves. He lectured frequently on federal jurisdiction at the University of Missouri Law School. Former slaves and their officers who were members of the Sixty-Second and Sixty-Fifth United States Colored Infantry contributed $6,500 to help create the Lincoln Institute (now Lincoln University) to provide schooling for blacks. Krekel served as a trustee of the school and lectured there, as well.

After more than twenty years on the bench, a friend asked Krekel why he did not retire. He responded, "Vat, me retire, I should say not. When I go down the street now people say, 'Der comes Judge Krekel,' but if I should retire they would say, 'Der come that old Dutch son-of-a----!" He did finally resign in June 1888, and he died a month later.

Transportation Transformed

When Louis Blanchette came to Les Petites Côtes, travel was done by canoe up the strong currents of the Missouri River, dodging snags and floating trees and climbing over sandbars. He found a trail leading up from his homesite along a creek that came to bear his name. Around 1805, Nathan Boone and his brother Daniel Morgan Boone discovered a saltwater spring—a salt lick—in present-day Howard County. They opened a factory to produce salt, which was a valuable commodity in pioneer days because it was the only practical way to preserve meat. As their business grew, settlers were attracted to the excellent farmland of the surrounding region, which became known as the Boonslick. What began as a Native American trail became a road to the Boonslick region, and the road leading there from St. Charles was known as the Boonslick Road.

The original Boonslick Road started at today's intersection of Boonslick Road and South Main Street (although one source claims that the starting point of the road was not moved there until 1853). The road followed the present-day road of the same name to today's Highway 94 and Old Highway 94 until it deviated almost due west to Cottleville. It struck today's Highway

364 near its intersection with Highway K and then followed Highway 364 and Highway N past Interstate 64. The Boonslick Road eventually terminated in Franklin, on the Missouri River across from Boonville. Soon Franklin became a jumping-off point and the eastern terminus of the Santa Fe Trail.

In 1819, the first steamboat, the *Independence*, came to St. Charles on its way to Franklin. Thereafter, St. Charles was a regular stop on lines plying the river. But the war and advances in technology made plain that railroads were the key to future agricultural and industrial development.

Three major railroads were chartered in quick succession in the decade before the Civil War. The Pacific Railroad was to be built from St. Louis westward along the south bank of the Missouri River. The Hannibal & St. Joseph Railroad was planned to connect the Mississippi and Missouri Rivers between those two towns. Prominent citizens—including Arnold Krekel, Dr. Charles M. Johnson, John Coalter, Isaac Sturgeon, John O'Fallon and B. Gratz Brown—were not far behind in chartering the North Missouri Railroad in 1851. The North Missouri was to run from St. Louis to a point opposite St. Charles. From St. Charles, it was to pass "as near as practicable, or as may be, along the dividing ridge or plain of the country which separates the tributaries of the Mississippi and Missouri rivers to the northern boundary line of this State."

Construction began in 1854, and on August 2, 1855, the North Missouri completed the nineteen miles from St. Louis to a ferry landing on the Missouri River opposite St. Charles. The railroad reached Hudson in 1859. It intersected with the Hannibal & St. Joseph, but it did not connect with it because the North Missouri was built to a gauge of five feet, six inches between the rails, while the latter's gauge was four feet, eight and one-half inches. Passengers could reach Hudson from St. Louis in about eleven hours, but those traveling beyond to St. Joseph or other points west had to get off the North Missouri cars and get on the Hannibal & St. Joseph cars. Likewise, freight had to be unloaded from one railroad and loaded on to the cars of the other. This was a less than satisfactory situation for travelers and shippers alike, although hoteliers and draymen in Hudson welcomed it. Passengers and freight had to go through a similar process when using the ferry between St. Louis County and St. Charles until 1864, when the railroad purchased a vessel able to carry railroad cars across the river.

The war was hard on the North Missouri. The line suffered about $100,000 in damage when it was attacked by the bridge burners in 1861 and another $150,000 in damages from raids in September and October 1864—all told, more than $2.5 million in today's terms. Its rolling stock was

St. Charles, Missouri

The *North Missouri*, a ferry that carried railroad cars and passengers to St. Charles from 1864 to 1871. *St. Charles County Historical Society.*

depleted and in disrepair. The state stepped in and authorized a bond issue to pay for improvements and expansion to the Iowa border and to Kansas City. Over three days in August 1867, the North Missouri converted to a standard gauge of four feet, eight and one-half inches, allowing equipment "to run direct from St. Louis to St. Joseph."

With one logistical hurdle overcome, management decided to end the "ferry bottleneck." The St. Charles Bridge Company (one of whose investors was James B. Eads, later to build a more famous bridge across the Mississippi) began work on the new bridge in 1868. It encountered numerous obstacles, including a flood that destroyed one of its seven piers in 1869 and scoured away part of the bank on the St. Charles side. In November 1870, a steel column collapsed, resulting in the deaths of eighteen men. (A monument to the men stands in Oak Grove Cemetery.) Finally, on May 29, 1871, amid much hoopla, the bridge was opened to traffic. The bridge towered over St. Charles's northern riverfront. Costing $2.1 million, it stretched for 6,535 feet over seven spans from 305 to 321 feet in length. Its western end curved northwest to the new station high on a bluff above the river. It was regarded at the time as a "most splendid" engineering marvel, one that would "stand for ages to come." Most important for the railroad, the grossly inefficient ferry operation was eliminated. It was possible for a train to run unimpeded from St. Louis to the end of the line in Kansas City and Iowa.

A Brief History

Bird's Eye View of the City of Saint Charles (1869), anticipating completion of railroad bridge. Library of Congress.

The opening of the North Missouri Railroad, May 29, 1871. *John J. Buse Collection, State Historical Society of Missouri (St. Louis).*

St. Charles, Missouri

Although St. Charles had supported the railroad from its inception, it lost the company shops to Moberly, a new town in central Missouri organized by St. Louis real estate interests. Unlike the owners of the Pacific Railroad and the Hannibal & St. Joseph, the backers of the North Missouri were unsuccessful in obtaining land grants to help pay the cost of building the railroad. The state had, however, lent its bonding capacity to raise the necessary funds, secured by a lien on the company's property. The railroad's owners persuaded the state to release its $6 million lien for a payment of a measly $200,000, but the line suffered from continued financial troubles. Finally, bondholders foreclosed on the property in 1871 and sold it to buyers who renamed it the St. Louis, Kansas City & Northern Railroad. Ultimately, the road became part of Jay Gould's Wabash Railroad.

The spectacular Missouri River bridge, which had suffered tragedy during its erection, endured two more disasters less than a decade after its opening.

In March 1879, the State Railroad Commission issued a report assuring the public that the St. Charles bridge, which had attracted public attention for "its great height and length and seeming frailty," was "perfectly safe, having been thoroughly examined and tested for its strength."

On the evening of Saturday, November 8, 1879, an eastbound seventeen-car train carrying livestock crept slowly past the St. Louis, Kansas City & Northern station and on to the west span. O.C. Kenly, the conductor, was riding the engine. He felt the bridge shiver and then collapse. The cars behind the engine plunged eighty feet into the river below. The caboose was carrying two brakemen and four drovers who were riding the train along with their animals. One of the brakemen was on the roof. (The railroad likely required him to be there while crossing the bridge; at that time, brakemen set the brakes by hand on each car. There were no air brakes.) A drover, J.M. Strahan, heard a strange noise and went to the rear platform of the caboose. When he heard the cars ahead of him begin to crash, he jumped and walked unharmed into town. Three men died, and four others were injured. The railroad concluded that the wreck was caused by the derailing of one of the cars, which then brought the rest of them cascading down. However, a coroner's jury also pointed to the lack of maintenance, which left much of the deck planking rotting away.

Just over two years later, another train plunged into the river. On December 8, 1881, a westbound train of thirty-one cars, eighteen of them carrying livestock, entered the east span. This time, two brakemen were riding the roofs. Suddenly, the "sound of parting and crackling [was] heard." The engine fell into the river. "With frightful and blood-chilling regularity the

A Brief History

The Wabash Railroad station in St. Charles. This image shows the sweeping curved approach from the west end. *St. Charles County Historical Society.*

slowly moving cars went over the end of the eastern approach and mingled in the river and wreck, ninety feet below." The rear brakeman, George Medcap, called to those in the caboose, "For God's sake, jump; she's going down." The cars rolled off the end of the bridge and piled up against a western pier. Engineer Jack Kirksby died in the wreckage (he was supposedly later found with his hand on the throttle), but fireman Newton Chamberlain managed to jump, and he survived. The cause was not conclusively determined. The railroad once again blamed a derailment. Critics blamed the bridge's design. The bridge's alleged defects were addressed when it was rebuilt in 1883, and there were no further similar accidents. The span was replaced in 1936 by a new bridge built about one-half mile downstream. Not only was the new bridge better constructed, but its location also enabled the Wabash to straighten out the long curve on the western end. It is still in use today by the Norfolk Southern Railroad.

Unlike the other railroads in Missouri, the Missouri-Kansas-Texas Railroad (commonly known as the Katy) was not built from east to west or north to south, but largely from west to east. Chartered in 1870, its original goal was to connect military posts in Kansas. It pushed southward into Indian Territory and Texas. The Katy began to lay tracks from Sedalia to Fort Scott, Kansas, and from Sedalia to Boonville, reaching the Missouri

St. Charles, Missouri

River in May 1873. The Katy built a line from Moberly to Fayette in June and bought an existing rail line that connected Moberly and Hannibal in 1873. When a bridge across the Missouri River was completed in January 1874, the Katy had connections to Chicago at Hannibal.

Nearly twenty years later, the Katy started its line to St. Louis from New Franklin. It followed the north bank of the Missouri River under the bluffs and along the prairies. It was a beautiful, scenic route, but one subject to the whims of periodic flooding. The railroad reached St. Charles in July 1893. It ran along the riverfront to a station at the foot of Tompkins Street. From there, it passed under the high Wabash bridge to the floodplain north and east of town. Entry into St. Louis was delayed while the Chicago, Burlington & Quincy completed a bridge across the Missouri River into northern St. Louis County. The Katy joined the CB&Q at Machens, in eastern St. Charles County, and used its tracks to reach St. Louis.

The railroad's fortunes waxed and waned. It went bankrupt in 1915, but the 1920s promised a revival until it was crushed by the Great Depression. Most of the company's rails ran through the Dust Bowl. As with many railroads, it prospered during World War II—for example, regularly running one-hundred-car tank trains to St. Louis from the oil fields of the Southwest. It enjoyed the postwar building boom but again fell on hard times in the 1950s. Maintenance faltered, and employee morale fell. The company's president, William N. Deramus, directed his managers to "cut all personnel to the lowest possible number that will permit daily conduct of business." The railroad stopped running passenger trains through St. Charles on May 1, 1958.

At its nadir, the company hired John W. Barriger in 1965. Barriger had a reputation for plain speaking and reviving moribund railroads. After his first inspection tour, he said that the Katy "looks like a secondhand junkyard."

Raising the sunken locomotive after the December 1881 bridge disaster. *St. Charles County Historical Society.*

A Brief History

And, he liked to point out, it was "the only railroad on which a standing train could be derailed." (Such an incident actually occurred, when a rail broke under a train in one of its yards.) Barriger bragged that he was "not a man of words, but a man of a few million words." He breathed new life in the Katy with new locomotives and equipment, but its survival ultimately depended on a more financially stable railroad purchasing it. That finally happened when the Union Pacific started proceedings for approval of a purchase in 1985 that was finally granted in 1989. But the price of survival was the abandonment of much of its mileage, particularly in Missouri. Before the sale was complete, an October 1986 flood washed out the Katy's Missouri River line, and it stopped serving St. Charles altogether.

The bad news was followed by good news, even excellent news. The old roadbed was acquired by the state and, in 1990, was converted into the Katy Trail State Park, a bicycle and pedestrian trail that now runs for 240 miles from Machens to Sedalia—the longest such trail in the United States.

Although St. Charles had a railroad bridge that crossed the Missouri River from 1871, citizens who wished to travel by other means still had to take a ferry. One enterprising man, John Enoch, tried to fix that problem by building a 1,500-foot pontoon bridge in June 1890. The military had

John Enoch's pontoon bridge, built in 1890. It lasted until winter, when it was swept away by ice on the Missouri River. *St. Charles County Historical Society.*

St. Charles, Missouri

The highway toll bridge and streetcar bridge completed in 1904. *Library of Congress.*

used pontoon bridges during the Civil War with much success, but they were considered temporary. And the builders of the St. Charles pontoon bridge failed to consider one important factor: the power of Mother Nature. In December 1890, the bridge was swept away by ice in the river. The populace was back to using a ferry boat until it, too, was sunk by ice in 1903. Fortunately, a new highway bridge at St. Charles was in the works.

The St. Charles and St. Louis County Bridge Company completed a combination highway and streetcar bridge from St. Charles Rock Road in St. Louis County to Second and Adams Streets in St. Charles in 1904—just in time for the World's Fair in Forest Park. Those driving wagons or automobiles had to pay a toll until the bridge was taken over by the State of Missouri in 1932 and became part of U.S. Highway 40. The St. Louis, St. Charles & Western Railway Company shared the bridge with highway traffic. The electric streetcar line provided service to Wellston, where it connected with other streetcar lines serving the City of St. Louis and St. Louis County. The streetcar terminal was at Second and Adams Street, and its oddly shaped building still stands, although the line was abandoned

in 1932. Local promoters boasted that "St. Charles…has an electric line communicating with St. Louis every thirty minutes during the day and is a convenient and delightful place for those desiring homes near a great city having every modern convenience, water, gas, electric light, sewers, good streets and sidewalks."

THE BEHEMOTH

River transportation had always been important to St. Charles, whether it was canoes, pirogues, keelboats or steamboats. Well into the latter half of the nineteenth century, steamboats continued to play an important, albeit diminished, role in the town's commerce. The steamboat most associated with St. Charles—because it can still be seen today in low-water conditions—is the *Montana*.

The *Montana* was, as historian William F. Lass termed it, a "behemoth;" 252 feet long, with its stern paddle wheel adding another 30 feet to its length, 100 feet longer than most of the Missouri River boats. The vessel was 48 feet, 8 inches wide, with guards along its hull that made its total width 58 feet. The *Montana* had a main deck, boiler deck and Texas deck topped by a pilothouse that towered 50 feet over the river. It could accommodate one hundred passengers, who enjoyed "custom-made upholstered furniture, expensive silverware, a piano." And yet, even with a full load of cargo and passengers, it drew only 3 feet of water. The *Montana* (like most steamboats of the era) could, as Mark Twain put it, "float on a heavy dew."

The *Montana* and its sister boats the *Wyoming* and *Dakotah* were built and owned by the Missouri River Transportation Company in 1878–79 at Pittsburgh. The company, better known as the Coulson Line for its owners Sanford, John, Martin and William Coulson, specialized (as its name implied) in freight and passenger business between St. Louis and Fort Benton, Montana (the head of navigation on the Missouri River).

The Coulsons hired or partnered with the best river pilots. Among them was Grant Marsh, the first mate on a boat whose second mate was Samuel Clemens. After the war, Marsh was the pilot of the Coulson steamboat *Far West*. The *Far West* was known among river folks for making the run between Sioux City, Iowa, and Fort Benton in the fastest time ever. It entered the consciousness of the American people when Marsh navigated it up the shallow Bighorn River to retrieve the wounded from the Battle of the Little

St. Charles, Missouri

The *Montana* underway. It and its sister steamboats were the largest vessels on the Missouri River. *St. Charles County Historical Society.*

Bighorn in 1876. The *Far West* hit a snag and sunk near St. Charles in 1883, one of twenty-five riverboats to sink at or near the city.

The Coulson Line was backed by eastern financiers, one of whom was William S. Evans. Evans was noted for his spectacular diamond-stud pin and for his superstitious ways. Every boat the line owned had exactly seven letters in its name because Evans believed that brought good luck. His luck ran out when it came to the *Montana*, however.

In May and June 1879, the *Montana* made its only two runs to Fort Benton, delivering 550 and 600 tons of cargo, respectively. On its second return trip, it was docked at Bismarck, North Dakota, when, on June 30, 1879, a tornado ripped half the cabin off the vessel and blew it ashore. It cost $15,000 to repair the boat—nearly one third its original cost. The *Montana* never returned to its namesake state, being limited to carrying freight and passengers on the Mississippi and lower Missouri Rivers.

June 22, 1884, found the *Montana* docked at St. Charles, downstream from the Wabash railroad bridge. It was headed to Kansas City with a full load of cargo under Captain William R. Massie, a veteran riverboat man. The river was high and running fast. The boat pushed off from shore and headed between the piers of the bridge. A swift eddy caught the rudder, causing the

A Brief History

pilot to lose control. Witnesses said the *Montana* struck the third pier from the St. Louis County (or south) side. Massie managed to beach the boat on the south shore in twelve feet of water. No one was killed or injured, but the boat was a total loss.

In the next week, salvers removed the freight and the fancy furniture and accoutrements. Steamboat owners were nineteenth-century recyclers. About one hundred feet of the front of the boat's hull was removed and likely used to build or repair other boats. Its engines were removed and re-used, as well.

The stripped-down hulk was left where the *Montana* sunk, and there it remains today. During periods of very low water, what is left of the hull rises like a ghost out of the river across from Blanchette Landing in St. Charles. Only the port side is visible; the starboard side is buried in the silt and sand of the river.

In 2002, the river was very low. A team of archaeologists from East Carolina State University's Maritime History Program excavated the site. They documented its construction but discovered few artifacts, the wreck having been picked over in the years since the disaster. The archaeologists' field notes posted online do record the discovery of the remains of a barrel and their excitement at finding a pencil that had probably been used by the

The *Montana* shortly after its sinking in 1884. *St. Louis Mercantile Library at the University of Missouri–St. Louis.*

crew. In 2003 and 2004, the History Channel featured the *Montana* on two of its series, *Deep Sea Detectives* and *Wild West Tech*. Neither of these episodes is publicly available online at the time of this writing, although there are short amateur videos on YouTube.

The Rise of the American Car and Foundry Company

In the years after the Civil War, St. Charles not only enjoyed better transportation with the building of the Missouri River bridge and the entry of a second railroad into town but also saw increased industrialization and urbanization. The moving of the North Missouri car shops to Moberly—finally accomplished by 1870—seemed like a fatal blow to the city's hopes to move beyond agriculture as its economic focus. But the move ultimately benefited the town.

Several prominent businessmen met to discuss organizing a company to build railroad cars at the same riverfront site as the former railroad shops. Some, such as John K. McDearmon and Dr. Samuel Overall, were from longtime St. Charles families. Most of the others were German immigrants and the sons of German immigrants who dominated the economic and political life of the town after the war. Valentine Becker, a successful merchant, owned stock in the local bank, insurance company and gas company. Henry Denker was a grocer and the owner of a successful packing company. August Huning was another merchant. Stephen Henry Merten owned a mill. John Thro also owned a mill and had interests in the bank, insurance company and tobacco company. Francis Oberkoetter sold boots and shoes, served as a city councilman and owned part of the bank and insurance company. John Mittelberger was the mayor and an early discount merchant. (His family proudly noted in the 1885 *History of St. Charles* that the store sold the "best classes of goods" at the lowest prices possible and it carried "no goods bought either at fraudulent bankrupt sales, stolen, or bought on credit never to be met and paid.")

The investors incorporated the St. Charles Car Manufacturing Company (later shortened to St. Charles Car Company) in 1873. Its officers included Denker as vice president and Benjamin Emmons Jr., scion of another longtime St. Charles family, as corporate secretary. The company completed its factory in April 1874. It was relatively simple to build railroad cars

A Brief History

The St. Charles Car Company factory about 1887. *St. Charles County Historical Society.*

because they had wooden bodies and required mostly the work of skilled carpenters. The only metal parts were the hardware, truck sets and link-and-pin couplers, which could be obtained elsewhere. The St. Charles Car Company quickly found business from local railroads; its first order of fifty freight cars came from the St. Louis, Iron Mountain & Southern Railroad.

The decade of the 1870s, however, was a tough time to get involved in the railroad business. Financier Jay Cooke's failed attempt to sell bonds to build the Northern Pacific started the Panic of 1873. The Great Railroad Strike of 1877 roiled labor relations and further weakened the economy. In St. Charles, the value of the Car Company shares, so hopefully purchased earlier in the decade, fell to the point where they were being bartered for loads of hay or corn.

During the twenty-five years of its separate existence, the St. Charles Car Company built cabooses, refrigerator cars for meat packers and breweries, stock cars, gondolas and hopper cars to carry coal. In 1886, it added what would become its specialty: the construction of fine passenger cars. By 1899, the company had sixteen hundred employees. Homes in Frenchtown, an area of the city adjoining the plant so named for the background of the persons originally living there, were owned almost entirely by Germans by 1875. This skilled immigrant labor provided the carpenters, cabinet makers, joiners, trimmers, blacksmiths, finishers, timekeepers and others who composed

most of the factory's workforce. Cleta Flynn described Frenchtown during the late nineteenth century as virtually a "company town."

The railroad industry was modernizing in the 1890s. The development of knuckle couplers to replace dangerous link-and-pin couplers, and the advent of automatic air brakes, made possible heavier loads and longer trains and kindled a demand for all-steel railroad cars. The St. Charles plant was in danger of being passed by. Rumors began to spread that the company was for sale. It was feared that the factory might cut back operations or even close. Henry Denker told the local press that while the company was to be sold to American Car & Foundry (ACF), a New Jersey holding company, the St. Charles plant would remain in business. And in 1899, ACF bought not only the St. Charles Car Company but also twelve other railroad car companies, allowing it to instantly gain control of over 50 percent of the market for railroad cars.

With so many properties under its belt, ACF decided to make each of them specialize. St. Charles was the center of the company's passenger car manufacturing. For the next sixty years, it produced not only workaday passenger and baggage cars but also some of the finest private railroad cars in the land and specialty cars for customers such as the Ringling Brothers Circus. By 1909, with a payroll of over $1 million, the ACF plant in St. Charles was the largest employer in Missouri. The company's local leader was James Lawler, who experienced a rise worthy of Horatio Alger. Starting as a blacksmith in 1879 at $2 a day, he became a foreman and, later, the plant superintendent. He was appointed district manager in 1899, a post in which he served until his death in 1922. Lawler was praised by the local press for having the ACF plant grow "to be one of the best equipped plants of that great corporation."

War, Peace, Depression, Revival

When World War I came, ACF expanded to two thousand employees. Lawler was quoted as saying that "the company is doing quite a lot of war work in St. Charles which he is not at liberty to discuss, but we can tell the people that the car shops are doing their share of war work and straining every point to get the work out." It built a new, well-equipped machine shop, "equal to any other kind in the United States." The secret work included building over twenty-five hundred escort wagons—horse-

drawn wagons to haul supplies on the western front—and a variety of parts for artillery pieces.

Although St. Charles had a large population of second- and third-generation Germans, it was not a hotbed of pro-German sympathies when the war came. Many wanted to preserve their *kultur* but yielded to war hysteria. The St. Charles High School, for example, suspended the teaching of German in 1918. The German American Bank changed its name to the Commercial Bank; the Immanuel German Evangelical Lutheran Church and the St. John German Evangelical Church dropped "German" from their names. The St. Charles *Cosmos-Monitor* applauded the Lutherans, saying, "let us all be 100 percent American and drop hyphens and anything else that is not patriotic." Most of the anti-German restrictions came from above. The federal government, for example, required all German-born citizens to produce their naturalization papers or register with the police as citizens of Germany. Sixty St. Charles residents were swept up in this decree. But since most of the local officials were of German heritage, the excesses of anti-German feelings elsewhere were otherwise largely avoided.

Men ages twenty-one to thirty were required to register for the draft in June 1917. Unmarried men were taken first, stimulating what seemed to be an upsurge in marriages. One newspaper commented that "from all parts of the county parents are giving their consent to marriage of their sons who are underage. If it is the work of Cupid, of course it is O.K. But it is not patriotic these days."

Residents of St. Charles County of German ancestry were among the most patriotic. Steve Ehlmann found that, of the 1,166 men from St. Charles who served in the war, 759, or 65 percent, had German surnames. Of the 49 men from St. Charles who died in the war, 29 had German surnames. Civilians of German ancestry also supported the war, including doctors and nurses who volunteered to serve in France. St. Charles County exceeded its quota for the sale of Liberty Bonds in four of the five drives. So many ACF workers, many of them German Americans, joined or were drafted into the armed services that a shortage of skilled workers resulted. It was rumored that many would be sent back to work in the shops.

The 1920s brought St. Charles prosperity, automobiles, Prohibition and crime. The authors of the city directory boasted that "the hills which attracted the romantic soul of the founder are now dressed in beautiful homes, prosperous places of business, public buildings, churches, public and private schools and the necessary industrial institutions to make the city a balanced community."

St. Charles, Missouri

The number of automobiles in St. Charles increased from 200 to 2,108 between 1916 and 1921. Anyone who could afford it could drive a car. The state did not require driver's licenses until 1937. The city had been oiling its streets since 1911 and paved thirty-five miles of streets by 1930. Bus service provided serious competition to the streetcar, cutting the time for the trip to downtown St. Louis to thirty minutes. While most of its residents worked in St. Charles, improved transportation put it on the cusp of becoming a suburb of what was then the sixth-largest city in the United States. The Victory Highway—later designated U.S. Highway 40—was begun in 1923. When proposals surfaced to bypass St. Charles because of the toll bridge, St. Charles and St. Louis Counties reached an agreement to buy the bridge and turn it over to the state.

In 1914, Kathryn M. Linnemann "decided to do something about the lack of libraries" in St. Charles. She lined the halls of her home with books and invited the public inside. Later, the first library building was opened at Fourth and Jefferson Streets. The library moved to a building behind the high school, but it was destroyed by fire in 1918. Linnemann was not deterred. She started from scratch and rebuilt the library. In 1929, the library became

The first tax-supported public library in St. Charles, at 572 Jefferson Street. The first public library was started in Kathryn Linnemann's home in 1914. *St. Charles County Historical Society.*

a tax-supported institution. It moved into a former private house at Sixth and Jefferson in 1931.

Prohibition did not sit especially well with a population that enjoyed its beer and wine. More ominously, it and the automobile brought crime from the big city to the town. St. Charles was spared any train or bank robberies by Frank and Jesse James or similar desperadoes. But the temptation of an easy mark for gangs looking to turn a quick dollar brought them to the railroad in town.

Willis Thornhill was a longtime messenger for St. Charles banks and the post office who took the mail each evening to the railroad stations. Around 6:15 p.m. on February 4, 1921, Willis and his one-horse wagon picked up the mail—first class, second class and parcel post—for delivery to the Missouri-Kansas-Texas train scheduled to arrive at the St. Charles station at 6:32 p.m. While sitting about twenty yards north of the station, where the mail and baggage cars usually stopped, Thornhill was approached by five armed men. They seized the first-class mailbag, and Thornhill was forced to lie facedown on the floor in the back seat of a touring car. The gang drove to the St. Charles toll bridge in a relatively new criminal tool, the "getaway car," first used in Paris in 1911.

"Five and the car," they told the toll taker. As they drove east at high speed, Thornhill heard a man on the running board say, "Let's kill this fellow." A man inside, evidently the leader, said, "No. If there's any killing, I am out of it." The running board man protested, "Well, dead men can't talk." When he was interviewed later, Thornhill did not tell reporters what he was thinking while the men debated his fate. But, fortunately for him, the leader repeated, "I'm out of it if there's any killing. You know me. I'm running this, and I'll tell him what to do."

Exactly thirty-two minutes and twenty-two miles later, the robbers let Thornhill out in St. Louis near the Bellefontaine and Calvary Cemeteries. The leader warned Thornhill to wait a few minutes before he tried to report the robbery and took off up the street. Thornhill walked to a nearby store and called the police. The robbers got away with $26,100 in Liberty Bonds—as good as cash—from the First National Bank of St. Charles and the St. Charles Savings Bank.

The gang struck twice more. At Jefferson City on March 1, the robbers got away with $34,000 in Liberty Bonds after accosting the mail messenger and dropping him off unharmed at New Bloomfield, Missouri. In August, the gang robbed another messenger in Wood River, Illinois. In each of the robberies, the crooks seized mail with Liberty Bonds, kidnapped the

St. Charles, Missouri

The Missouri-Kansas-Texas Railroad depot, originally at the foot of Tompkins Street on the riverfront, was moved to Frontier Park in 1976. *Vicki Erwin collection.*

messenger and let him go after driving him safely away from the scene of the crime so he could not report it immediately.

The authorities suspected these crimes were the work of one of the St. Louis Irish crime gangs. Michael "The Shamrock" McNamara fingered the Jefferson City perpetrators and was killed for being a snitch. The police arrested Allan Morris—no known colorful nickname—who named Thomas McKean, alias John T. Doyle, and John "The Mule" Blair as participants. Morris was "slain by gangsters" for identifying his fellow robbers.

The robberies were said to be the work of the Hogan Gang, a band led by Edward J. "Jellyroll" Hogan. Hogan's men not only dealt in robbery and the sale of illegal liquor (Prohibition was in full swing), but Hogan himself was also a politician serving in the Missouri General Assembly. Although the motivations of the various factions remain murky, the St. Charles, Jefferson City and Wood River robberies may have played a role in the Hogan Gang's three-year war with Egan's Rats, a rival Irish gang led by William T. "Willie" Egan, a powerful ward leader in St. Louis.

The war got personal when Hogan paid three men, including Doyle, to shoot Willie Egan in front of his saloon. Both sides began indiscriminate killing that lasted until 1923. Doyle was killed in a shootout with police after a car chase into North St. Louis in January 1922. Over the next thirty-six months, twenty-three men died in various ambushes and drive-by shootings.

Finally, a priest, a police official and a reporter for the *St. Louis Star* brokered a peace treaty.

Egan's Rats was broken up shortly afterward by federal authorities. Hogan's Gang had more staying power. Jellyroll Hogan served in the legislature until 1960. He died in 1977. No one was ever prosecuted for the St. Charles robbery or the murders that followed it.

When the country fell into the throes of the Great Depression following the stock market crash of 1929, newspapers in St. Charles insisted that it was "exceedingly well positioned for a continuation of prosperity." This was just whistling in the dark. The number of building permits plunged. Factory employment shrank by 40 percent. Longtime businesses such as the St. Mary's Oil Engine Company went bankrupt. Banks failed, and those that did not were repeatedly robbed. There were twelve bank robberies in St. Charles County between May 1920 and December 1933, with a loss of $100,000 in deposits. There was a hobo jungle, or "bum's hollow," near Blanchette Park where the Wabash Railroad trains began to slow down for the curve leading to the Missouri River bridge. A "Hooverville" sprang up along the MKT railroad tracks on the Missouri River, and another shantytown was built by displaced families on an island in the Mississippi River.

Conditions slowly improved in the 1930s. ACF received a contract for sixty-five new cars in 1937, prompting the headline "Means Work for Large Number of Men." The coming of World War II in Europe led to the beginning of construction of a new ordnance plant in Weldon Spring. The government awarded ACF an "educational" order for 329 M-3 Stuart light tanks for the American and British armies. The company made a high-quality product at "suitable speed" and won additional orders. It took 186 pounds of blueprints and up to 3,500 parts to build a light tank. The ACF factory in St. Charles constructed the tanks, including installation of their 37mm main guns, on a 980-foot-long assembly line from parts shipped in from elsewhere. By August 1941, ACF was turning out 200 light tanks a month. The British were impressed with the tank's handling abilities, but, alas, its armament was outclassed by German panzers and they quickly became obsolete.

The end of World War II saw the end of rationing of civilian goods. The first of the baby boomers was born, and the economy took off to serve them and the civilian population that was long starved for consumer goods and services. ACF shared in the boom, as it was called on to manufacture new railroad passenger cars to replace those worn out by hard service during the

war. But the industry was changing. Airlines and automobiles were changing the nature of travel in the United States.

People turned to the convenience of driving their own car to work, shop and play. Gas was cheap, and cars were readily available for most persons' budgets. By the middle of the 1950s, the automobile was king. Congress passed the Interstate Highway Act in 1956, authorizing the construction of 42,500 miles of new, limited-access highways, with 90 percent of the cost paid for by the federal government. The first segment of the new interstate highways built in the program was the western approach to the Blanchette Bridge across the Missouri River at St. Charles.

The airplane, while still expensive, could take passengers to destinations in hours that would require days on a railroad train. With the development of the passenger jet in the 1960s, the time disparities in travel became even greater. Railroads began to curtail passenger service, and it was then stopped altogether. The Katy halted its passenger service in 1958. The Wabash followed suit in 1960.

The decline of railroad passenger service doomed the St. Charles ACF plant. For a time, its jobs were saved when the company won a contract to build the aft fuselage of the U.S. Air Force's B-47 Stratofortress, the first jet strategic bomber. But the B-47 was soon replaced by the B-52. By 1959, ACF manufacturing operations in St. Charles were over. The company kept its marketing and engineering departments in town and later moved the corporate headquarters to St. Charles.

There were major social changes, as well. In 1946, African Americans were finally allowed to use the public library. The swimming pool and schools were desegregated in 1954. Even as late as 1996, there were hints of racial prejudice in the defeat of an attempt to pass a tax to finance the extension of light rail service from St. Louis to St. Charles County. Other cultural clashes emerged in the turbulent 1960s. Some citizens objected to the presence in the library of magazines such as the radical left-wing *Ramparts* and to books with sexually explicit passages, such as Philip Roth's *Portnoy's Complaint* and John Updike's *Couples*. At one point, the director was fired and temporarily replaced with a nonprofessional in lieu of the professionally trained assistant director. But the library overcame these administrative and personnel difficulties. The St. Charles Library merged with the St. Charles County Library in 1973 to create one of the most modern and forward-looking library districts in the state. It has three regional branches, four general purpose branches, two express branches and three mini-branches. One of the regional

branches commemorates the founder of the St. Charles library system, Kathryn Linnemann.

As the city of St. Louis lost its economic power and began to decay, its residents—especially its white residents—began to move to the suburbs. At first, they moved to the inner ring of towns bordering the city, then to the outer suburbs in St. Louis County and, by the 1980s, across the Missouri River to St. Charles County. The county became the fastest-growing in the state and one of the fastest-growing in the country. Its population increased by 47 percent in the 1980s, by 33 percent in the 1990s and by 27 percent from 2000 to 2010. What had once been farmland was now the site of new subdivisions as more and more people moved to "affordable" St. Charles County. Sprawling new cities emerged, and old villages became the core of towns that spread across the county. The 2010 Census showed that three of the ten largest cities in Missouri are in St. Charles County: O'Fallon (85,040), St. Charles (68,796) and St. Peters (56,971). St. Charles County (385,590) is the third-largest county by population in Missouri, after St. Louis County and Jackson County (Kansas City and suburbs).

The nature of the county seemed to change overnight. What had been two-lane farm-to-market roads in 1980 became four-lane arterials connecting the burgeoning suburban subdivisions to the interstate highways that fed into St. Louis County. The first McDonald's arrived in 1965. Today, these formerly sleepy highways are home to every fast-food franchise, big-box store, convenience store and strip mall imaginable.

11

THE GREAT FLOOD OF 1993

From its earliest discovery, the Missouri River was known to be a violent stream. Its roiling floodwaters ripped thousands of trees from its banks and carried them downstream, posing a most significant hazard not only to the canoes of the Native Americans who first inhabited the state but also to the steamboats that plied the river from the early nineteenth century. The Missouri is often called the "Big Muddy." The name is well earned. Prior to the construction of dams and levees in the Missouri basin, it carried from 175 million to 320 million tons of silt or sediment downriver each year. Even now the river carries 20 to 25 million tons of silt per year.

Settlers who came to St. Charles quickly learned that the price of farming in the rich bottomlands was enduring the Missouri River's periodic flooding. Typically, there were two major floods each year: the April Rise, caused by the melting snow on the plains far upstream in the Dakotas and Montana, and the June Rise, fed by snowmelt in the Rocky Mountains and summer storms. Before the Corps of Engineers undertook extensive dam building, channeling and levee building, these floods—particularly the June Rise—could send ten times the normal flow of water downstream.

While the city of St. Charles sits largely atop the low hills that gave it its first name, much of St. Charles County (43 percent) is in a floodplain. From the area's earliest days, one could see where past floods left lakes as the trace of former channels. A comparison of modern maps with those from Lewis and Clark's time demonstrates that the main channel could move miles after

a flood, making what were once islands part of the mainland or slicing off part of the bank into an island.

For 150 years, the "great flood" referred to the one in 1844. But many later floods caused extensive damage to farms, crops, buildings, roads and railroads. The 1935 flood covered 57,000 acres around St. Charles. The 1942 flood covered 80,000 acres. The April Rise in 1943 was so severe that it cut a swath across the farmland north of town that became known as "Gran's Cut" and created Gran's Lake. The area continued to get hammered by floods after World War II because the only significant barrier to the floodwaters was the Missouri-Kansas-Texas Railroad's elevated roadbed. In 1947, 65,000 acres were flooded; in 1951, 45,000 acres were flooded; and in 1973, the flood was so severe that it closed the Wabash Railroad bridge for a time for fear that the damage would make train travel across it unsafe. In 1986 came the worst flood since 1844. But none of them matched what was to happen in the spring and summer of 1993.

Although little was done to build levees or other facilities to contain floodwaters in St. Charles, the federal government built fifteen dams on the main stem of the Missouri upstream in the Great Plains. From the Omaha District to the St. Louis District of the Corps of Engineers, there were 121 federally built levees and 1,067 privately built levees. The prior meanderings of the Missouri River during the April and June Rises were for the most part tamed. At least they were tamed for the kinds of floods typically seen on the river.

The summer and fall of 1992 saw above-average rainfall in the Missouri and Upper Mississippi basins. That winter, the area experienced heavy snowfall. In the spring, further storms pounded the area, by which time the ground was saturated, causing the persistent rain to run off into the rivers and creeks that drained into the Missouri and Mississippi. In March, the National Weather Service predicted the potential for major flooding.

The rain continued to fall. Flooding began on tributaries of the Mississippi in Minnesota in late May after a nine-inch rainfall. A high-pressure system stalled on the East Coast, drawing warm, moist air up from the Gulf of Mexico to the Midwest. The warm air met cool air from the jet stream out of Canada, and everything held in place. Heavy rain began to fall on the plains. Single rainfalls of up to thirteen inches fell over a period of just a few days. And the rains continued.

To gain some perspective on the amount of moisture these rains produced, consider that an inch of rain falling on one acre of ground is equal to 27,143 gallons of water. Some areas of Kansas and Missouri saw

A Brief History

three and one half *feet* of rain between April and July—over 1.1 million gallons of water on just one acre.

Residents of Missouri waited and watched as a virtual wall of water moved downstream from the plains and Upper Midwest. The April Rise flooded the usual spots in St. Charles County. The "river rats" who lived along the banks of the Missouri and Mississippi were used to dealing with such interruptions in their lives. The high water stuck around for about six weeks, but by Memorial Day, most of those evicted by the spring flood could return to their homes and begin the tedious process of repairing them.

Flood stage at St. Charles is twenty-five feet. Above that, the waters start to edge over the banks into Frontier Park on the riverfront, and some low-lying roads become impassable. The floodwaters threatened cancellation of the annual Fourth of July festivities. The river crept over the twenty-five-foot mark on July 3, but not far enough to interfere with the celebration. But the river levels would not fall below flood stage for another fifty-nine days.

Rain continued to fall, and the floodwaters continued to rise. The levee broke at Winfield on the Mississippi and sent that river into northern St. Charles County. At St. Charles, the river narrows between the bluffs on

A LANDSAT satellite image showing the extent of the Great Flood of 1993. *National Aeronautics and Space Administration.*

which the city is located and the levees on the St. Louis County side, creating an hourglass shape that compresses the flow of water. In a flood, the water shoots out north of town faster and higher than it enters from the south. In this flood, the current—running at seventeen feet per second (about eleven miles per hour)—scoured the bottom of the river, lowering its bed at St. Charles by more than four feet. The Missouri River is normally twelve feet higher than the Mississippi. On July 16, the river topped the abandoned Missouri-Kansas-Texas Railroad embankment serving as a de facto levee north of town and ran downhill to the north, cutting a new channel twenty miles long and, in some places, twenty feet deep, from the Missouri to the Mississippi. As much as 50 percent of the flow from the Missouri was diverted to this channel. On July 30, the Monarch Levee opposite bluffs on the St. Charles side of the Missouri failed, inundating over five thousand acres of farmland and businesses in the Chesterfield Valley with eight inches of muddy water. On July 31, a violent thunderstorm struck. Seventy-mile-per-hour winds whipped the floodwaters, causing six-foot waves in West Alton.

On August 2, floodwaters crested at a record 39.6 feet in downtown St. Charles, 14.6 feet above flood stage. (There is a plaque on the sidewalk on the south side of First Capitol Drive just below Main Street to mark the high-water mark and to commemorate the many volunteers and city employees who put in days of their time to protect the city.) The official National Weather Service gauge across the river from downtown recorded the crest at 40.04 feet, just a fraction of an inch below the flood of 1844.

Frontier Park disappeared. Water poured into the historic Katy railroad station and threatened the bandstand. It nearly reached the buildings on the east side of South Main Street and did flood into the old mill (now a restaurant) located at Boonslick Road and South Main Street next to Blanchette Creek. The river would not recede below flood stage at St. Charles until August 30. The respite was brief, for the river rose above twenty-five feet again on September 3 and remained above flood stage until October 7. The Missouri River was out of its banks at St. Charles for a total of ninety-four days.

Other area towns, particularly those on the Mississippi, were hit even harder. The river at Grafton, near the confluence of the Illinois and Mississippi Rivers and just upstream from Portage Des Sioux, was above flood stage for 195 days between March 26 and October 10, for all but a handful of days during that time. The gauge at the Melvin Price Locks, just downstream from West Alton, showed the river at flood stage for 179 days

A Brief History

Frontier Park from First Capitol Drive, showing the crest of the Great Flood of 1993. *St. Charles Historical Society.*

Frontier Park from First Capitol Drive, 2016. The plaque designating the high-water mark is visible on the sidewalk, to the right of the closest drain. *James Erwin collection.*

beginning on April 8. St. Louis, below the confluence of the two mighty rivers, was at flood stage off and on between April 11 and October 7 for a total of 146 days.

The governor called out the National Guard to provide relief efforts and security for affected areas. More than fourteen thousand volunteers filled sandbags. Local businesses donated food and, as important, water—many of the wells and water systems were either flooded or threatened. Emergency service centers operated around the clock making sure there were enough sandbags and sand to fill them. They also provided necessary food, water, sanitary facilities (many sewage plants were flooded) and medical services to victims and volunteers.

Mississippi and Missouri barge traffic was halted for two months. Many railroad trains had to be rerouted. Highway bridges over the Missouri River at Herman, Jefferson City, Rocheport and Kansas City were closed from time to time, cutting off parts of the state completely or requiring lengthy detours. The river was no respecter of any of man's institutions. On August 15, a pre–Civil War cemetery at Hardin, near the Missouri's banks, was caught in the flood, and caskets containing the bones of those long dead were split open and carried east. The remains that could be recovered were reburied in a mass grave on September 11.

The country came to the realization that this was, as one National Weather Service hydrologist said, "the largest and most significant flood event ever to occur in the United States." Helicopters blanketed the sky searching for new levee breaks and dramatic pictures to show on the evening news. There was no dearth of them. One farmer spelled "Save Our Horses" on the roof of his barn. Downstream from St. Louis, a helicopter news crew caught shocking images of the river sweeping away the home, barn and silos of a farm. The importance of the story became apparent when national news anchors showed up to broadcast with the floodwaters as a background in mid-July. Politicians swarmed the area, each expressing horror and sympathy—no doubt sincere, but not missing their photo opportunity to do so, either.

When the floodwaters finally receded in the fall, it was time to assess the damage. In the states of Missouri, Minnesota, Kansas, Iowa, Wisconsin, Nebraska, North Dakota and South Dakota, there were fifty flood-related deaths and damages estimated at $15 billion. Forty federal levees and over one thousand private levees—more than 75 percent of all private levees—failed. Perhaps as many as forty thousand homes were damaged and thousands of persons left homeless. Seventy-five towns were completely inundated. Some

of those were simply abandoned or moved to the bluffs above the rivers. The flooded farmland was devastated. The river dumped an estimated 21.8 tons of sand and 55 million tons of silt and clay on the floodplains.

In St. Charles County alone, the Federal Emergency Management Administration paid out $9.3 million to homeowners and $14.3 million to businesses. The county suffered $5.1 million in damages to its property. The state provided $9 million in replacement housing, $7 million in levee repairs and $6 million in crop disaster payments. It spent $1.8 million to pay for sand removal alone.

The 1844 flood was of similar proportions to the 1993 flood. But, of course, it occurred at a time when the state was not as densely populated and developed as it would be 150 years later. And so, the flood of 1993 earned the name the Great Flood.

12
ST. CHARLES TODAY

Beginning in the 1980s, St. Charles underwent a radical change, from a largely agricultural county to one with new subdivisions and shopping malls seemingly popping up everywhere. But as beautiful, comfortable, affordable and convenient as the new subdivisions were, there were casualties of suburbanization, too. As in many cities, the formerly bustling downtown lost businesses to the malls and strip malls along the highways. Downtown St. Charles was now off the beaten path. The highway that used to be the principal route from St. Louis to Kansas City no longer went through the heart of the old city, but to the south. And yet there were persons who fought to retain and remember the city's historic roots. The St. Charles County Historical Society was organized in 1956. It has become a thriving source for historians, genealogists and anyone looking for information about St. Charles or even just a picture of the old homestead.

By the mid-1960s, Main Street had been reduced to a few antiques stores, a pharmacy, a few businesses hanging on to survival and a collection of run-down buildings ripe for demolition. The State of Missouri bought the former First Capitol building in 1961, but nothing was done immediately to rehabilitate it. And then, in 1964, a visionary came to town.

Archie Scott had graduated from Southern Illinois University the previous fall. He came to St. Charles and immediately saw the possibilities of rehabilitating it as a historic district. He was disgusted by the "bums, the hobos, and the dilapidated buildings" where hippie squatters ripped out the interior for firewood. The mill on Blanchette Creek that had been there

St. Charles, Missouri

The First State Capitol of Missouri before its renovation. *St. Charles County Historical Society.*

since before the Civil War was on the verge of being condemned, but he started a campaign to save it, helped materially by a movie he produced and marketed. He bought, restored and moved into what is said to be the oldest home on Main Street, at 719 South Main. He spearheaded drives to preserve and rehabilitate other historic structures.

But Scott's efforts alone could not have saved Main Street from further deterioration. He was joined by others, pioneers of a new sort, such as John Dengler and Donna Hafer. Ann Hazelwood edited a monthly newsletter called the *South Main Star* to keep residents and activists apprised of what had been done and what still needed to be done. Interested persons met weekly to discuss ongoing projects and plot the best ways to move the city and the state to help rehabilitate and preserve the historic downtown.

There were challenges and controversies everywhere. St. Peters proposed opening a landfill on Main Street. The historic Katy Railroad depot was in danger of being demolished. The Katy Trail ran through parts of town that subjected its users to sights of trash, rusting car parts, buckets, barrels

A Brief History

and pipes, old refrigerators and heavy equipment—hardly an enticing view for potential tourists and Main Street customers. Blanchette Creek was clogged with junk such as old grocery carts. To restore the "look" of historic St. Charles, preservationists successfully sought the removal of electricity and telephone poles from Main Street.

This group of dedicated preservationists finally convinced the state to appropriate the money to renovate the First State Capitol—the signature rehabilitation project on Main Street. In 1965, the city council renamed Clay Street First Capitol Drive in recognition of the city's heritage. The city created the Main Street Historic District and enacted strict codes to preserve the buildings and the atmosphere of a historic area. In addition to renovations, the area's architecture and history were researched. The South Main Preservation Society placed plaques on the historic buildings in the area so that visitors would be made aware of their history.

In 1970, Main Street received federal recognition in the National Register of Historic Places. Businesspersons returned to the area, renovating buildings and establishing a unique blend of craft and gift shops, bookstores, clothing stores, coffee shops and restaurants. No big-box stores or fast-food restaurants for this street. A controversial pedestrian mall was tried and eventually scrapped, to the relief of many merchants in the district.

The First State Capitol of Missouri today. *St. Charles Convention and Visitors Bureau.*

Federal money made possible the construction of Riverside Drive and the building of Frontier Park out of what the *South Main Star* called "little more than a sandbar with the tendency to flood." The Main Street Historic District was expanded in the 1980s. Since 1990, nineteen locations in St. Charles and St. Charles County have been added to the National Register of Historic Places, for a total of thirty-three as of this writing. These include Stone Row at 313–330 South Main Street (distinctive limestone buildings dating to the First Capital era) and the Frenchtown Historic District (bounded by North Fifth, Clark and French Streets and the Missouri River). Two recent additions are the Midtown Neighborhood Historic District (bounded by Clark, Madison, Jefferson, Kingshighway, Second and Third Streets) in 2014 and the Lindenwood Neighborhood Historic District (bounded by Watson, Gamble, Sibley and Elm Streets, with an alley between Houston and North Kingshighway) in 2016.

The 200th anniversary of Lewis and Clark's departure on their voyage of discovery was commemorated not only with ceremonies when the modern-day Corps of Discovery shoved off in its period boats but also by the construction of the Lewis and Clark Boathouse and Nature Center, a fascinating museum of the explorers and their achievements. Other museums include the Frenchtown Heritage and Research Center, the St. Charles Heritage Museum and Park, the Heritage Center at the Nathan Boone Home, the Shrine of St. Rose Philippine Duchesne at the Academy of the Sacred Heart, the Old Borromeo Church and, of course, the First Missouri State Capitol Historic Site. One of the old ACF buildings is now the Foundry Arts Centre, housing three art galleries and studios for individual artists. For those who want a taste of riverboat gambling (although no longer on a riverboat), there is a casino at the south end of Main Street.

One of Archie Scott's favorite sayings was "Everything matters." It isn't just the buildings that count. The cultural events in the district celebrate and recall the region's history. The Festival of the Little Hills every August brings together thousands to peruse arts and crafts, eat delicious food and enjoy entertainment on Main Street and in Frontier Park. Las Posadas, a candlelight parade the first Saturday of December, recalls Spanish traditions celebrating the birth of Jesus. Christmas Traditions brings a festive atmosphere to Main Street with colorful characters ranging from Saint Nicholas to Christmas Fairies to carolers in Victorian costumes. Other events include the *Fête de Glace*, a winter activity featuring ice carvers who create statues and figures from blocks of ice; Lewis & Clark Heritage Days; MOSAICS Missouri Festival for the Arts; Oktoberfest; and the Riverfest

A Brief History

Foundry Arts Centre, formerly part of the American Car & Foundry Company plant. *Vicki Erwin collection.*

Fourth of July celebration. One can even enjoy a "ghost tour" of South Main Street. The preservationists, property owners, business owners and citizens have striven to make the historic district truly what the South Main Preservation Society calls a "living historical village and cultural hub."

In the 250 years since Louis Blanchette met Bernard Guillet at the foot of Les Petites Côtes, the little French village has grown to a modern city that is still a beautiful place to live, but one that remembers and honors its past.

BIBLIOGRAPHY

Ambrose, Stephen E. *Undaunted Courage: Meriwether Lewis, Thomas Jefferson, and the Opening of the American West*. New York: Simon & Schuster, 1996.
Anderson, Ephraim McD. *Memoirs, Historical and Personal: Including the Campaigns of the First Missouri Confederate Brigade*. St. Louis, MO: Times Printing Company, 1868.
Annual Report of the Adjutant General of the State of Missouri, 1863. Reprinted in the appendix to *Journal of the Senate of Missouri, Twenty-Second General Assembly*. Jefferson City, MO: J.P. Ament, 1863.
Baumann, Timothy E. "The DuSable Grave Project in St. Charles, Missouri." *Missouri Archaeologist* 66 (December 2005): 59.
Bava, Katherine. "Conflict and Division within the Presbyterian Church." *Confluence* (Spring/Summer 2011): 26.
Bay, W.V.N. *Reminiscences of the Bench and Bar of Missouri*. St. Louis, MO: F.H. Thomas and Company, 1878.
Beale, Howard K. *The Diary of Edward Bates, 1859–1866*. Washington, D.C.: United States Government Printing Office, 1933.
Billion, Frederic L. *Annals of St. Louis in its Territorial Days: From 1804 to 1821*. St. Louis, MO: privately published, 1888.
Boman, Dennis. *Lincoln and Citizens' Rights in Civil War Missouri: Balancing Freedom and Security*. Baton Rouge: Louisiana State University Press, 2011.
Brackenridge, Henry. *Journal of a Voyage Up the Missouri Performed in Eighteen Hundred Eleven*. In Reuben Gold Thwaites (ed.), *Early Western Travels 1748–1846*. Cleveland, OH: Arthur H. Clark Company, 1904.

Bibliography

Bresnan, Andrew L. "Western Sharpshooters: The 66th Illinois Volunteer Infantry and Their Henry Repeating Rifles." Henry Repeating Rifle. Accessed August 27, 2016. http://44henryrifle.webs.com/westernsharpshooters.htm.

Brown, Jo Ann. *St. Charles Borromeo: 200 Years of Faith*. St. Louis, MO: Patrice Press, 1991.

Bryan, William S., and Robert Rose. *A History of Pioneer Families of Missouri*. St. Louis, MO: Bryan, Brand & Company, 1876.

Burnett, Betty, ed. *The Flood of 1993: Stories from a Midwestern Disaster*. Tucson, AZ: Patrice Press, 1994.

Carter, Gari, ed. *Troubled State: Civil War Journals of Franklin Archibald Dick*. Kirksville, MO: Truman State University Press, 2008.

Changnon, Stanley A. *The Great Flood of 1993: Causes, Impacts, and Responses*. Boulder, CO: Westview Press, 1996.

Chapman, Carl H., and Eleanor F. Chapman. *Indians and Archaeology of Missouri*. Columbia: University of Missouri Press, 1983.

Charter and Acts Relating to the North Missouri Railroad Company. St. Louis, MO: George Knapp & Company, 1865.

Chittenden, Hiram Martin. *The American Fur Trade of the Far West*. Vol. 1. New York: Francis P. Harper, 1902.

Clark, M. St. Clair, and David A. Hall, comp. *Cases of Contested Elections in Congress from the Year 1789 to 1834, Inclusive*. Washington, DC: Gales and Seaton, 1834.

Clay, Steven. E-mail to author regarding Charles Bentzoni. September 4, 2016.

Coddington, Ron S. *African American Faces of the Civil War: An Album*. Baltimore, MD: Johns Hopkins University Press, 2012.

Conard, Howard L. *Encyclopedia of the History of Missouri*. New York, St. Louis, MO: Southern History Company, 1901.

Corbin, Annalies, and Bradley R. Rogers. *The Steamboat Montana and the Opening of the West: History, Excavation, and Architecture*. Gainesville: University Press of Florida, 2008.

Craig, Dan, Kirby Kavanaugh, Eric Mayuga and Liza Ortillo. *The 1871 St. Charles Railroad Bridge*. N.p., 1992.

Cubit Planning, Inc. "Missouri Cities by Population." Accessed November 8, 2016. http://www.missouri-demographics.com/cities_by_population.

———. "Missouri Counties by Population." Accessed November 8, 2016. http://www.missouri-demographics.com/counties_by_population.

Culmer, Frederic A. "Abiel Leonard, Part I." *Missouri Historical Review* 27 (January 1933): 113–20.

Daily Missouri Republican, January 10, 1862.

Danisi, Thomas C. *Uncovering the Truth about Meriwether Lewis*. Amherst, NY: Prometheus Books, 2012.

Bibliography

Danisi, Thomas C., and John C. Jackson. *Meriwether Lewis*. Amherst, NY: Prometheus Books, 2009.

DePeyster, Arent Schuyler. *Miscellanies*. Dumfries, UK: Dumfries and Galloway Courier Office, 1813.

Dibble, Philer K. *Memorandum of Outrages*. Hamilton Gamble Papers, Box 1, Folder 8(2). Missouri State Archives.

Dickey, Michael. *People of the River's Mouth: In Search of the Missouria Indians*. Columbia: University of Missouri Press, 2011.

Dobak, William A. *Freedom by the Sword: The U.S. Colored Troops, 1862–1867*. New York: Skyhorse Publishing, Inc., 2013.

Dunne, Gerald T. *The Missouri Supreme Court: From Dred Scott to Nancy Cruzan*. Columbia: University of Missouri Press, 1993.

East Carolina University Maritime History Program: St. Charles Steamboat Project. Accessed September 17, 2016. https://www.archive.org/web/20080509092205/http://www.ecu.edu/maritime/Field/fall2002/steamboat.htm.

Ehlmann, Steve. *Crossroads: A History of St. Charles County, Missouri, Bicentennial Edition*. St. Charles, MO: Lindenwood University Press, 2011.

Ekberg, Carl J., and Sharon Person. *St. Louis Rising: The French Regime of Louis St. Ange de Bellerive*. Urbana: University of Illinois Press, 2015.

Elwang, W.W. "The Authors of Pioneer Families of Missouri." *Missouri Historical Review* 28 (July 1934): 255–59.

Emmons, Ben L. "The Founding of St. Charles and Blanchette Its Founder." *Missouri Historical Review* 18, no. 4 (July 1924): 507–20.

Encyclopedia of Arkansas History & Culture. "Alida Clawson Clark." Accessed August 31, 2016. http://encyclopediaofarkansas.net.

Erwin, Vicki Berger, and Jessica Dreyer. *St. Charles (Then and Now)*. Charleston, SC: Arcadia Publishing, 2011.

Fausz, J. Frederick. *Founding St. Louis: First City of the New West*. Charleston, SC: The History Press, 2011.

Federal Judicial Center. "Arnold Krekel." Biographical Directory of Federal Judges. Accessed October 17, 2016. http://www.fjc.gov/servlet/nGetInfo?jid=1318&cid=999&ctype=na&instate=na.

Fehrenbacher, Don. *The Dred Scott Case: Its Significance in American Law and Politics*. London: Oxford University Press, 1978.

Flint, Timothy. *Recollections of the Last Ten Years*. Boston: Cummings, Hilliard and Company, 1826.

Flynn, Cleta Marie. *A.C.F.: American Car & Foundry*. St. Charles, MO: St. Charles County Historical Society, 2013.

———. "The First Ladies of Frenchtown." *St. Charles Heritage* 22 (April 2004).

———. *St. Charles County, Missouri History through a Woman's Eyes*. St. Charles, MO: St. Charles County Historical Society, 2014.

Bibliography

Foley, William E. "Friends and Partners: William Clark, Meriwether Lewis, and Mid-America's French Creoles." *Missouri Historical Review* 98 (July 2004): 270–82.

———. *The Genesis of Missouri: From Wilderness Outpost to Statehood*. Columbia: University of Missouri Press, 1989.

———. *A History of Missouri*. Vol. 1, *1673 to 1820*. Columbia: University of Missouri Press, 1999.

———. *Wilderness Journey: The Life of William Clark*. Columbia: University of Missouri Press, 2004.

Forbes, Robert Pierce. *The Missouri Compromise and Its Aftermath: Slavery and the Meaning of America*. Chapel Hill: University of North Carolina Press, 2007.

Fort Osage National Historic Site. "George Sibley." Accessed February 18, 2016. http://www.fortosagenhs.com/george-sibley.html.

Founders Online. Thomas Jefferson Papers. Accessed June 30, 2016. http://www.founders.archives.gov/documents/Jefferson.

Fry, James B. *The History and Legal Effect of Brevets*. New York: D. Van Nostrand, 1877.

George, Raymond B. *Missouri-Kansas-Texas Lines in Color*. Edison, NJ: Morning Sun Books, 1996.

Gottschalk, Phil. *In Deadly Earnest: The Missouri Brigade*. Columbia: Missouri River Press, 1991.

Grant, H. Roger. "The North Missouri: A St. Louis Railroad." *Railroad History*, no. 213 (Fall–Winter 2015): 91–101.

Gravemann, Dianna, and Don Gravemann. *St. Charles: Les Petite Côtes*. Charleston, SC: Arcadia Publishing, 2009.

Gregg, Kate L. "The Boonslick Road in St. Charles County." *Missouri Historical Review* 27, no. 4 (July 1933): 307–14.

Hager, Ruth Ann (Abels). *Dred & Harriet Scott: Their Family Story*. St. Louis, MO: St. Louis County Library, 2010.

Hazelwood, Ann. Interview with author, November 10, 2016.

History of Boone County. St. Louis: Missouri Western Historical Company, 1882.

History of St. Charles County, Missouri (1765–1885). N.p.: Paul Hollrah, reprint, 1997.

Hopewell, M. *Legends of the Missouri and Mississippi*. London: Ward, Lock and Tyler, n.d.

Houck, Louis. *A History of Missouri from the Earliest Explorations and Settlements until the Admission of the State into the Union*. 3 vols. Chicago: R.R. Donnelley & Sons Company, 1908.

Hurt, R. Douglas. *Nathan Boone and the American Frontier*. Columbia: University of Missouri Press, 1998.

Jefferson, Robin Seaton. "Mr. Main Street." *Streetscape Magazine* (Spring 2007). Accessed November 8, 2016. http://www.preservationjournal.org/pioneers/ScottA/Archie2.pdf.

Bibliography

Journal of the House of Representatives, Second General Assembly. St. Charles, MO: Nathaniel Paschall, 1822.

Journal of the Missouri State Convention, October 1861. St. Louis, MO: George Knapp & Company, 1861.

Journals of the Lewis and Clark Expedition. Lincoln: University of Nebraska. Accessed July 1, 2016. http://www.lewisandclarkjournals.unl.edu.

Juern, Joan M. *Call to the Frontier: Gottfried Duden's 1800's Book Stimulated Immigration to Missouri*. Augusta, MO: Mallinckrodt Communications Research, 1999.

Kaminski, Edward S. *American Car & Foundry Company: A Centennial History, 1899–1999*. Wilton, CA: Signature Press, 1999.

Kamphoefner, Walter B. *The Westfalians: From Germany to Missouri*. Princeton, NJ: Princeton University Press, 1987.

Keeven-Franke, Dorris. "Gottfried Duden." Accessed October 17, 2016. http://www.stcharlescountyhistory.org/2012/11/19/gottfried-duden.

———. "Gottfried Duden: The Man Behind the Book." In *Missouri's German Heritage*. Edited by Don Heinrich Tolzmann. 2nd ed. Milford, OH: Little Miami Publishing Company, 2006.

———. "A Memorial to the 56th Regiment of the U.S. Colored Troops." St. Charles History. Accessed October 23, 2015. http://www.stcharlescountyhistory.org/category/civil-war.

———. "Pioneer Families." Accessed August 8, 2016. http://www.homepages.rootsweb.ancestry.com/~schmblss/home/History/PioneerFamilies/Bios/keeven.htm.

King, Roy T. "Robert William Wells, Jurist, Public Servant, and Designer of the Missouri State Seal." *Missouri Historical Review* 30, no. 2 (January 1936): 107–31.

Konig, David Thomas. "The Long Road to *Dred Scott*: Personhood and the Rule of Law in the Trial Court Records of St. Louis Slave Freedom Suits." Missouri Secretary of State. Accessed August 5, 2016. http://www.s1.sos.mo.gov/CMSImages/MDH/TheLongRoadtoDredScott.pdf.

Krekel, Arnold. *Untitled Autobiographical Sketch*. Krekel Family File. St. Charles County Historical Society.

LaPlata Home Press, March 8, 1879.

Larsen, Lawrence H. *Federal Justice in Western Missouri: The Judges, the Cases, the Times*. Columbia: University of Missouri Press, 1994.

Larson, Lee W. *The Great Flood of 1993*. Silver Spring, MD: NOAA, National Weather Service, 1995.

Lass, William E. *Navigating the Missouri: Steamboating in Nature's Highway, 1819–1935*. Norman, OK: Arthur H. Clark Company, 2008.

Launer, Louis J. "Arnold Krekel." *St. Charles Heritage* 16 (April 1998): 38.

Bibliography

Leftwich, Reverend W.M. *Martyrdom in Missouri: A History of Religious Proscription, the Seizure of Churches, and the Persecution of Ministers of the Gospel, in the State of Missouri During the Late Civil War.* Vol. 1. St. Louis, MO: S.W. Book and Publishing Company, 1870.

Linklater, Andro. *An Artist in Treason: The Extraordinary Double Life of General James Wilkinson.* New York: Walker Publishing Company, 2009.

Lovejoy, Joseph C., and Owen Lovejoy. *Memoir of the Rev. Elijah P. Lovejoy; Who Was Murdered in Defence of the Liberty of the Press.* New York: John S. Taylor, 1838.

Machi, Mario, Allan May and Charlie Molino. "St. Louis." American Mafia. Accessed September 11, 2016. http://www.americanmafia.com/Cities/St_Louis.html.

Malone, Dumas. *Jefferson and His Time.* Vol. 4, *Jefferson the President, First Term, 1801–1805.* Boston: Little Brown and Company, 1970.

Masterson, V.V. *The KATY Railroad and the Last Frontier.* Columbia: University of Missouri Press, 1988.

McCandless, Perry. *A History of Missouri.* Vol. 2, *1820 to 1860.* Columbia: University of Missouri Press, 1972.

McGuiness, Margaret M. *Called to Serve: A History of Nuns in America.* New York: New York University Press, 2013.

McMillan, Margot Ford, and Heather Robinson. *Called to Courage: Four Women of Missouri History.* Columbia: University of Missouri Press, 2002.

Michener, James A. *Centennial.* New York: Random House, 1974.

Million, John W. *State Aid to Railways in Missouri.* Chicago: University of Chicago Press, 1896.

Missouri Highway and Transportation Department. *The Old St. Charles Bridge.* Jefferson City, MO, 1990.

Moberly Monitor-Index, March 12, 1970.

Moore, Glover. *The Missouri Controversy, 1819–1821.* Lexington: University of Kentucky Press, 1966.

Morgan, Robert. *Boone: A Biography.* Chapel Hill, NC: Algonquin Books, 2007.

National Archives and Records Administration. *Union Provost Marshal's File of Papers Relating to Individual Civilians.* Record Group 109, M345, various rolls.

Oberg, Barbara B., ed. *The Papers of Thomas Jefferson.* Vol. 34, *1 May–31 July 1801.* Princeton, NJ: Princeton University Press, 2007.

O'Neil, Tim. *Mobs, Mayhem & Murder: Tales from the St. Louis Police Beat.* St. Louis, MO: St. Louis Post-Dispatch, 2008.

Parrish, William E. *Missouri Under Radical Rule 1865–1870.* Columbia: University of Missouri Press, 1965.

———. *Turbulent Partnership: Missouri and the Union 1861–1865.* Columbia: University of Missouri Press, 1963.

Bibliography

Phillips, Christopher. *Missouri's Confederate: Claiborne Fox Jackson and the Creation of Southern Identity in the Border West*. Columbia: University of Missouri Press, 2000.

Rable, George. *God's Almost Chosen People: A Religious History of the American Civil War*. Chapel Hill: University of North Carolina Press, 2010.

Rader, Perry S. "The Location of the Permanent Seat of Government." *Missouri Historical Review* 21, no. 1 (October 1926): 9–18.

Report of the North Missouri Railroad Company, Appendix, Exhibit B, reprinted in *Journal of the Senate of Missouri, Twenty-Second General Assembly*. Jefferson City, MO: J.P. Ament, 1863.

Richards, Leonard L. *"Gentlemen of Property and Standing": Anti-Abolition Mobs in Jacksonian America*. New York: Oxford University Press, 1971.

Riddler, Rory. *The Bitter Divide: A Civil War History of St. Charles, Missouri*. St. Charles, MO: Frenchtown Heritage and Research Center and City of St. Charles, 2013.

Roberts, W. Milner. *Report on the Present State and Prospects of the North Missouri Railroad*. Philadelphia, PA: McLaughlin Brothers, 1866.

Sandweiss, Lee Ann, ed. *Seeking St. Louis: Voices from a River City, 1670–2000*. St. Louis, MO: Missouri Historical Society, 2000.

Sedalia Weekly Bazoo, November 18, 1879.

Shoemaker, Floyd C. *Missouri and Missourians: Land of Contrasts and People of Achievements*. 5 vols. Chicago: Lewis Publishing Company, 1943.

———. *Missouri's Struggle for Statehood, 1804–1821*. Jefferson City, MO: Hugh Stephens Printing Company, 1916.

———. "St. Charles, City of Paradoxes." *Missouri Historical Review* 36, no. 2 (January 1942).

16th Infantry Regiment Association, Officers of 11th Infantry Regiment, "1st Lt. Charles Bentzoni." Accessed August 30, 2016. http://16thinfassn.org/?page_id=3419.

Society of Friends. *History of Southland College*. Richmond, IN: Nicholson Press, 1906.

South Main Star, November 10, 1991; December 10, 1991; January 10, 1992; February 10, 1992; March 10, 1991.

Steel, Dorothy. "The History of Public Libraries in St. Charles." Master's thesis, University of Missouri, 1977.

Steffen, Jerome O. "William Clark: A New Perspective of Missouri Territorial Politics 1813–1820." *Missouri Historical Review* 47, no. 2 (January 1973): 171–97.

Stevens, Walter B. "Alexander McNair," *Missouri Historical Review* 27 (October 1922).

———. *St. Louis: The Fourth City, 1764–1911*. Vol. 2. St. Louis, MO: S.J. Clarke Publishing Company, 1911.

Bibliography

Steward, Dick. *Duels and the Roots of Violence in Missouri*. Columbia: University of Missouri, 2000.

St. Charles City County Library District. Accessed November 8, 2016. www.youranswerplace.org/branches-hours.

St. Joseph Morning Herald, March 25, 1863.

St. Louis Post-Dispatch, November 10, 1879; December 9, 1881; February 5, 1921; February 6, 1921.

St. Louis Star and Times, February 5, 1921; August 4, 1921.

Switzler's Illustrated History of Missouri from 1541 to 1881. St. Louis, MO: C.R. Barns, 1881.

Templin, Lucinda De Leftwich. "Two Illustrious Pioneers in the Education of Women in Missouri: Major George C. Sibley and Mary Easton Sibley." *Missouri Historical Review* 21, no. 3 (April 1927): 420–37.

Thompson, Ernest Trice. *Presbyterians in the South*. Vol. 2, *1861–1890*. Richmond, VA: John Knox Press, 1963.

Thwaites, Reuben Gold. *Travels in the Far West, 1836–1841*. Vol. 1. Cleveland, OH: Arthur H. Clark Company, 1906.

Trogdon, Jo Ann. *The Unknown Travels and Dubious Pursuits of William Clark*. Columbia: University of Missouri Press, 2015.

Valone, Stephen J., ed. *Two Centuries of U.S. Foreign Policy: The Documentary Record*. Westport, CT: Praeger Publishers, 1995.

The War of the Rebellion: A Compilation of the Official Records of the Union and Confederate Armies. Washington, D.C.: United States Government Printing Office, 1880–1901.

Way, Frederick, Jr. *Way's Packet Directory, 1848–1994*. Rev. ed. Athens: Ohio University Press. 1983.

Wild, J.C. *The Valley of the Mississippi Illustrated in a Series of Views*. St. Louis, MO: Chambers and Knapp, 1841.

Williamson, Hugh P. "Abiel Leonard, Lawyer and Judge." Missouri Bar. Accessed September 11, 2016. http://www.mobar.org/journal/julaug2015/leonard.htm.

Wolferman, Kristie C. *The Indomitable Mary Easton Sibley: Pioneer of Women's Education in Missouri*. Columbia: University of Missouri Press, 2008.

Yockelson, Mitchel. "'Their Memory Shall Not Perish': Commemorating the 56th United States Colored Troops." *Gateway Heritage* 22, no. 3 (Winter 2001–2).

INDEX

A

American Car & Foundry (ACF) 140, 145, 146
Anderson, Ephraim 112, 113

B

Bagwell, Alzada (Zaidee) 114, 115, 116
Bagwell, Augusta 114, 116
Barton, David 70, 71, 72, 73, 75
Bates, Edward 59, 60, 70, 72, 89, 99, 110, 119, 124, 125
Benton, Thomas Hart 54, 65, 66, 70, 72, 73, 75
Bentzoni, Charles 117, 119
Blanchette, Louis 7, 8, 11, 12, 13, 14, 15, 16, 85, 126, 161
Boone, Daniel 18, 19, 20, 22, 23, 45, 61
Boone, Nathan 18, 19, 20, 22, 23, 48, 71, 81, 86, 126
Boone, Olive Vanbibber 19, 20, 23
Burdine, Amos 62

C

Camp Jackson 100, 101, 109

Chouteau, Auguste 15, 33, 36, 42, 44, 47, 50
Chouteau, Pierre 17, 42, 47, 48
Clark, George Rogers 39, 40
Clark, William 8, 40, 41, 42, 43, 44, 45, 47, 48, 52, 53, 55, 56, 59, 72, 75, 92
Colgin, Daniel 61, 62
Collier, Catherine 62, 63
Côte Sans Dessein 52, 53, 62, 76, 81

D

Delassus, Don Carlos Dehault 17, 18, 34
Devore, Uriah 75, 76, 78
Donaldson, James 36, 37, 38
Dorsey, Caleb 102, 103, 104
Drake, Charles 123, 124
Duchesne, Rose Philippine 56, 57, 58, 59
Duden, Gottfried 85, 86, 87, 89
Duquette, Marie Louise 43, 45, 55, 56, 58, 78

Index

E
Easton, Rufus 33, 34, 35, 36, 37, 38, 51, 52, 53, 54, 59, 63, 64, 66, 91

F
Farris, Robert P. 109, 110, 111, 124
Fifty-Sixth United States Colored Infantry 117, 119
Flanagan, Joseph M. 112, 114
Flint, Timothy 55, 56
Fort Osage 48, 64, 65
Frontier Park 151, 152, 160

G
Green, Duff 70, 78
Guillet, Bernard 7, 8, 11, 161

H
Hempstead, Edward 37, 45, 50, 51, 52

J
Jefferson, Thomas 25, 26, 27, 30, 32, 33, 35, 36, 38, 39, 40, 45, 51, 70
Johnson, Charles 102, 103, 104, 127

K
Katy Trail State Park 133, 158
Krekel, Arnold 89, 99, 105, 106, 107, 108, 109, 110, 123, 124, 125, 126, 127
Krekel, Mattie Parry 125

L
Leonard, Abiel 82, 83
Les Mamelles 17
Lewis, Meriwether 8, 40, 41, 42, 44, 45, 47, 48, 55, 59, 92
Linden Wood Female Academy 66, 109, 124
Linnemann, Kathryn M. 142, 147

Livingston, Robert R. 25
Lovejoy, Elijah P. 91, 92, 93
Lucas, John B.C. 36, 37, 38, 53, 70
Luckett, Henry 112, 113
Luckett, Hiram 116, 117
Luckett, Robert Frank 112, 116
Luckett, William Chap 112, 116
Luckett, William F. 112, 115, 116

M
Marquette, Father Jacques 9
McNair, Alexander 48, 52, 67, 72, 75, 77, 78, 79, 80, 81
Meigs, Return, Jr. 36, 38, 45
Millington, Dr. Seth 92, 93
Missouri Gazette 50, 52, 53, 70, 71
Missouri-Kansas-Texas Railroad 131, 132, 133, 143, 145, 146, 150, 152, 158
Montana 135, 136, 137, 138

N
New Orleans 13, 18, 25, 26, 27, 31, 39, 40, 66, 89
North Missouri Railroad 102, 112, 115, 127, 128, 130, 138

P
Perez, Lieutenant Governor Manuel 14
Pettus, William 71, 78, 80, 83
Point du Sable, Jean Baptiste 66, 67, 78

R
Reid, Nathaniel 110, 111

S
Scott, Archie 157, 158, 160
Scott, Dred 94, 95, 96, 97, 98, 100
Scott, John 52, 53, 69, 72, 73
Second Missouri (Confederate) Infantry 112, 113, 114, 115, 116
Sibley, George 64, 65, 66, 93

INDEX

Sibley, Mary Easton 63, 64, 65, 66, 93, 110, 124
St. Charles Car Company 138, 139, 140
St. Charles Demokrat 87, 89, 107
Stoddard, Amos 30, 31, 34, 35, 41, 44

T

Taney, Roger 97, 98
Tayon, Charles 15, 17, 18, 44
Third Arkansas Infantry (African Descent) 116, 117
Thornhill, Willis 143
Treaty of Cession 27, 32, 69
Trudeau, Lieutenant Governor Don Zenon 17, 18, 20
Tuhomehenga 12, 14

W

Wells, Robert 80, 81, 93, 94, 96, 124
Wilkinson, James 35, 36, 37, 38, 40, 41
Williams, Reuben 117

ABOUT THE AUTHOR

James W. Erwin graduated from Missouri State University with a BA in mathematics. After service in the United States Army, he obtained an MA in history from the University of Missouri and a JD from the University of Missouri Law School. He practiced law in St. Louis for more than thirty-seven years. Mr. Erwin and his wife, Vicki Berger Erwin, owned a bookstore in the Main Street Historic District in St. Charles for eight years. They live in Kirkwood, Missouri.

*Visit us at
www.historypress.net*

This title is also available as an e-book